FRESHEN
YOUR PAINTINGS WITH
NEW IDEAS

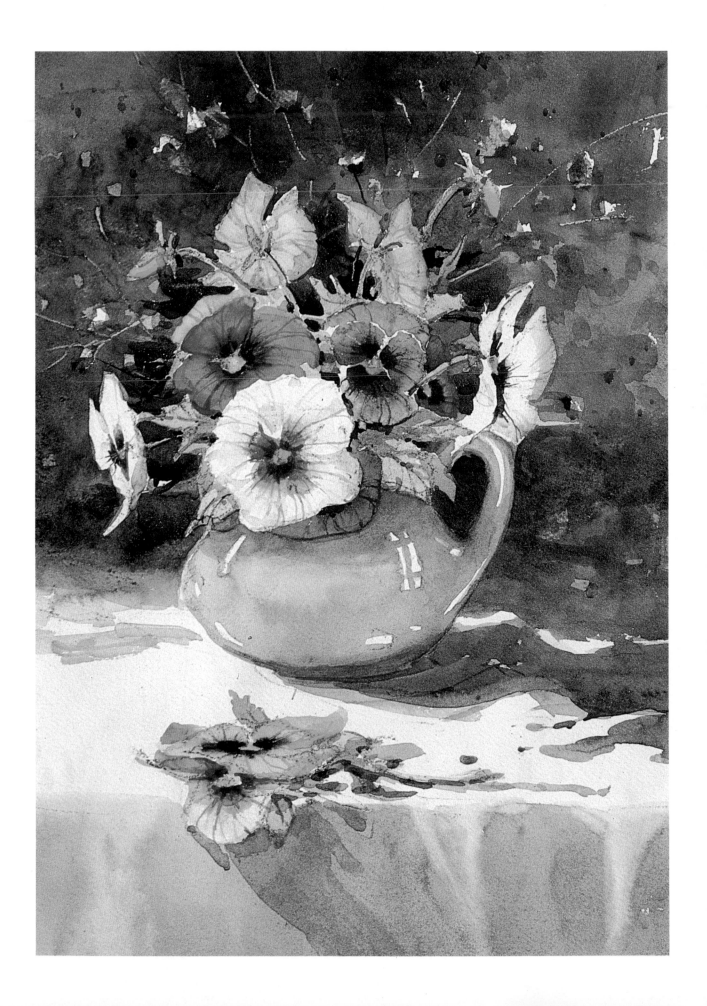

FRESHEN
YOUR PAINTINGS WITH
NEW IDEAS

LEWIS BARRETT LEHRMAN

NORTH LIGHT BOOKS
Cincinnati, Ohio

(Cover Illustration)
Rainy Season, Four Corners
Ed Mell
Oil on canvas
30″ × 40″

(Opposite Title Page)
Spring Fling
Marilyn Simandle
Watercolor
16″ × 12″

98 97 96 95 94 5 4 3 2 1

Library of Congress Cataloging in Publication Data

Lehrman, Lewis Barrett
 Freshen your paintings with new ideas / by Lewis Barrett Lehrman.
 p. cm.
 Includes index.
 ISBN 0-89134-566-3
 1. Painting—Technique. 2. Painting—Themes, motives. 3. Painting—Psychological aspects. I. Title.
ND1500.L44 1994
751.4—dc20 94-2363
 CIP

Edited by Rachel Wolf
Interior design by Paul Neff
Cover design by Brian Roeth

METRIC CONVERSION CHART		
TO CONVERT	**TO**	**MULTIPLY BY**
Inches	Centimeters	2.54
Centimeters	Inches	0.4
Feet	Centimeters	30.5
Centimeters	Feet	0.03
Yards	Meters	0.9
Meters	Yards	1.1
Sq. Inches	Sq. Centimeters	6.45
Sq. Centimeters	Sq. Inches	0.16
Sq. Feet	Sq. Meters	0.09
Sq. Meters	Sq. Feet	10.8
Sq. Yards	Sq. Meters	0.8
Sq. Meters	Sq. Yards	1.2
Pounds	Kilograms	0.45
Kilograms	Pounds	2.2
Ounces	Grams	28.4
Grams	Ounces	0.04

Dedication

This book is dedicated to the creative spirit that resides in all of us, and thus it is dedicated to you.

Despite *"Stop your daydreaming!" "Keep your mind on business!" "Not another of your crazy ideas!" "What could you possibly know?"* . . . and all the other forms of negativity in the world, creativity survives. Despite the pressures of the day and the fatigue of the night, the errors of the past and the problems of the future . . . be assured, the creative spirit is alive and well within you. It is your birthright.

It is the driving force of the universe, this unmeasurable quality called "creativity," so close that we may often miss seeing it. And yet it is ours simply for the calling.

Acknowledgments

First and foremost, I would like to acknowledge and thank my wife, Lola, whose enthusiasm and continuing support of my writing efforts enable me to continue along this creative and fulfilling path.

I also wish to gratefully acknowledge the community of professional fine artists in Arizona and around the country, upon whose good nature I draw for insights, interviews, background, demonstration paintings, and the finished works that appear in these pages. The openness and generosity exhibited by each and every artist in sharing "secrets" with my readers is truly wonderful, and has done much to make my part of the job possible. The talent and the perseverance are theirs . . . and so, deservedly, the recognition.

My thanks, also, to the staff of the Scottsdale Artists' School for their ongoing help, especially in setting up the panel discussion that appears in the back of the book, and to Carolyn Robbins of the Scottsdale Center For The Arts, at which facility that panel discussion was held on May 20, 1993.

Finally, I'd like to acknowledge the efforts of my editor, Rachel Wolf, and the designers and staff at North Light Books, who were more than equal to the not-insubstantial task of organizing and editing this mélange of ideas.

Contents

In the Realm of Ideas 1

Chapter One **Ideas From the World Around You** 3

Peter Van Dusen: Convey the Emotion of the Moment
Raleigh Kinney: Build Composition by Simplifying
Len Chmiel: Inspiration Begins With "On-the-Spotters"
Joe Abbrescia: Overcome Artist's Block With a Painting Trip

Chapter Two **Getting Fresh Reference Material** 23

Tom Darro: Assemble a Story With a Photo Session
Lew Lehrman: The Joy of Journals and Sketchbooks
Gerry Metz: Experience the Scene — and the Elements

Chapter Three **Creating Realism From Abstract Design** 35

Ted Goerschner: Start With Simple, Colorful Shapes
Dick Phillips: Look For Abstract Patterns in the Scene

Chapter Four **Taking Another Look at Flowers** 47

Marilyn Simandle: Express the Mood of the Season
Diane Maxey: Give New Life to an Old Photo

Chapter Five **Portraying the Human Spirit** 57

Harley Brown: Capture Your Subject's Personality
Ardyth Bernstein: Inspiration From the Nightly News

Chapter Six **Exploring Your Inner Space** 67

Lew Lehrman: Painting Thoughts and Feelings From the Past
Gary Kolter: Weave a Story With Memorabilia

Chapter Seven **Finding a New Direction** 75

Joni Falk: Take Advantage of "Happy Accidents"
Diane Maxey: Plan First, Then Let Yourself Paint
Cheryl English: Wander a Different Creative Path

Chapter Eight **Expressing Creativity in Commissions** 89

Bob Abbett: Focus Creativity in an Animal Portrait
Lew Lehrman: Paint a Personal House Portrait
Ann Manry Kenyon: Develop Expression in a Portrait Commission

Chapter Nine **Allowing Yourself to Do
Something Different** 105

Miles Batt: Paint One Scene Five Ways
Charles Sovek: Discover a New Approach to Color
James Christensen: Turn Your Imagination to the World of Fantasy

**What Do I Paint Next?
Four Artists Talk About
Staying Fresh and Creative** 122

Creativity's Deadliest Enemies 128

The Artists 130

Index 134

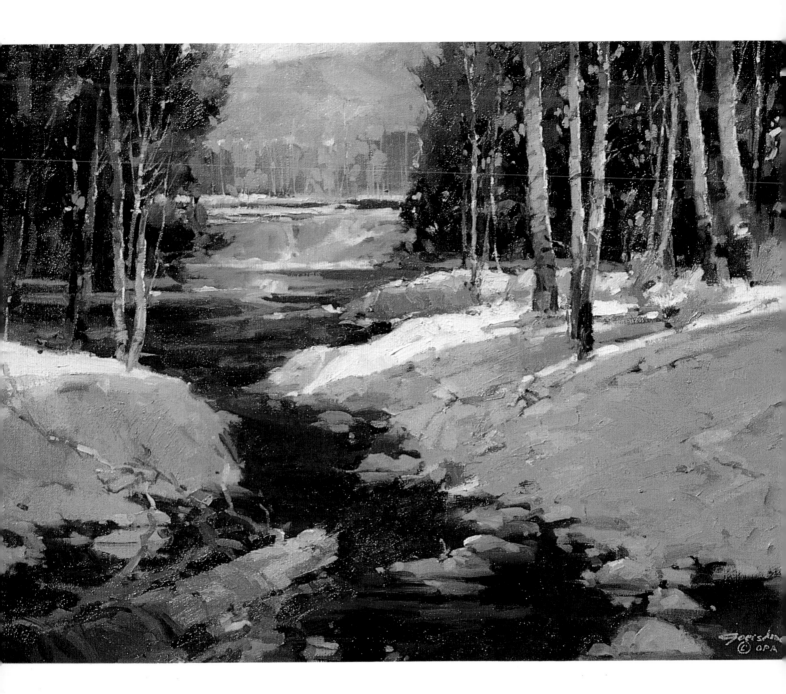

Introduction

In the Realm of Ideas

First Light, Sierras
Ted Goerschner
Oil on canvas
36″ × 48″

How do you feel when you visit a museum or a gallery? For me it's like approaching a magnificent banquet spread. Arrayed before me I see the wonderful wealth of the human imagination. I may not wish to partake of everything, but invariably I'll come away brimming—yes, richly nourished—with the limitless variety of creative expression I have experienced.

Creativity is the engine that drives every form of innovation, whether a new vaccine, a river-spanning bridge, a symphony, a novel, or a work of visual art. This wondrous capacity to make something out of nothing is unique to the human race—our birthright.

It would be easy to begin our journey through the realm of ideas with an elaborate theoretical dissertation on human creativity, its development and psychology. Instead, let's keep things as simple as possible: An idea is nothing more than an expression, in the mind, of a *perceived plan*—the solution to a problem.

In art, that problem might be stated: "How can I express the beauty of this landscape?" Or, "How shall I convey the unique personality of my subject?" "How can I communicate this feeling?" Or even, "What shall I paint next?"

That "perceived plan" is the painting that exists in our minds, before we spill it out on canvas or paper. From that point on, it's a matter of skill, and craft, and solving the specific problems of composition, color, value, and technique.

In exploring the realm of ideas for this book, I spoke with dozens of professionals, and recorded a wide spectrum of views on the subject. My conversations took me to the studios of artists whose shelves are lined with sketchbooks, each filled with a lifetime's worth of painting ideas just waiting to be worked on, and to artists toiling through dry spells of self-doubt and rejection, which so often follow periods of creative growth and professional fulfillment.

If preparing this book has resulted in any insights at all, it is confirmation of my belief and experience that the more one draws upon the wellspring of ideas, the more will be there to draw upon.

I encourage you to dip into this book on any page, in any chapter, at random, as the spirit moves you.

Learn, by looking over an artist's shoulder, just a few of the many paths to creativity.

Browse the many "Idea Starters" to find some pathways back to your own inherent creativity, the realm of ideas, and the world of art.

Explore the joy of sketchbooks and journals, the excitement of the ever-popular floral, the strange world of fantasy painting, and the pleasures of painting "just for fun."

Take part in an exciting panel discussion between professional artists on the subject of becoming, and staying, fresh and creative.

In short, approach the book in any way at all. Ideas follow no rules, and, at least in exploring this little world, neither should you.

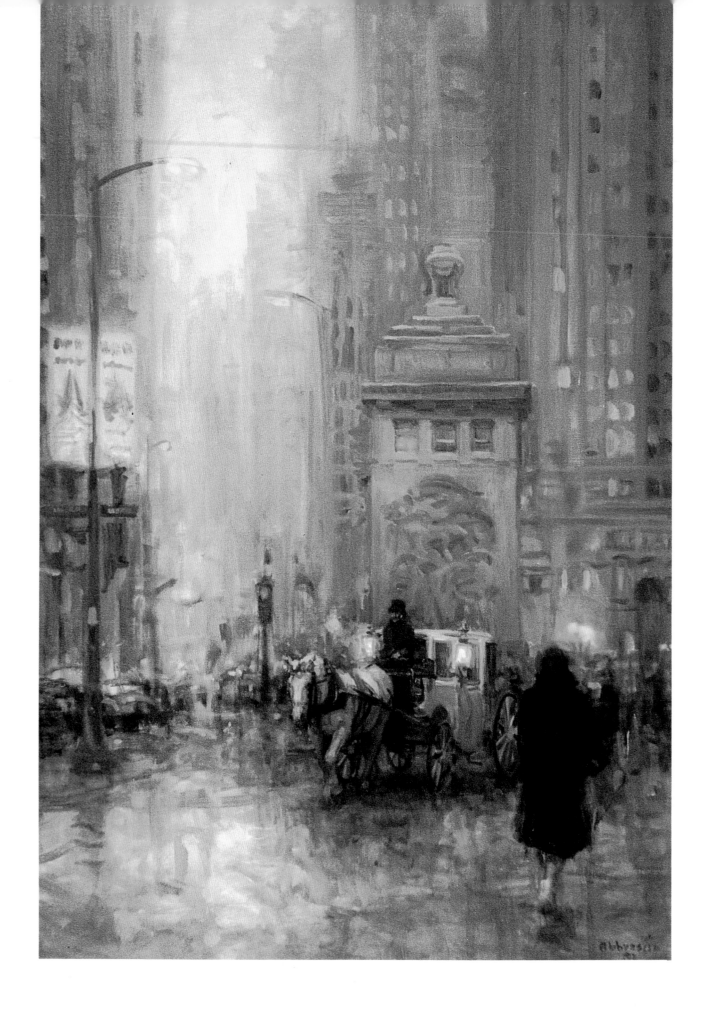

Chapter One

Ideas From the World Around You

The world around you. That's a pretty big category. Most of the paintings ever painted could fit under that heading. But think about this: It's a pretty big world!

In this chapter, you'll see how Peter Van Dusen uses an old photo and his skills as artist and story teller to create a dramatic Gloucester Harbor scene. You'll watch Raleigh Kinney evoke, from an on-location sketch, the sparkle and color of a bright Catalina Island morning.

It doesn't stop there. Len Chmiel and Joe Abbrescia take remarkably similar paths to painting nature: They experience their subjects first. They stand out there, the sun on their heads, their feet slowly freezing, the wind blowing, the bugs biting, the light changing. It's not *supposed* to be comfortable. It's *Nature*. No one's found a way to fake that, and their passion comes through in the paint.

What about ourselves as artists? Because we live in the world, do we sometimes take what we see for granted, at least in the artistic sense? Probably. It's impossible to see *everything* as potential subject matter. Yet, though a lot of the world seems less than beautiful, there are subjects to be found, literally, all around us — in the commonplace as often as the grand. Seeing these subjects, and then presenting them so that others can experience their beauty, is entirely a function of our own creativity.

A stack of laundry can become a wonderful painting. Try it.

Peter Van Dusen

Convey the Emotion of the Moment

The fishing boat Peter selects for *Safe Haven* was photographed from the deck of a tour boat heading for a day of whale watching out of Gloucester, Massachusetts. The subject has strong emotional appeal for Peter.

P.V. — I love these Gloucester fishing boats. This one was returning to safe harbor, weathered and wet, from the stormy open sea.

As often happens, the photo is far less dramatic to the casual viewer than Peter's emotional recollection of the moment, and therein lies the genesis of his concept, and the art of the painter.

Building the Story

With just the outline of his concept in mind, Peter begins a series of value sketches. Masses are blocked in, moved around and evaluated. A first visualization of his composition starts to take shape on paper.

Now, his idea beginning to gel, the artist moves on to color. Using oil paints on sketch paper, Peter tries a first effort, quickly realizing that a light sky does not convey the mood he desires.

His second oil sketch is more successful. The upper mast stands highlighted against the darker sky. He likes the effect of the darker wa-

ter mass in the foreground, which gives weight to the bottom of the painting. Ultimately, though, he decides that the greenish water is too "tropical" for Gloucester.

In his third oil sketch Peter pushes the sky color past the maximum ("Too dark now," he decides). He has also muted the green of the water.

These preliminary studies have given Peter the opportunity to explore his feelings about the scene, and he realizes that its drama and meaning will be enhanced with slanting, late-afternoon light, illuminating boat and buildings on the distant shore.

Reference Photo

Peter's original photo, though interesting, lacks the dramatic intensity the artist feels is called for in a subject like this.

Value Studies

A series of value studies helps Peter clarify composition, and affords him time to become familiar with his subject.

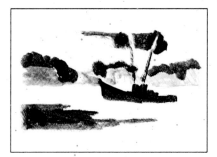

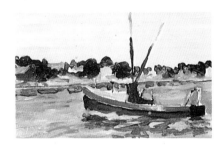 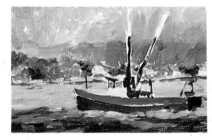 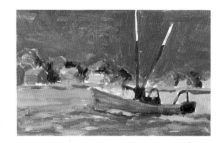

Color Studies

Quickly sketched in oil on paper, these little color studies enable the artist to explore and evaluate alternatives.

Developing It in Monochrome

With these decisions made, the artist feels confident moving on to the canvas.

Coming to art after a long career in the sciences, Peter prefers a fairly precise rendition of his subject for this type of painting. A stretched and primed 24″ × 30″ Belgian linen canvas is washed with muted burnt sienna and French ultramarine. The drawing is penciled in.

Developing values in monochrome is the next step. Peter is still using the burnt sienna/ultramarine mix. He finds this a useful way of confirming value relationships and composition.

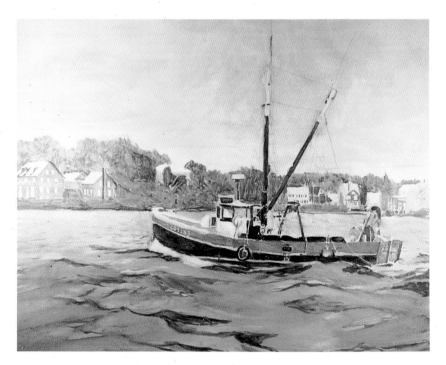

Monochrome

Working in monochrome at this early stage, the artist can limit his decision-making to matters of value and composition.

Tuning Up to Color

When the artist feels he has fully developed his value relationships in monochrome, it is a relatively simple task to begin plugging in color. Now, with values established, it is primarily a matter of shifting to the desired hues. The painting begins to come alive with virtually no shift in value relationships.

Changing the Mood

When he has completed laying in the color, Peter stands back to survey the scene he has created. After long minutes studying it, he further evaluates his feelings about the treatment of the sky.

P.V. — Having a warm, light sky takes away from the drama of the boat. It doesn't give the feeling of the cold, rainy ocean off the New England coast that I want. I'll go to a deeper, grayer sky, which makes a better backdrop. That will enable me to reflect contrasting light off the mastheads, too.

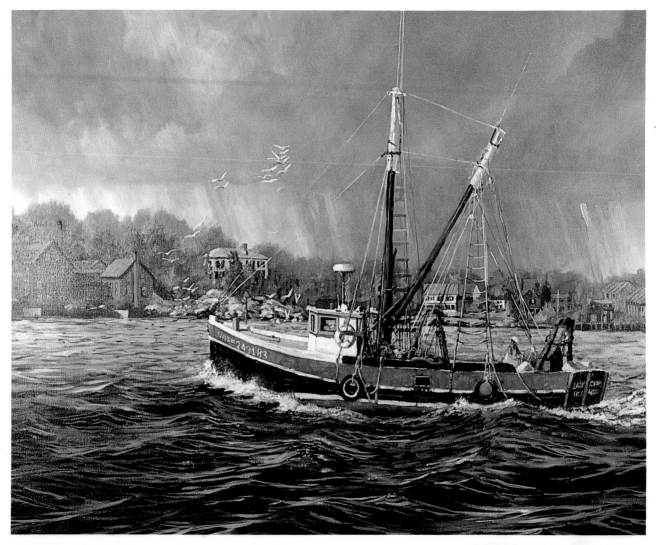

Getting It Right

A look at the finished painting shows how effectively Peter has realized his concept. A stormy sky in middle-value grays separates well from both dark and light values in the boat's mast and boom. Dramatic lighting from left is defined on the buildings along the distant shore and in white highlights on the boat itself. The dark, wind-tossed waters in the foreground add needed weight to the painting and emphasize the light that sweeps across the middle ground. Notice, too, how reflected sky color

Safe Haven
Peter Van Dusen
Oil on canvas
24″ × 30″

is picked up on the left sides of these foreground waves, further dramatizing the scene, suggesting the bright sky that surely exists outside the painting's frame.

In painting *Safe Haven*, Peter powerfully demonstrates how combining what the artist sees with what he feels about his subject can result in a painting that is stronger than either.

Idea Starter
Capture the Excitement

Going someplace? Take your camera. Shoot a roll of pictures, and right then and there, take it to the one-hour photo shop. Then go out for a sandwich, or just hang around. Pick up your prints or slides the minute they're ready, and head directly to your studio. Start a painting while the visual excitement of the scene is still fresh in your mind.

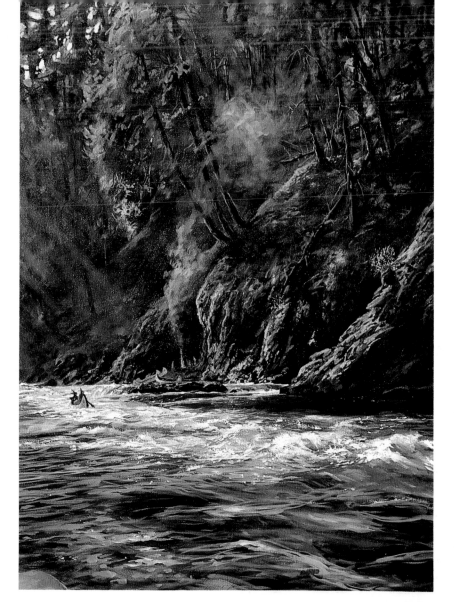

River Encampment
Peter Van Dusen
Oil on canvas
36″ × 24″

"Sometimes one's olfactory memories can evoke the most powerful of images," said Peter, showing me this picture. "In this case it was remembering that wonderful aroma of a campsite at morning: smelling the pine-scented air, drifting wood smoke, the rushing river, and cool, damp, moss-covered cliffs. Suddenly I could visualize the whole scene. This is the south fork of the McKenzie River in Oregon, where I spent so much time years ago."

Peter has moved the scene back in time a century or so, increasing its tension with the addition of a possible Indian war party.

Land Ho
Peter Van Dusen
Oil on canvas
24″ × 36″

Peter Van Dusen shows his skill at enhancing the drama of a scene:

A classic old sailing barque makes the last miles to port through a drenching squall. Emerging into warm afternoon sunlight, sails still wet and shining, sea birds flying around the beautiful prow, this proud vessel presents a stirring sight.

Raleigh Kinney
Build Composition by Simplifying

If there is one thing I admire (and there are many) about Raleigh Kinney's watercolors, it's his ability to simplify, yet make his painting look as if the details are all there should you want to look for them.

Raleigh is a dedicated watercolorist who came to Arizona following a Minnesota teaching career some thirteen years ago. Since then he has devoted his time not only to practicing and teaching his craft, but also to marketing his watercolors directly to his public. You'll see Raleigh and sometimes his wife, Darlene, at many of the best art festivals, fairs and exhibits around the Southwest, which keeps him a very busy artist, indeed.

For this demonstration painting, Raleigh takes a few hours off to come to my studio, toting equipment, paper, and an armload of paintings and sketchbooks to leaf through.

As we talk about subjects and locations, I am treated to a studio-chair tour of his favorite southwestern painting locales.

Turning the pages of one of Raleigh's sketchbooks, we strike a rich load of material from Catalina, that picturesque subtropical vacation island off the coast of southern California.

Raleigh stops at one sketch, a strong vertical. A photo of the scene is pasted to the facing page.

A Subject That Gets Him Excited

R.K.—I sketched this on location. This is the kind of subject that really appeals to me. There's something about the design, the pattern, the diagonal relationships, the buildings that are really only interesting light and dark shapes. Catalina is mostly stacked up there on the hill. You can get unusual angles looking up, or looking down—a great impetus for a painting.

I remark the differences between photo and sketch.

R.K.—In sketching, I strain what I see through my sensibilities—simplifying, designing, and in this case, exaggerating pattern.

He begins redrawing his composition onto an unstretched half sheet of 140-lb. Arches cold-press watercolor paper.

As one might expect from a watercolorist who teaches so many groups and workshops, Raleigh has painted from this sketch before. Familiar as he is with its contours, he takes new liberties with it, further simplifying and refining composition as he pencils it in.

First Washes

R.K.—I'll be using a triad of dye colors for this piece: Antwerp blue, rose carthame and permanent yellow; but I'll begin with cobalt (which is not a dye color, but a light transparent). I'll bring in various other colors later for variety.

Raleigh, who more often works on wet paper, decides this time to keep his paper dry. He's seeking, he says, a crisp, colorful, resort-like look—a brightly sunlit, Raoul Dufy-like pattern and feeling.

R.K.—I'll play that kind of tune right from the beginning, and see whether I can keep the freshness and excitement going.

He begins at the top. In memory (as in the photo), he recalls, the water was such deep blue that it appeared nearly black. Raleigh

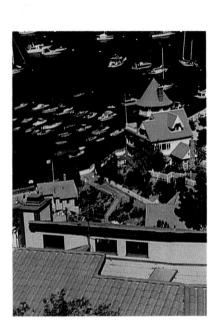

Reference Photo (Left)

Raleigh Kinney took this photo of the Catalina Island scene during a sketching session.

Sketch (Right)

The artist did this sketch perched high atop a Catalina Island bluff. Raleigh prefers to sketch on location, designing, rearranging and simplifying in the process. He'll then follow his sketch for reference as he paints, referring to the actual scene before him principally for colors and details.

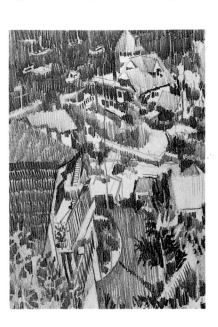

Step 1

The initial line-in reveals and confirms the underlying design: repeating diagonals and blocky rhythmic forms that will tumble down through right center.

Step 2

Raleigh builds his painting from the top down, establishing major relationships and rhythms right from the outset.

Step 3

Building color and value contrasts. Notice how strongly strengthening the value of the water livens up the composition.

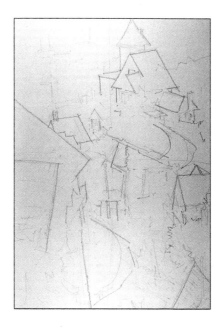

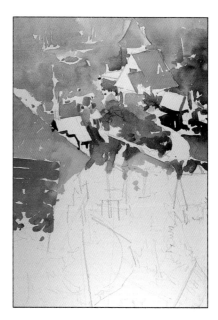

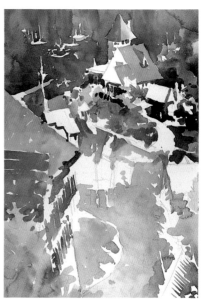

washes in a middle-value blue that he'll build on later, cutting around sailboat shapes and mast outlines as he goes.

Raleigh Makes His Mark

The artist selects his big, floppy no. 36 round "Goliath" brush.

R.K. — The round brush gives me a different sort of mark. I don't get that clipped diagonal. The round brush makes a little more of a "daub." That's the fun of it. I also work the side as well as the tip of this brush, and get an entirely different kind of effect with that.

The painting takes form from the top down, as buildings, rooftops and trees take shape. Already apparent is that essence of Raleigh's art I mentioned at the outset: his uncanny ability to omit detail, yet convey the impression that it's there.

Building Value and Color Contrasts

As the painting progresses, Raleigh gradually closes out whites; he establishes the strong rhythms of the painting, along with the vertical movement through the center.

He stands back to evaluate how the painting looks so far.

R.K. — It's all middle values. I'll go back in now and start to build the value and color contrasts the painting needs.

A second, much stronger blue is glazed over the original water area with immediate positive results.

R.K. — The key to doing this without losing it — without turning it to mud — is to keep your washes clear and gem-like. Work with two-color mixes as much as possible.

Now Raleigh turns his attention to the smaller areas in the painting, glazing in new, more intense colors, breaking major shapes into yet smaller shapes, defining (yet not *refining*) details.

As he builds color and value contrast and textural interest, the sunny, jazzy rhythms of Catalina Island come vividly to life.

R.K. — In a painting like this, you really see a kind of design, an approach, a look at pattern, and a lot of potential in the way it can be interpreted. These are the kinds of things that implore me to paint.

Catalina Colors and Patterns
Raleigh Kinney
Watercolor
14" × 21"

Finish

There's a lot *less* to this painting than meets the eye! Large foreground masses of foliage and rooftop contrast with the excitement of the village far below. Sharp shadows, intense sunlight, sparkling blue water, all are suggested with an absolute minimum of detail.

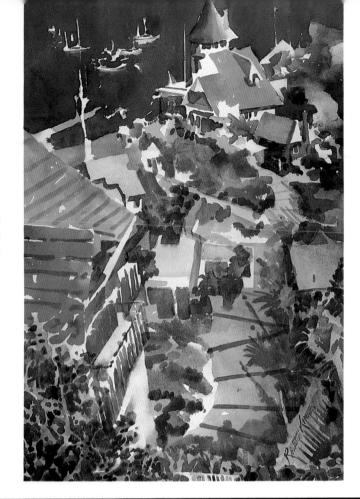

The Painting I'll Never Sell

I did this painting back about 1979. The two boys are our two sons.

I value this painting not so much for its subject matter, but the way I painted it. I was just beginning to play with more simplified pattern, and simplified shapes, enjoying the textures . . . though the colors are not as intense as I'm using today.

We were still living in Minnesota then, just before we moved to Arizona, and much of what you see here represents a door that was opening for me, the beginning of what has grown in my work since we've been living here.

Since doing this painting, I've grown in my work: stronger use of color, much more texture and pattern, greater simplicity, better division of shape. But this is where it all started.

Pilot to Co-pilot hangs in our house. It reminds me of when I first could see the direction my work would be going. It's one painting I'll never sell.

— *Raleigh Kinney*

Pilot to Copilot
Raleigh Kinney
Watercolor
21" × 27½"
Collection of the artist

Len Chmiel

Inspiration Begins With "On-the-Spotters"

As the artist puts it, he reacts to visual stimulus—the excitement of experiencing, then painting that excitement. Nothing unusual there: Many artists pack palette and canvas into the countryside in search of that very stimulus and response.

What's interesting about Len Chmiel's approach is that, though he regards his small (usually around 12″ × 16″) plein air pieces as finished paintings in every respect, he rarely sells them. Instead, he keeps them, as many of us would keep our own priceless sketchbooks, calling on them in his Colorado studio months or even years later as he seeks to evoke the essential truth of that plein air experience.

What Gets His Studio Paintings to Work

L.C.—That "on-the-spotter" is my first-hand information about the scene. My anchor point. Everything has to key into it. That's the only way I'll get my studio painting to work.

His subject matter might be anything at all.

L.C.—I might sit in my garden and paint the flowers, or head out to a new area and just visually react to something. Whatever I get excited about, I paint. I put all of my picture-making skills into each one. I don't look at them as sketches. As far as I'm concerned, they're finished paintings.

Whether painting in his garden,

out in the forest, or in the mountains of Nepal, Len's plein air painting kit doesn't vary much: paint box filled with palette, pigments and brushes, plus sufficient canvas boards to see him through. (He returned from a three-week trip to Nepal with twenty-three oils, several watercolors, uncounted sketches, and seventy-six rolls of exposed film!)

L.C.—I carry my camera to record detail. I might even use a slide for inspiration, especially if I've photographed a fleeting moment. But rarely do I work from photos.

A Concept Takes Shape

I asked Len Chmiel to show how he uses his "on-the-spotters" as the genesis of his major paintings.

L.C.—Take this snowy grove of cottonwood trees (below left). The 12″ × 16″ was my "on-the-spotter." It sat in my studio for about a year, while I planned to enlarge it to, perhaps, 50″ × 65″. I wanted to capture that surrounding, snowy feeling—like being in a forest with all that white and silence. Gradually, though, I began to expand it horizontally to enhance the effect with a more interesting shape.

A pencil drawing is his next step, as he starts to develop the possibilities of the horizontal format. I asked Len if he has worked through many sketches to arrive at final concept and format.

L.C.—I had pretty well thought it out, visualized it, knew it would work before putting pencil to paper. So this was my only sketch. When I did it, I thought I could lead the eye into the painting with that little stream at lower left, half-hidden in the snow. I liked that idea well enough to use it in the preliminary painting I did next.

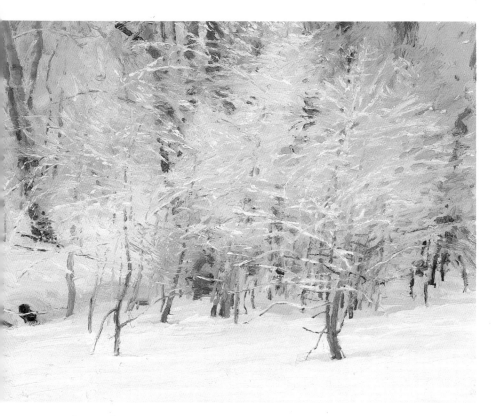

Winter Frieze
Len Chmiel
12″ × 16″
Oil on canvas board
Collection of the artist

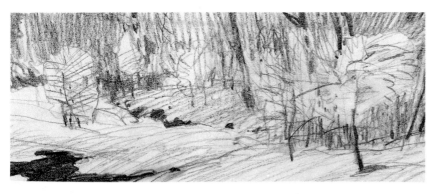

Preliminary Pencil Drawing

What works in this pencil sketch for *Of Snowy Billows and Dawn* may not necessarily translate to the canvas.

Oil Study

Len Chmiel's small (6¼" × 16") study for *Of Snowy Billows and Dawn*. After being reworked, this is how it finally appears as the artist begins his full-size painting.

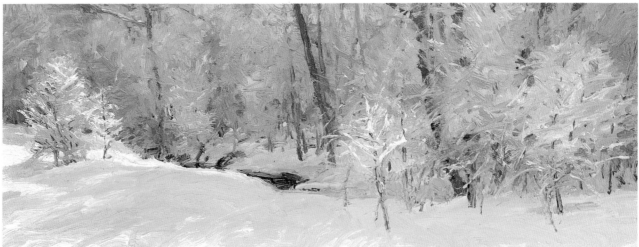

It Has to Feel Right

L.L. —*Where did the stream come from?*

L.C. —I had plenty of reference for it, both in my photo file and from other paintings I'd done.

I remark that the stream in the sketch shows up neither in the preliminary painting nor in the finished work.

L.C. —I'm not the kind of painter who works with golden sections and things like that. I don't divide up my space. I just do what feels right, and when I painted that stream in, it just didn't feel right. I ended up leaving just a bit of it in the middle ground.

That decision leaves the artist wondering what could be used to create a new means of entry into the foreground.

Problem Solving

L.C. —How I was able to solve that problem demonstrates the value of my "on-the-spotter." Studying it, I can go back and relive that moment and touch its reality all over again: The day started off overcast, and there were no shadows on the snow in the flat forest light (which is the way I chose to paint it).

As he was working, Len recalls, the sun came out. The snow melted off the branches, leaving him with a black-and-white composition— neither what he had started with nor what he wanted! Now, however, suddenly remembering the shadows cast on the snow, he is able to use shadow masses to achieve the feeling of depth he seeks.

Still working on his small oil

study, Len experiments, scraping off and painting in. The shadows help, but he's looking for a still stronger way to make the foreground "lie down." Gradually the answer comes to him in the form of a small sapling, at right center, closer to the viewer than any of the others.

L.C. —This is just what I need to complete the feeling of volume. This gives me a vertical form to contrast with my horizontals.

He continues to work on the sapling, adjusting it, making it bolder, then thinning it back, studying the effects for long minutes between takes. Aware that he can't solve all the compositional problems in this small study, and not wanting to lose momentum, he covers the study with clear acetate, grids and scales it up, and sketches the scene to his full-size canvas.

Laying in Masses

Len begins laying in his masses: first the shapes of the tree trunks, establishing rhythm and value range, then light valued masses, beginning at right, working left. Both his small oil study and his original 12″ × 16″ "on-the-spotter"

are right there on the easel, never out of sight.

L.C. —Even though I did the study and keep it in front of me, I always refer back to my "on-the-spotter" for first-hand information about the scene.

Once initial values are estab-

lished, development becomes more subtle. Shadows are added, taken away, added back, adjusted, as the artist works to bring forth the reality of his "on-the-spotter." It's a process that can go on for days, or even for several months.

Step 1
Though he often refers to his small study, Len Chmiel relies on his "on-the-spotter" for his most important decisions as he lays in values on the big canvas.

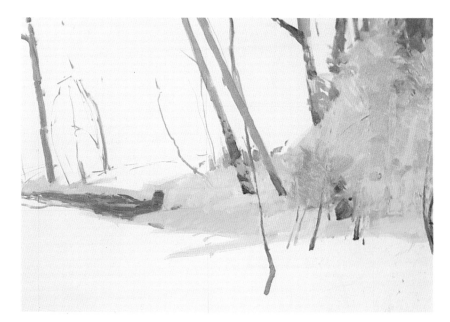

Step 2
Nearing the painting's completion, the artist realizes that there's something he's not happy with. See if you can spot the problem. Compare this picture with the finished painting to see how Len Chmiel resolved it.

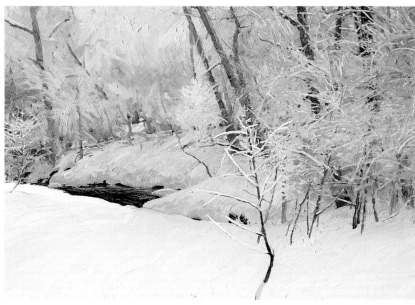

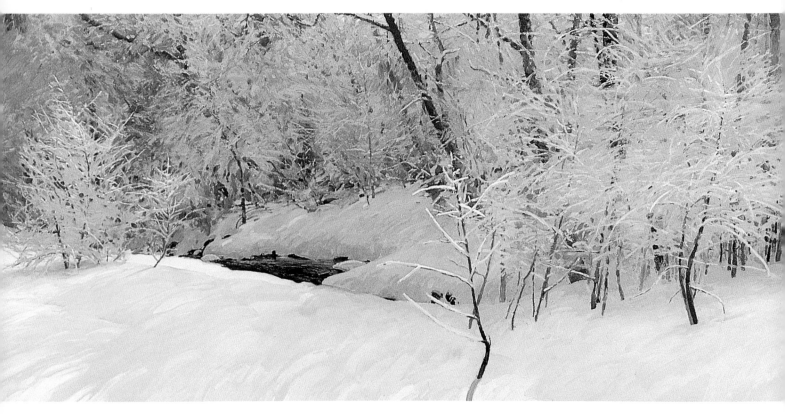

Of Snowy Billows and Dawn
Len Chmiel
Oil on canvas
34″ × 73″

Something's Not Right

L.C.—For a while, I thought the painting was finished. Something was bothering me, though, and I couldn't put my finger on it. Changes are very subtle at this point, and I just have to live with the painting until I understand what the problem is.

I finally realized what was bothering me: the background trees behind the foreground sapling. One tree in particular was attaching itself to the sapling, because of its weight and its value, compressing rather than expanding the space between them.

One of the hallmarks of Len Chmiel's work is the thoughtful way he fine-tunes his details, never seeing his painting as finished until everything is just as he wants it.

He stays in close contact with what he experienced and captured in his "on-the-spotter." That visual record of a moment in time, existing partly on canvas, more significantly in the mind of the artist, is powerfully combined on canvas as the artist brings his painting to completion.

Idea Starter
Think "Process"

Just this once . . . concentrate on the process, not the product! Many artists seem to forget that, at least in the early stages of their career (and, arguably, throughout that career), the main reason they should be painting is to learn—*not* to complete the painting.

Try to approach your next painting with this premise clearly in mind: You're painting solely to enjoy the process of painting, not to arrive at the final product.

If you can, it becomes far easier to take chances, to experiment, to take some new and risky direction without fear of failure. When you focus fully on the act of painting, *the finished product is irrelevant!* Success is guaranteed, because the knowledge and experience gained are fully within you.

The Painting I'll Never Sell

I know I'll never sell this one. Though I painted it in 1991 as an "on-the-spotter," even now I think it's the best painting I've ever done.

Gin Clear represents to me the way everything I know about painting came together in this one painting—without plan or warning.

It was winter, and I was out along the river one morning looking for a place to paint, headed toward something I thought was kind of dramatic and pretty, when I passed this scene. Even though I love looking into water, painting shapes and reflections as purely abstract forms, this

morning I decided to pass it by. Yet I kept coming back to this little pool, walking between the two scenes and debating which one to work on.

I have this kind of battle with myself every so often. My intuition versus my intellect. This time my intuition won.

Gin Clear was as difficult a painting as I've ever attempted: the movement of water, the abstract quality of the subject, the transparency, looking down into the water, yet capturing the reflections from above, while keeping everything moving in a subtle way.

To make this painting work, I

used all my compositional skills, all my intuition, plus all my faculties as the painter I've invested my entire life to become.

I'll never sell *Gin Clear*. It's part of my own collection. And it reminds me of what is possible in my work, when I'm able to rise completely to the occasion.

—Len Chmiel

Gin Clear
Len Chmiel
Oil on canvas board
12″ × 16″
Collection of the artist

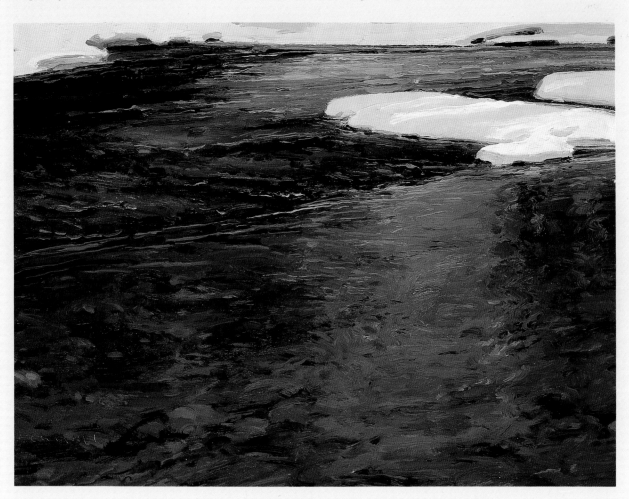

Joe Abbrescia

Overcome Artist's Block With a Painting Trip

Because Joe Abbrescia is the kind of artist who enjoys painting a wide variety of subjects, his focus is never on just one subject in particular. His inspiration arises from what he personally experiences, and what excites him.

J.A. – Over the years, I've learned that to overcome creative block, I have to totally under- *stand what's blocking me. It usually turns out to be boredom with what I'm painting. And that usually means it's time to take a painting trip, for a day or more, maybe for a week or two.*

Joe's trips have taken him, among other places, to Venice, Mexico, New York, and, as it happens this time, the Grand Canyon.

Four of the 16″ × 20″ on-location paintings the artist completed during his Canyon visit. *Canyon III* suggests the kind of color vibrancy that appeals to the artist, while *Canyon IV* intrigues him with the way its foreground frames the distant scene. *Canyons I and II*? They'll most probably be finished and signed, or perhaps the basis of future paintings.

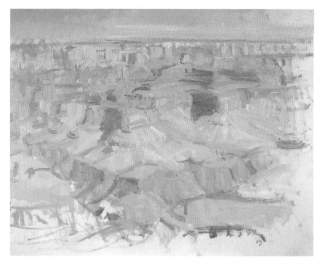

Canyon I

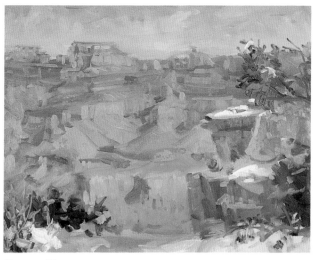

Canyon II

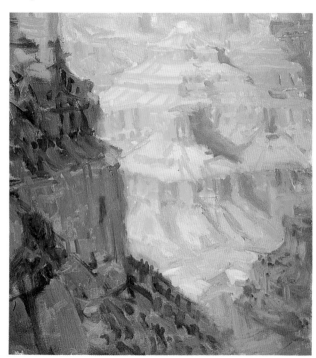

Canyon III

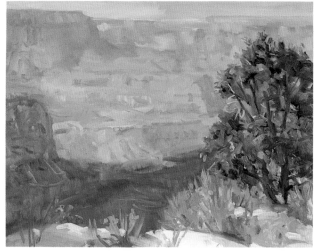

Canyon IV

J.A. — I pack my half-size French easel, a load of 16″ × 20″ gesso-primed Masonite panels, my trusty camera, and off I go.

This time, he spends four wintery days at the Canyon, setting up at the edge each morning and each afternoon, going for a finished painting each outing.

J.A. — All kinds of weather. About a foot and a half of snow one day. Just delightful!

When my students feel creatively blocked, I ask them: "If I were a genie and could wave my wand, where would you like to be painting right now?" They always know! Wherever your head is, that's where you are. And that's where you should be painting!

The Canyon dictates how long his paintings will take. Three hours is optimum, due to changing light from morning to afternoon. He tries to complete each painting that day, because the next day the light — and his feelings about what he sees — may be very different. Between times, he shoots loads of color slides for future reference.

Back at his studio in Scottsdale, Arizona, Joe evaluates his results, deciding that several might make the basis for a large painting.

J.A. — Having been out there at the Canyon, I come back with a definite attitude toward the scene, the season, the colors — which enables me to bring that immediacy to my 40″ × 60″ canvas.

Setting up field paintings around his easel, Joe proceeds to develop the subject in miniature on an 11″ × 14″ Masonite panel. Several of Joe's reference slides prove valuable, too.

J.A. — Even with all this reference, it still has to be solved. This oil sketch lets me experiment with color harmonies and preview the composition.

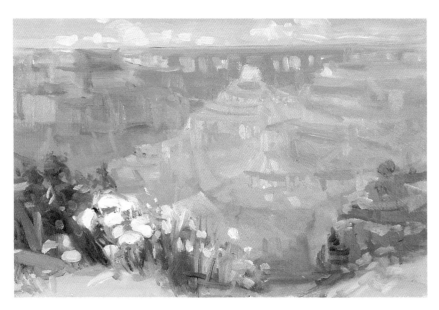

Color Sketch

Joe Abbrescia's small study shows the results of experimentation to resolve problems in sky treatment and value.

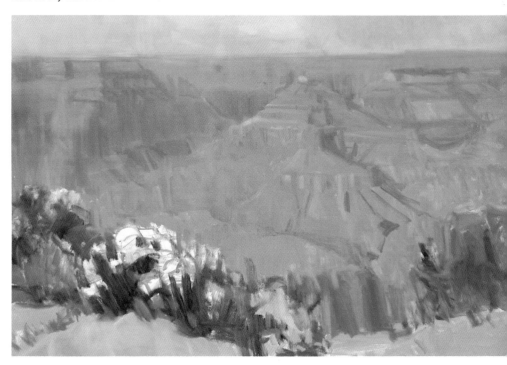

Step 1

Facing nearly seventeen square feet of blank canvas, Joe strives to establish color and value as quickly and accurately as possible right from the start.

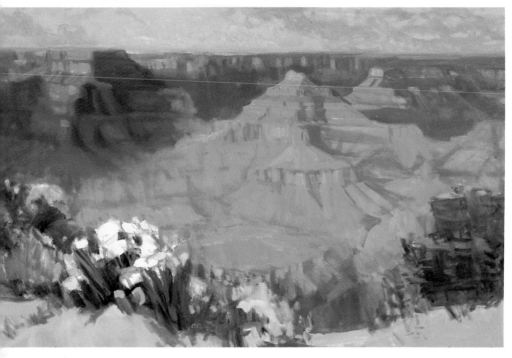

Step 2
About midway through the painting, critical adjustments have been made to color and value. While sky and center of interest are close to being finished, foreground values will be further refined before the artist is satisfied.

Feeling positive now about his small sketch, Joe prepares to transfer it over to his 40″ × 60″ stretched canvas.

He begins with a freehand raw sienna lining-in of the composition. He prefers raw sienna in a high-key painting such as this because when painted over, it doesn't involve itself with the other colors.

Diluted with solvent, the actual colors of the scene are quickly washed in.

J.A. — Even though it's reasonably solved, there's not much information on the canvas at this stage. Yet right from the start I look at the painting as if it's finished. For that reason, I can suddenly see that the raw sienna works as part of the painting, adding a feeling of light.

Though he has tried to work out problems on his small sketch, some of his solutions inevitably don't enlarge well. He returns to the study, experimenting and evaluating before bringing his revisions to the large canvas.

By the time the painting has reached its middle stage, Joe has intensified the light, developed the sky, built up values throughout the painting, and brightened the snow on the shrubbery.

J.A. — The open sky in my little study just wasn't working. There was no dark pattern. To get the kind of light I wanted to move through the composition, I saw that I'd have to heighten values in the foreground. These approaches were easier to test and adjust on the small study.

In his finished painting, Joe Abbrescia vibrantly captures the grandeur of the Grand Canyon. Note the increased effectiveness of the lightened foreground, even in comparison with the revised initial sketch. A line of light brings one's eye into the painting from lower left, through the snow-capped shrubs, leading directly to "Isis," the massive formation at the center of interest, and around which the dark pattern seems now to ponderously rotate counterclockwise.

J.A. — Regardless of my reference material, my planning and my preliminaries, it's clear to me that as each painting progresses, it takes on a life of its own. I have to pay attention to that, nurture it and allow it to develop. It's essential that you keep the door open to creativity when you paint, allowing yourself to be sensitive to what the painting is telling you, and then letting it happen.

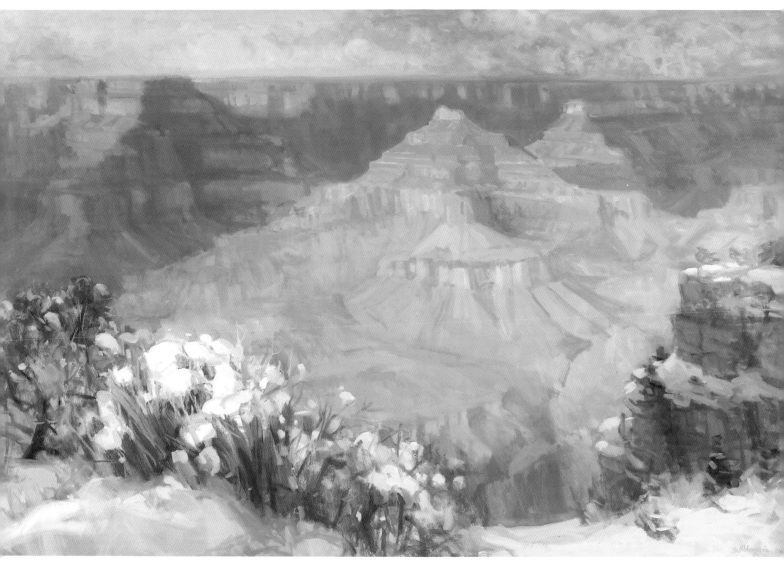

A Grand View
Joe Abbrescia
Oil on canvas
40" × 60"

Finish
Note how lightening the foreground has brought it closer, increasing the sense of depth and distance. Raw sienna under-painting is still readily visible in the fore-ground shrubbery.

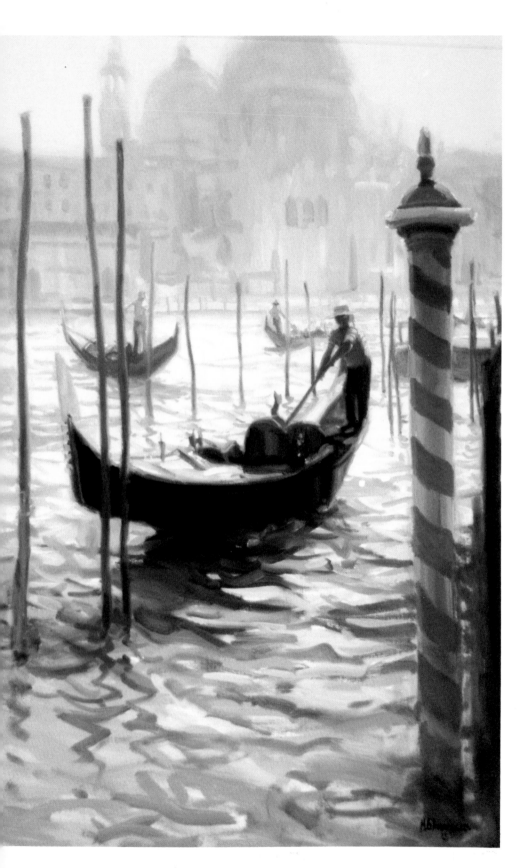

The Grand Canal
Joe Abbrescia
Oil on canvas
30″ × 20″

Artists through the ages have carried on a love affair with Venice, and Joe Abbrescia is no exception. He makes a painting trip to the fabled city whenever he can, and never fails to be overwhelmed by its history, ambience, light and colors.

This studio painting was done from an 8″ × 10″ panel the artist painted on location. Seeing his study again back home, the impressions of that moment on the Grand Canal flooded his mind, transporting him back to the scene. He knew he had much more to say about the subject.

Idea Starter
Take a Trip!

Art grows out of experience, and maybe it's time you stockpiled some exciting new experiences. Plan a trip for a day, or for as long as you can handle. Pick a destination that excites you. It could be the next town, or halfway around the world. Take along your camera and shoot a ton of pictures. Bring a sketchbook and your favorite portable materials. Let it be known that the primary purpose of your trip is to gather reference, to experience the locale, and to incorporate your experiences into your art.

The Painting I'll Never Sell

I keep very few of my paintings. I just can't afford to! But this one I'll never sell, because for me it's a landmark . . . a breakthrough . . . and a reminder.

I've come to believe that my best storehouse of ideas is what my eyes see and what delights me. That has meant two things: (1) building up a trust and belief that I'm entitled to my own view of the world, and (2) if I can get in touch with that viewpoint, it's where my best ideas will come from.

What you, personally, see is unique, and as long as you don't get in the way of that, you'll have a real creative flow going.

Getting in the way of that flow creates artistic blocks.

It's our responsibility as artists to understand what works for us—not what we think *ought to* work for us—and then to show up for it. That's very important. Which brings me to this painting.

I was driving down the California coast on one of my painting trips when I rounded a bend in the road, and this scene practically leaped out at me. I was so excited! I pulled off the road, set up my easel, and couldn't paint it fast enough. I was dancing and whistling! I never, once, was actually aware that I was painting!

I know that I showed up totally for this painting. And every time I look at it, I'm reminded how strong that moment was, and that's something I never want to forget.

—Joe Abbrescia

From the Cliffs
Joe Abbrescia
Oil on canvas
20″ × 24″

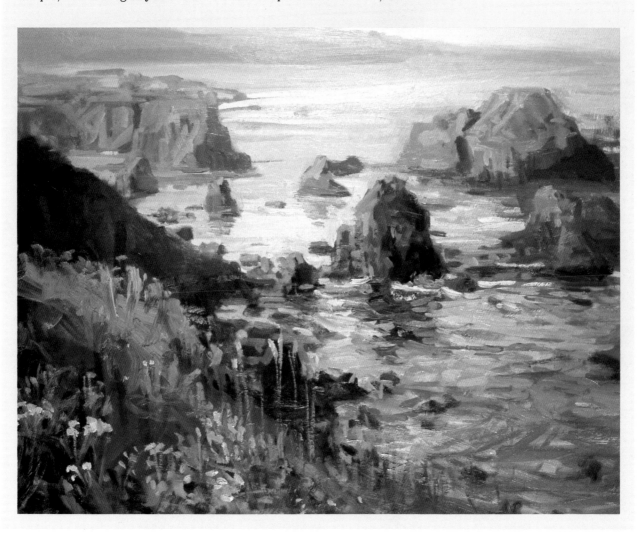

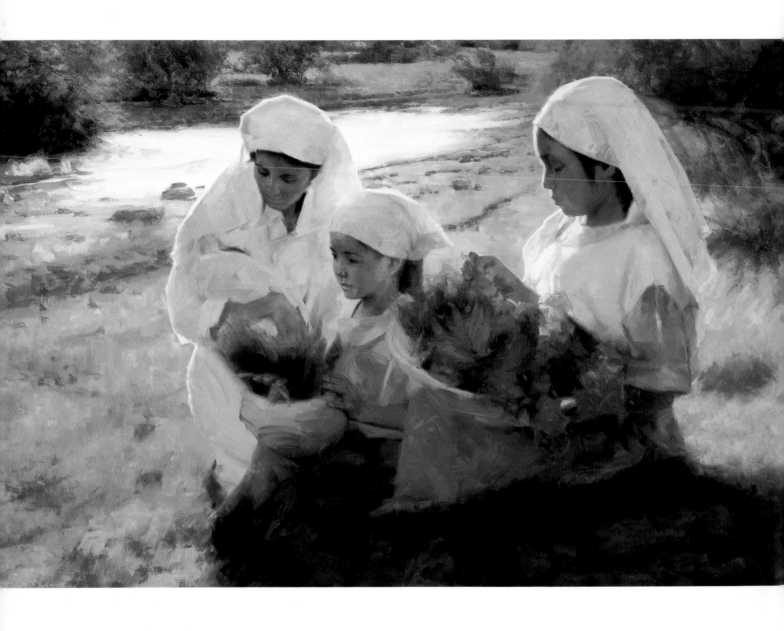

Chapter Two

Getting Fresh Reference Material

It was Peter Van Dusen who, in response to my question about enemies of creativity, cited "tired reference material" as one of the greatest. A valid point.

Gerry Metz and Tom Darro are two successful professionals who know the vital importance of fresh reference, yet each goes about gathering and using his reference material somewhat differently. Tom stages carefully orchestrated photography sessions to gain the reference he needs for a particular painting concept. The objective of Gerry's wilderness photo expeditions is to expand and refresh his general files for whatever painting concept he might come up against.

Both artists believe their work will only be as good as their resource material. And their work is very good indeed. Many artists look to photography as only supplemental reference. Inevitably, these are artists whose studio shelves are lined with countless sketchbooks filled with everything from scribbles to fully realized color concepts. Each page of their sketchbooks, these artists often would tell me, contains sufficient impressions for dozens of paintings . . . lifetimes of inspiration at their fingertips!

These accounts will start you thinking about the role that reference material plays (or could play) in your own work, ways in which you might add to your files, and the importance of keeping your reference materials fresh and exciting.

Tom Darro

Assemble a Story With a Photo Session

Many professionals develop their painting concepts out of well-maintained photo files, occasionally backing them up with magazine illustrations and the like. Still others seem to be able to pull paintings out of memory or thin air, with no visible resource material whatever. Tom Darro, however, believes that an artist is only as good as the reference he has to work with.

T.D. — My material is very important. Many fine painters run into trouble because they refuse to go all out to tell a story. I think that shows in the work. If you start with a good story, and your painting technique is reasonably solid, you'll come out with a good painting. A teacher of mine once said, "What you go in with is what you'll come out with." I believe that.

When he has a painting idea, Tom Darro goes all out to get the very best reference, and that means an on-location photo session complete with performers and supporting crew.

Not inexpensive, a "shoot" will often be aimed at gaining reference for *two* concepts the artist has in mind. That is the case today.

T.D. — I've seen so many broken homes in our society — in the Indian community too — that I began thinking about how children tend to group together for mutual protection in times of adversity. My original thought was to have a group of children around a burro, looking off toward the mesa, looking into their own future. But due to an unusual problem with the burro, I turned the concept completely around.

This idea eventually becomes *Children of the North Country.* Tom's subject matter of choice is the Native American, and invariably his concepts are expressed in that context.

T.D. — I wanted a second idea, too, a natural outgrowth of the first. I thought, let's bring together a beautiful desert mother and her children.

"My Paintings Are a Group Effort"

Photo sessions involve days of careful planning, and a full day on location. His friend, Carol, is in charge of costumes. Fred, a professional animal handler, furnishes a horse and a burro. Joey, a man of many talents, provides food and refreshments, drives the old blue van, and makes sure tables, chairs, photo equipment, reflectors and so forth are all on hand. My photo assistant, Vince, will be there to assist.

Tom's Native American models, always authentic, include friends, personal acquaintances and professional models. Five are involved in today's shoot.

T.D. — I spend my whole day choreographing and shooting. I'll go through as many as twenty rolls of film, and that's the least expensive part of the venture.

When he views his slides, Tom knows immediately which ones best express the concepts he's envisioned.

T.D. — When I go into the studio with my first choice, the painting nearly paints itself! It hits the market, people love it, and it sells right away!

Next time, if I go back to those shots, I'll be digging for second best. That one's just a little harder to paint, and takes a little more time to sell. If I were to continue down to the last one, it'd be a downright struggle to paint, and hardest of all to sell. That has to tell me something.

Reference Photo (Above left)

One of many exposures as the artist worked toward visualization of his concept for *Children of the North Country.*

On Location (Above right)

Carol (in sunglasses) prepares Suc, one of the models, for the pose.

Props (Right)

Waiting around, this rare white burro shows more patience than most of the crew as preparations proceed.

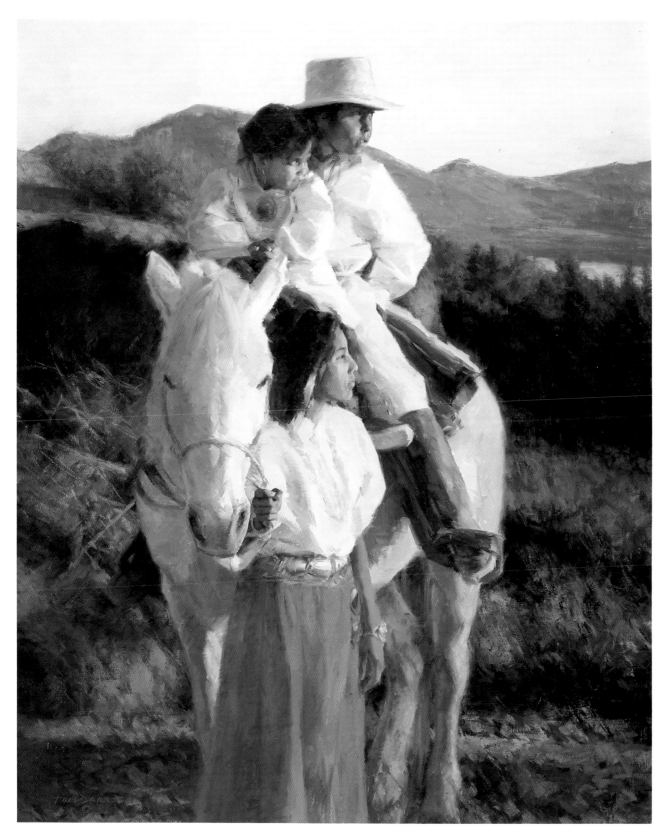

Children of the North Country
Tom Darro
Oil on linen
50″ × 40″
Collection of Overland Trails Gallery,
Scottsdale, Arizona

Fitting Reference to Concept

For a subject with this many components, rarely does a single slide embody everything Tom is seeking. In this instance, he'll refer to one slide for the baby, a second for the mother's head, and a third for the burro. Composition and details may come from other shots entirely.

Refining his concept, he pulls all the elements together in a detailed pencil sketch before moving to his stretched single-primed Fredrix Antwerp linen canvas, further textured with Winsor & Newton titanium white.

When Tom has determined placement of key elements, he will scrape and smooth those textured areas that call for finer detailing.

T.D. — My drawing is done on the canvas with Conté pencil, then fixed.

Toning In

T.D. — I want to establish the overall pink and yellow quality of the light, the general light pattern and basic local color. My pigments for toning the canvas are thinned with twenty parts turpentine to one part Damar varnish. I keep these washes a little darker than any of my planned lights, so they'll show up when I paint them.

White reduces the chroma of each of these washes, to avoid dominating the overpainting hues.

T.D. — The heart of the painting is really in the heads.

To establish the darkest dark, Tom lays in hair masses; then, as the lightest value, the mother's blouse.

T.D. — I'll start the flesh tones with the baby's head, since she has the lightest skin, and key the other faces to hers.

Building Out From the Core

He continues applying flesh tones and expanding the various values outward. Even at this early stage, Tom now has a dependable tonal guide in place: darks, lights, important midtones. The core of the painting is well started.

T.D. — There are at least three good reasons for beginning like this: First, all my subsequent judgments can be more precisely evaluated against that core. Second, the degree of finish on the heads will determine the degree of finish as I move outward. Third, the heart of the painting contains the majority of the information. Now I know how much information I'll need to support it as I move outward.

Reference Photo

This is one of the photos Tom decides on as reference for *Desert Mother*. Comparing it with the finished painting, you may be able to discern which portions appealed to him.

Step 1
At this stage, Tom has established both darkest and lightest values, and has begun the face of the baby, against which he will key his middle values.

Bringing It Up

Background and foreground are massed in with a fair degree of surface texture in preparation for scumbling in the final stages.

Tom returns to complete the core of the painting. Figures and burro are completed. The older girl's dress, an important element in the overall composition, is detailed. However the mother's dress, though massed in, remains incomplete.

T.D. – Now I put the painting away to dry completely. A few days later I'll give it a thin coat of varnish (50 percent Damar, 50 percent turpentine), then go back and build up middle ground and detail the dress.

Finally, I'll be ready for the most important step of all.

Step 2
At midpoint in the process, the artist, having fully stated the core of the painting, will begin building out.

Step 3
About three-quarters along, the principal masses have been painted. The mother's dress, a relatively busy element, will be worked on next, as will the many color variations in the surrounding landscape.

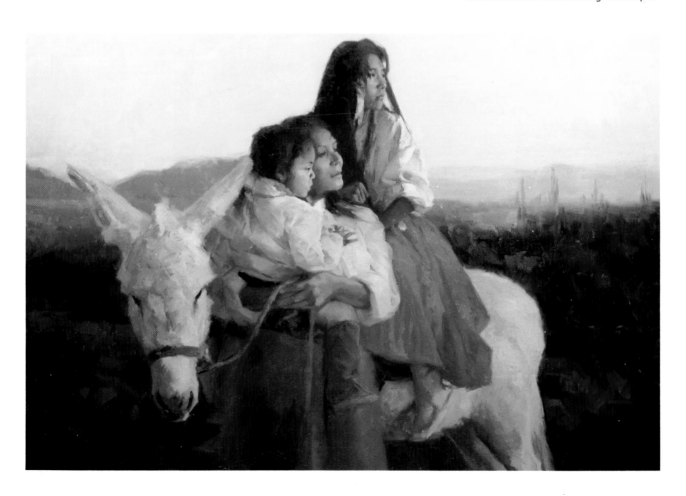

Unification

This is where the artist's knowledge of composition comes to the fore: carefully evaluating the canvas, refining design, establishing patterns of flow, resolving shapes, correcting small errors in value, perhaps simplifying a busy area, softening or defining an edge. This final step can take as long as all that preceded it.

T.D.—A very special part of the painting, this is the one percent that leaves the other ninety-nine behind. Though I try to work on every aspect of my craft, this single skill has been the principal focus of my efforts for the past ten years: to understand the subtlest nature of composition itself.

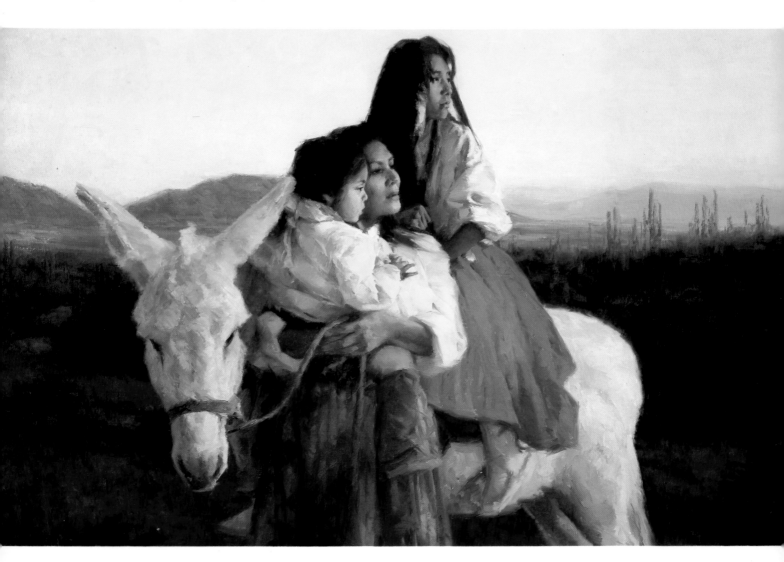

Desert Mother
Tom Darro
Oil on linen
34″ × 54″
Collection of Overland Trails Gallery,
Scottsdale, Arizona

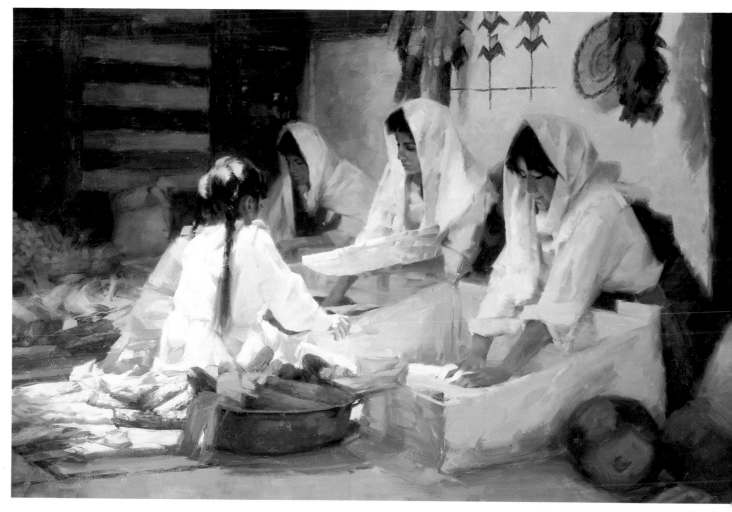

Winter Corn
Tom Darro
Oil on canvas
38" × 58"
Collection of Mr. and Mrs. James Fowler

"A wonderful way to get ideas," says Tom Darro, "is to follow a photo account of another artist's journey." *Winter Corn* began when the artist became engrossed in Susanne and Jake Page's turn-of-the-century book, *Hopi* (Abrams, New York, NY, 1982). As he studied it, realizing how much of Hopi tradition revolves around the preparation of food, Tom determined to paint a series on the subject.

To develop reference, the artist commissioned a professional scenic designer to build a movable wall set in a rented two-car garage. Then, assisted by his crew, he directed and photographed his costumed models as they actually prepared and ground corn.

Of course, no single photo could capture optimum position for so many moving figures, so it was inevitable that many different photos would be used to compose the finished work.

Lew Lehrman

The Joy of Journals and Sketchbooks

Not only is the sketchbook a wonderful means to record sights, sounds and feelings, it is an unsurpassed way to experience a moment more fully than even the most detailed photographic record.

Some years ago, my wife Lola and I toured Hungary, Austria, Italy and Germany. In addition to my trusty camera, I carried a 6" × 9" Aquabee spiral-bound sketchbook, a tiny Winsor & Newton "Bijou" watercolor box, and a fine-point technical pen. A 35mm film canister was my water jug. Wherever we went, I photographed as always, but I also sketched: aboard trains, seated at a sidewalk café or at the Vienna Opera, over dinner in fine restaurants, and often in our hotel room late at night. In addition to my pen-line and watercolor drawings, I added commentary about events and impressions—often as I was experiencing them, or within hours thereafter.

Within two weeks, what started as a sketchbook became a journal of some thirty-eight pages. (A half dozen were published in the travel section of the *New York Times* soon after we returned.)

Here's my point: Years later, I return to the photos I took during that trip, and I realize they're just photos—fleeting moments recorded on film, lacking any real emotional content. Yet when I read my journal, I'm immediately transported to where I was when I did each sketch. I can smell the aromas, taste the espresso, feel the quality of the light, vividly recall and relive each of the experiences I recorded so many years ago.

Sketching requires the artist to experience a scene in a way no instantaneous photo can, simply because in order to sketch it, you have to see it line by line, detail by detail, and take the time to do it. When that sketch is completed, the scene is forever a part of you.

Journal

Several pages from my Europe journal. Knowing that later I'll want to add commentary, I usually leave space around my drawings, then write to fill the space.

Sketches

The place: the lawn at Tanglewood, the summer performance home of the Boston Symphony Orchestra in the Berkshires of western Massachusetts. The time: afternoon or early evening—a wonderful interlude for daydreaming or for leisurely sketching. Here are three of many pages from a decade or more of summers. Never intended as more than a pleasant pastime, these and other sketches became the basis of *Twilight on the Lawn, Tanglewood*.

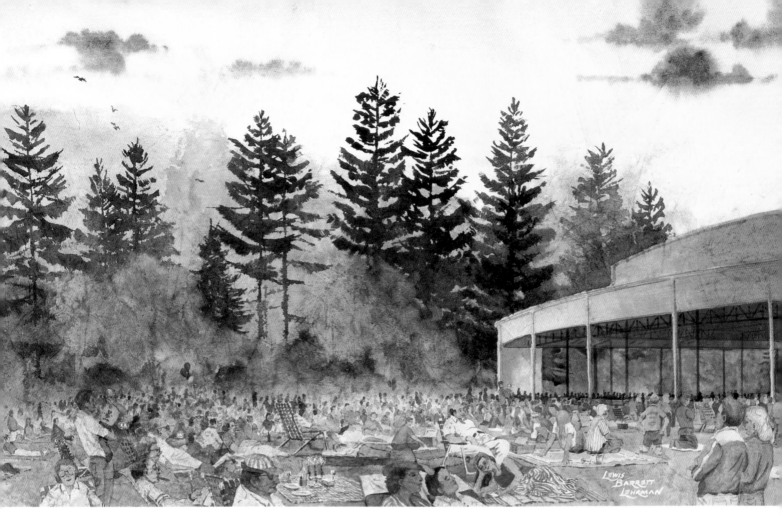

Becoming a Sketcher

What's wonderful about sketching is that you get to make your own rules, or follow none at all. Since you're doing this entirely for your own pleasure, your sketches can be as simple as a few lines on a page, or as complex as my own, complete with full notation of color, theme and commentary. Whatever gives you pleasure!

Your equipment can be as simple (a blank book and a no. 2 pencil) or as complex as you desire (colored pencils, a miniature watercolor box, or even a set of oil pastels). You can sketch in any situation where you have two free hands and a minute or two to spare. It's a wonderful way to pass the time. I've sketched aboard commuter trains, as a passenger in a car, sitting (disinterestedly) in front of the TV, waiting for the dentist, and in too many other places

to remember. I've sketched people, pussycats, personalities, passing scenery, abstract thoughts, way-out ideas, and . . . well, you get the idea. A few sketches have ended up as inspiring paintings, but all have become part of my experience, and contributed to whatever skills and insights I have as an artist.

Give Sketching a Try

The investment is minimal, and the joys and benefits are enormous. Decide, though, that the only person you'll be doing this for is yourself. Allow no one to critique, or even to see its pages, unless you are completely willing to have them do so. The finished product (sketch or sketchbook) is the least important aspect of this activity. The process and the pleasure of sketching, on the other hand, are the whole point.

Twilight on the Lawn, Tanglewood
Lewis Barrett Lehrman
Watercolor on Oriental paper
21″ × 32″

Idea Starter
Carry a Mini-Notebook

Find a pocket-size notebook in your local stationery store, and carry it with you. When you're stuck in traffic or waiting for the spin cycle to end, or when you encounter a scene or idea that might become a painting, record it in words or with a quick sketch. You know that if you don't capture it at the moment, it'll be gone forever.

Gerry Metz
Experience the Scene — and the Elements

When Gerry Metz begins to lose his creative edge, he knows it's time to replenish his reference files. A dedicated professional artist since the 1970s, Gerry knows the importance of fresh reference material, both internal and external. And since his paintings deal predominantly with the mountain men of the Old West, that invariably means he'll head for the wilderness.

G.M. — I go out two or three times a year, winter and summer, maybe to the White Mountains of Arizona, which are nearby, sometimes to the Grand Tetons, Yosemite or Glacier Park.

Gerry will book a model and rent horses, but he brings props from his own ample collection of western artifacts: colorful Hudson's Bay coats (called "capotes"), old rifles, rifle scabbards, fur hats, saddles, blankets and the like.

Now the artist turns director. On a sunny day, he'll photograph his model in a variety of situations, moving in all directions, from all angles, to show shadows in differing aspects.

G.M. — Overcast days are better, because the photos have a lot more form. When I refer to them, I can invent my own light.

When Gerry photographs, he's not merely interested in the rider and his mount.

G.M. — I want to see the way snow falls across a log, or how a creek bites away at the snow along its edges. Trees. Bushes. Details that make a painting more realistic.

Gerry photographs in all kinds of weather, day and night, and his shoot may run two to five days. A trip in January to the Tetons resulted in several hundred photos. He has his lab print directly to 8″ × 10″. A few appear on this page.

G.M. — I used to get smaller prints, until I discovered how much more detail shows up in 8 × 10s. They cost more, but I'll often see an idea in the background of a larger print that will spark a whole painting.

His reference file fills most of a five-drawer filing cabinet kept in his studio.

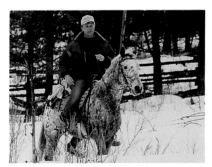

The Artist (Above)

Making headway in deep snow, Gerry goes in quest of the next photo location.

Reference Photos (Left)

Just a few of the many 8″ × 10″ prints that resulted from Gerry Metz's most recent photo expedition. Some of his Western artifacts surround them.

Mountain Man
Gerry Metz
Watercolor
15″×11″

The Tracker
Gerry Metz
Watercolor
15″×11″

Two paintings from Gerry Metz's popular "Mountain Men" series. An ever-popular theme in Western genre art, the mountain man has come to symbolize independence, freedom, resourcefulness and capability. He evokes an era fondly remembered: the wild and dramatic settings of the West.

Using Reference Files

It's important to understand the way the professional artist uses reference material, Gerry believes.

G.M. — A lot of people think I'll take a photo and paint right from it. Not at all. I pick up little pieces here and there: part of a figure from one, the rest from two more; the horse from another and background details from a half-dozen others. I change color, invent new composition and generally improvise. I'll refer back to my own library of books on the period, and filter all of it through my own experience.

Gerry Metz returns from his photo sessions laden not only with exposed film, but with replenished enthusiasm for his work.

G.M. — The time spent doing this is an important investment. There's no substitute for experiencing the wilderness, living the scene I'll later be painting, breathing the air and fighting the elements just as they did back then. Backing up my work with that kind of experience helps me make my paintings feel right.

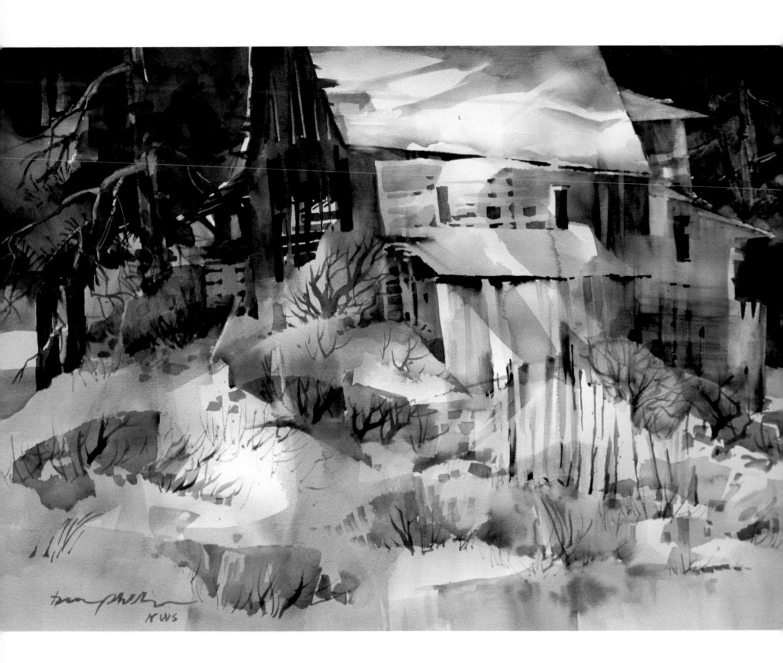

Chapter Three

Creating Realism From Abstract Design

Mountain Winter, New Mexico
Dick Phillips,
Watercolor
21″ × 29″
Courtesy of Gallery 'A',
Taos, New Mexico

The simple, general goal of a winter mood was in Dick Phillips's mind as he began this painting. Without a preliminary drawing, the painting was started with loose, large washes defining the shape and structure of the barn. The balance of the scene, says Dick, was invented, and final washes and details were placed to accommodate those that were already on the paper.

When I was interviewing artists for my first book (*Being An Artist*, North Light Books, 1992), I questioned outspoken artist Austin Deuel on his feelings about nonobjective art. "We're all abstract artists," he commented. "It's just that our abstract shapes end up looking like trees or houses or riders on horseback."

I had never thought about it quite that way, but I could suddenly see the truth in his viewpoint. After all, both we and the so-called "abstract artist" have this in common: We deal from moment to moment with the identical underlying problems of color, composition, form and value. What makes us different from the abstract painter is that our picture elements finally represent things in the real world.

Why not then, I thought, begin with abstraction, which is much simpler—since it is unencumbered by drawing, perspective and all the rest—and bring realism out of it once the underlying design has been clearly established?

It turns out, however, that I'm not the first to think of this. On the following pages two artists do exactly that: begin abstractly, evolve composition, and develop their paintings into vibrant representational works.

Ted Goerschner
Start With Simple, Colorful Shapes

Ted Goerschner is a talented painter and a much sought after instructor in oil painting. His many workshops, which attract painters at all levels of accomplishment, are invariably sold out. Approaching this demonstration painting, Ted remarked that a surprisingly small number of painters—even those on the professional level—have a clear understanding of abstract design and how it should underlie the representational painting.

Seeking the Abstract

In *Greek Sunset*, Ted creates reality out of the abstract.

Ted and his wife, watercolorist Marilyn Simandle (see her demo painting on pages 48-50), love to travel, returning from each of their ports of call with armloads of paintings and sketches, and rolls and rolls of color print film.

This snapshot of Mykonos harbor, photographed at sunset during a visit to that Greek island some years ago, was pulled almost at random from Ted's extensive reference file.

T.G. — Just look at this photo. It has everything in it but last Saturday night's dinner! My first job is to pick out my major shapes and simplify.

Ted's ground is a panel of oil-primed Fredrix Carlton Belgian linen, which has been glued to a mahogany panel, providing a rigid surface against which his vigorous brushwork can react. The canvas has been toned with a light gray wash to kill the white surface.

Getting Right to It!

His photo pinned up before him, and with no preliminary drawing, Ted begins laying in dominant and minor abstract shapes, focusing attention on a future point of interest. He's using his "neutral gray mud" mixture (a blend of leftover paint from previous painting sessions mixed with white, color adjusted, then stored in empty tubes he purchases for the purpose).

T.G. — What I have here is purely an abstract painting. This is the way I start just about everything. I look for the big shapes first, which will give me the underlying composition of the whole scene. I don't look for buildings or boats in it yet.

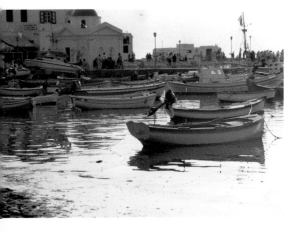

Reference Photo

The harbor at Mykonos. One of hundreds of photos the husband-and-wife artists brought back from the Greek Isles.

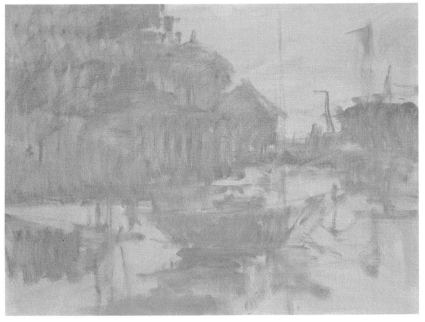

Step 1

Major and minor shapes are in place on Ted's gray-washed canvas. At this point (and at virtually every point from now on) the painting might be considered finished, though certainly quite abstract.

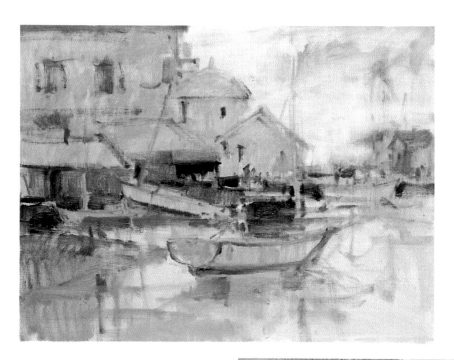

Step 2
Major dark and light masses are worked in, as the painting begins to take on depth, interest and recognizable detail.

Step 3
Only now does color make an appearance. Note how the artist moves his color through the painting, repeated, but always varied.

Values, Not Shapes

With a working abstract composition defined, Ted begins establishing his values. Very little color at this stage, and no detail at all. He punches darkest values in shadow areas near the center of interest (against which he knows his high-chroma colors will eventually contrast).

T.G. — What this will do is help move your eye around the painting. I can do that in many ways: with contrast, with color, with edges.

It is at this stage that recognizable shapes begin to emerge. It is still primarily an abstract painting.

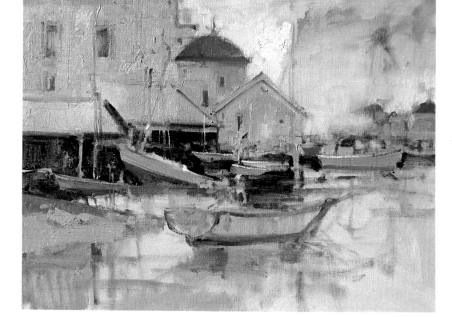

Now Colors

A high-chroma orange is laid in at the center of interest, then repeated in lower chroma passages at varying distances from it.

T.G. — I keep my hues in the middle to dark range here, balancing and moving them around to give the painting unity. I have to keep the most dominant effects in the center of interest, though.

If I start putting those bright hues all over, I'll end up with wall-paper!

Ted continues adjusting values, lightening the gray of sky and working into the watery reflections.

T.G. —I try to get my values set at the first shot. Sometimes I succeed, sometimes I don't. I evaluate as I go, then work back in and fine-tune.

Detail Last

As Ted proceeds, additional recognizable detail begins to emerge in the painting, though (due to its ori-gins) never losing the appeal of its abstract composition. Note the way color values are pushed up and down in value and chroma to give more contrast within each color. In one of several instances, a small area of intense orange in the center of interest plays off against larger, more subdued oranges further re-moved—repeated, rhythmic, yet dominant/subordinate.

Oil-primed Belgian linen canvas and good quality oil paints help Ted's surfaces dry faster. He uses no medium whatever. At this stage, the painting nearly complete, Ted sets it aside.

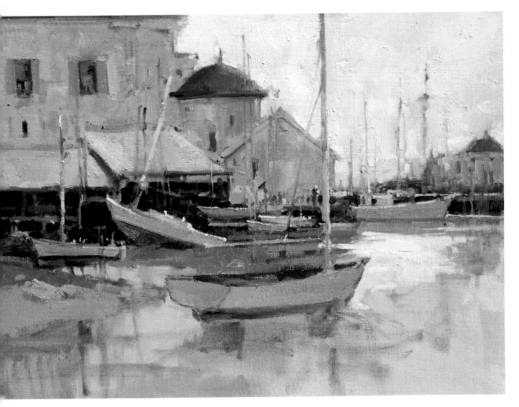

Step 4
More color is added, and detail, as values are pushed darker and lighter to add contrast.

Idea Starter
Mine Your Old Photo Albums

Stuck for a subject to paint? Haul out the oldest family photo album you can find, and take twenty minutes to go through it. You'll be amazed at the impressions and memories that will come to mind. Take a particularly evocative photo and work it into a sketch, with a future painting as a possible objec-tive. Or, with those special photos in mind, try to put into visual form some of the emo-tions they evoke.

Dig through your vacation snapshots—*you* know, the stack in the shoe box on the shelf in the hall closet—the ones that you've been plan-ning to organize the very next rainy evening that comes along. Right there in that box are at least fifty photos you took thinking, "That'll make a great painting." Well, now's the time. Pull out the best of them, and tack them to your wall, then select one and get working on it!

Few will deny that an art-ist's most powerful work is drawn from the deepest per-sonal experiences and emo-tions. Where better to start than with old photos?

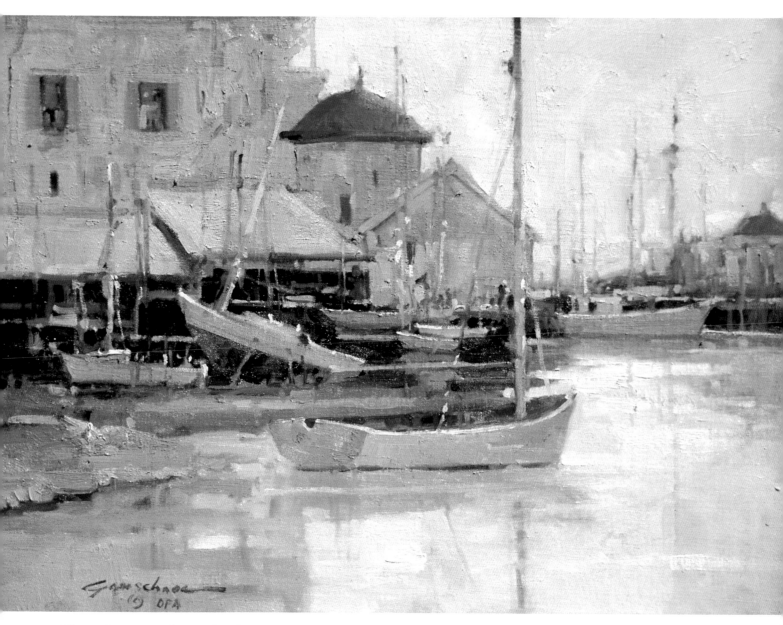

Time Out . . . Then Final Adjustments

T.G. – It's hard to get just the right look to the finished painting when my paint is too fresh. I like to wait a day or two until the surface sets, so the pigment stays put. That way, I can get the high

degree of contrast I like, and even add dry-brush effects that would be impossible over a wet surface.

In this final stage, Ted adjusts lightest values in water reflections, and darkest values in shadow and rooftop areas. With just a few touches of detail added, the painting is complete.

Greek Sunset
Ted Goerschner
Oil on canvas
18″ × 24″

Greek Harbor
Ted Goerschner
Oil on canvas
24" × 18"

First Light, Sierras
Ted Goerschner
Oil on canvas
36" × 48"

Meals on Wheels
Ted Goerschner
Oil on canvas
16″ × 20″

Each of these very different paintings began the same way: as simple abstract compositions. To glimpse the underlying pattern, try this: Place a sheet of tracing paper over a picture. Shade in all the middle to dark values with an even pencil midtone. Go back and shade in the darkest values over that, without attempting to draw anything. The resulting pattern will be quite close to Ted Goerschner's original abstract painting.

Breaking Surf
Ted Goerschner
Oil on canvas
20″ × 24″

Dick Phillips

Look for Abstract Patterns in the Scene

He arrives at my studio bearing an armload of sketchbooks overflowing with exciting drawings. Leafing through them, I decide that spending an hour or two rummaging through Dick Phillips's sketchbooks would be a pleasurable pastime.

He has slips of paper in various pages, and as he opens to them, I can see that he plans to build his painting around the many sketches he has made of the picturesque old mining town of Jerome, Arizona.

Jerome had become virtually a ghost town after its mines closed in the 1950s, but has come back since then, thriving today as an art center and tourist destination.

D.P.—There isn't any specific scene that I'll be painting, just an amalgam of all these on-location sketches I've done over the years, going back to 1973. My goal is not so much to portray what the place looks like, but its feeling and flavor.

Dick Phillips is, to coin a phrase, "coming from a different place" as a watercolorist these days. When you read his thoughts from the panel discussion in the back of this book, you'll learn why. Dick, a talented watercolorist and respected teacher of the medium for close to twenty years, has changed the major direction of his art in recent years from representational (watercolor) to abstract (acrylic). One result is that he tends to view his watercolors in a far more abstract light than before.

Not to Plan

As he begins preparing his first washes, Dick's paper is unmarked by any notation or sketch.

D.P.—I don't do any planning whatever for a painting like this. Most of the time, I begin by blocking in abstract patterns, then develop my painting from there.

He used to be more of a planner, he says—thumbnails, value sketches, careful drawings. But as the years went by, that approach no longer excited him.

D.P.—I found that the more I planned, the worse I painted. So I just quit planning.

Steeped in the imagery of Jerome, the result of many years of sketching and painting there, Dick feels confident in improvising. He's working on an unstretched sheet of Arches 140-lb. cold-press paper. Clipping it to his board at the corners, he selectively wets the sheet with his two-inch sky wash brush, and starts laying in light washes of cobalt blue and phthalo crimson, warmed with raw sienna.

D.P.—I use my color very arbitrarily. I'm not a "local color" painter. (Not an artist who likes to paint the folks who sit around the stove at the General Store, a "local color painter" wants the colors and values in the scene he's painting to be as close as possible to what he sees. Local color is defined as the actual observed color of an object.) I'm more interested in color interaction—exciting color rather than actual color.

Sketchbook Pages

A few of many views of the Arizona mining town of Jerome. These and other pungent evocations of this near ghost town turned tourist and artists mecca were produced over many years and many visits. During watercolor workshops in nearby Prescott, Dick would take his groups to Jerome merely to spend the day sketching, having them make paintings from their sketches the next day.

Step 1 (Top)
The painting begins in an unplanned, unlimited manner, guided only by the artist's keen knowledge of his subject, and his feeling for composition and color.

Step 2 (Above)
Having established his lightest values, Dick returns to lay in some of the darkest. Once he has his light/dark patterns established, he finds it easier to block in the succeeding elements.

Still Abstract

D.P. — I don't try to see an image at this stage, though if one should show up, I wouldn't be ashamed to grab onto it. I'm just putting down color, trying not to get it too dark, holding out some white shapes for later. I don't want to lose those.

Dick is aware that it's easier to change light values than dark. And when one works as abstractly as this, it's necessary to keep one's options open.

With his initial washes in place, and the very beginning of a feeling for his subject, Dick begins to work with his darker masses.

There's an Image in Here Somewhere

D.P. — I'll start getting a bit more specific, heading for my general theme — Jerome — blocking in some very specific shapes (trees, buildings, land forms).

Mixing a wash of permanent violet, ultramarine blue and burnt umber, Dick lays in the dark, distant mountain shapes, cooling them, adding a bit of modeling so they won't seem flat, cutting around the lower edges to create outlines for the yet-to-be defined middle ground elements.

As background elements dry, Dick begins work on the right middle ground mass, keeping it warm to contrast with the cool background and mountains.

D.P. — Once I get a few major light/dark patterns established, I'll have something to build from.

Having blocked in his intermediate darks, Dick decides that it's time to do something with the center, which he regards as being "uneventful."

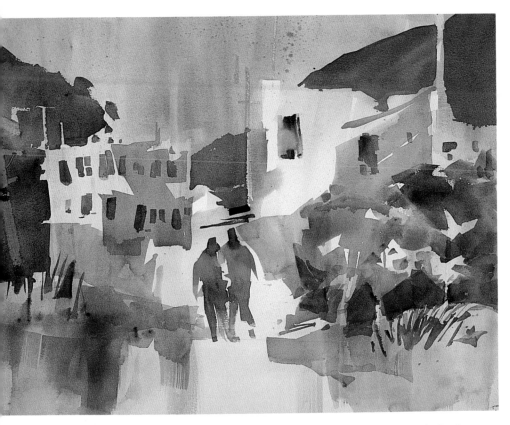

Step 3
The image begins to emerge from the abstract, as recognizable symbols, such as windows, grasses and fenceposts, are added.

Creating Interest

D.P. — I'm still building abstract shapes, trying to break up the surface into interesting patterns, yet starting to recognize that an element I paint will be the side of a building, or a bush, or whatever.

At this stage, the artist is primarily breaking up larger shapes into smaller ones, trying to say a little more with paint, without saying too much.

He brushes in window shapes and architectural elements, changing colors constantly to keep values from becoming monotonous.

The two figures appear at center now, as the artist begins to deal with his center of interest.

D.P. — It's important not to start thinking that I'm painting "things." I try to think in terms of abstract pattern.

With the figures in place, and using a no. 10 round, he begins working on some of the smaller shapes, refining them, adding just enough to make them recognizable as tree limbs, fenceposts, buildings and weeds.

D.P. — They're symbols the viewer can recognize. A nice thing about tree limbs is that you can draw them into any old shape, and instantly, somebody, somewhere will accept them as being a tree.

Trees begin to appear at right. Dick takes advantage of some of what he calls the leftover shapes in the middle ground to integrate his tree trunks into the picture, continuing to vary their color as he goes, to keep things interesting.

Knowing When to Stop

D.P. — One of the hardest things for me to learn was not to niggle the painting to death — to learn to understate, and not try to say more than I should. It takes doing this over and over, and messing up a lot of paintings along the way.

Dick is taking more time looking than painting now, as the piece nears completion. He adds a sign to the side of a building, glazes down some bright areas outside the center of interest to reduce value contrast, brushes in more tree calligraphy at left and a few power poles,

and breaks up some of the remaining larger areas with new glazes. He's "playing shape games," as he puts it.

Dick is less concerned with what these elements might represent than with abstract pattern and shape, with color for color's sake — not at all with the reality of the light source, or the effects of local color.

D.P. — Everything is conditioned on the pattern I laid down with my very first brushstrokes. That's what this kind of painting is about. Pattern. All the rest is nothing but window dressing!

Add a few finishing touches — some adjustments to color and value relationships, cleaning up a few edges, lifting out a few secondary shapes with masking tape and a small natural sponge — and the painting is done.

D.P. — I think beginning a painting abstractly and working toward an image would be a good exercise for someone who's feeling blocked.

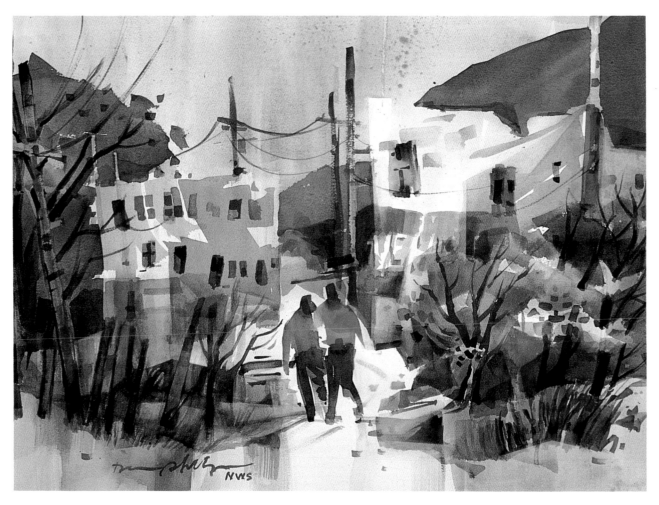

Urban Renewal, Jerome, Arizona
Dick Phillips
Watercolor
20″ × 28″

Finish

This painting succeeds as an abstract composition and as a vibrant representation of the place it is meant to portray.

Cibola
Dick Phillips
Acrylic on canvas
64″ × 74″
Courtesy of Suzanne Brown Gallery, Scottsdale, Arizona

Although Dick still enjoys conventional watercolor, this abstract painting is more representative of his current work. He applies bold color into wet, raw canvas, encouraging the colors to blend.

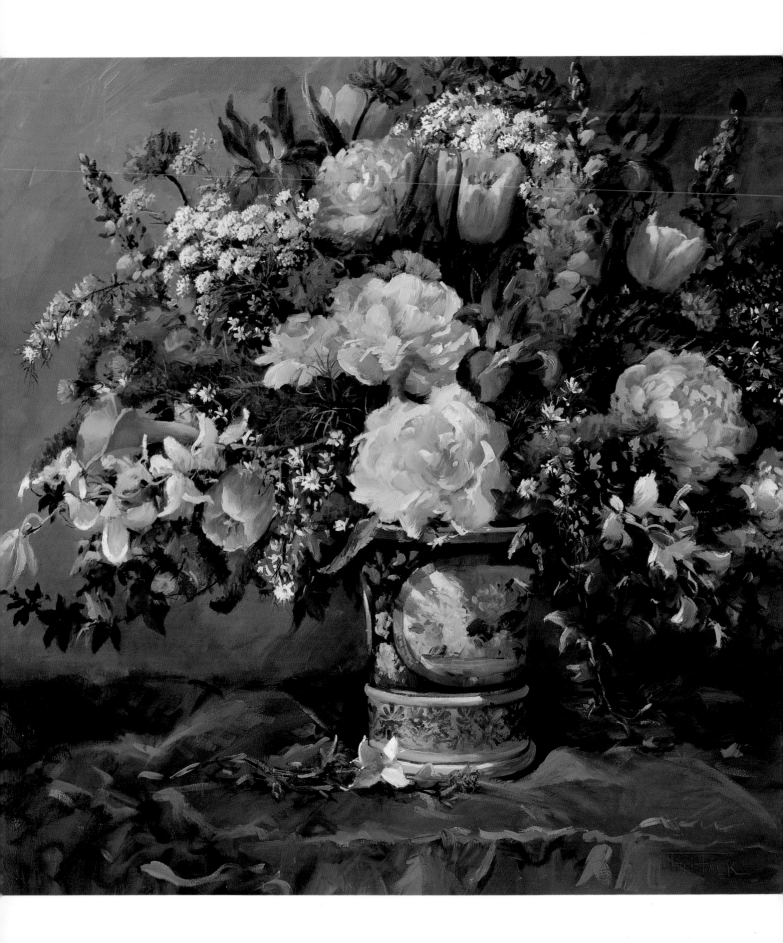

Chapter Four

Taking Another Look at Flowers

Why do you suppose floral paintings remain so popular after all these years? With all the wonderful artists who paint flowers, you'd think we'd all have become terminally tired of painting them, and collectors would long since have stopped toting them home. But somehow we haven't, and neither have they.

Perhaps it's because a floral gives the artist a great excuse to go wild with rich, intense color, texture, bold value contrasts, exciting composition. Maybe it's their rich sensuality that has such universal appeal. Perhaps collectors love possessing a brilliant bouquet that never fades, never dies. Maybe the reasons aren't even important.

Floral painting is Diane Maxey's passion, but for all that, her florals are merely a beginning point—an excuse, if you will—for running riot with form and color. Marilyn Simandle, on the other hand, is more controlled with her approach, yet her work overflows with the exuberance of color, texture and life.

Maybe that's what floral painting is: a celebration of life!

Marilyn Simandle
Express the Mood of the Season

Widely known for her exuberant watercolors, Marilyn Simandle is equally comfortable expressing her loose, splashy signature technique in a Mediterranean waterfront scene, a country landscape, a city street scene or a floral subject.

By happenstance, it is early springtime when I speak with Marilyn about the demonstration painting she has offered to do. Her choice of a seasonal floral subject seems unusually appropriate.

Something About Springtime

M.S. — There's something about springtime, when everything starts coming into bloom. It's my favorite time of the year. I enjoy working in the garden, and I just start thinking flowers.

Often I'll pick a bunch, bring them into my studio and set up a still life to paint right then and there. Of course, I take lots of photos to paint later at a workshop.

Unlike many florals, the subject Marilyn chooses is the essence of simplicity, focusing attention on just a few pansies in a china creamer.

L.L. — Does it seem to you that artists sometimes complicate floral subjects, then lose their way in that complexity?

M.S. — Absolutely. I find the simplest composition is the one that's most effective. A single flower can make a more powerful statement than the most elaborate arrangement.

Finding Composition

Virtually every one of Marilyn's paintings begins with a series of value sketches — rough, simple drawings that enable her to become familiar with her subject and explore alternative approaches.

M.S. — I'll do as many as it takes to find the composition and value pattern, large shapes connected, the darkest and the lightest values working together. At this point, I'm not looking for any detail.

Pleased with one of her sketches, Marilyn turns her attention to a stretched sheet of Arches 140-lb. cold-press paper, on which she loosely sketches her composition.

M.S. — I don't usually grid my drawing to transfer it. I prefer to eyeball it. I don't want everything too perfect.

Value Sketches

The artist's all-important first step to understanding her subject.

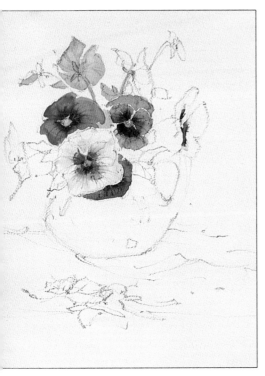

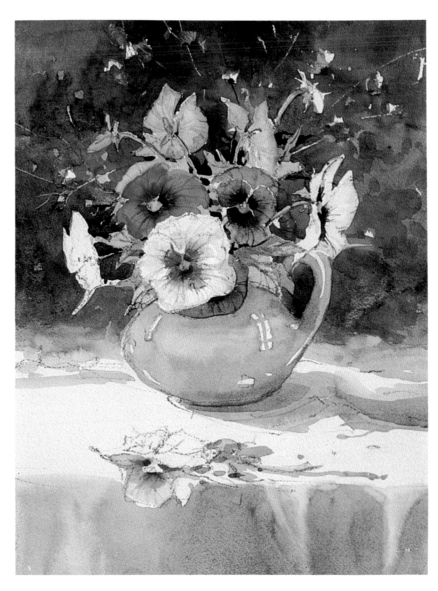

Step 1
After loosely sketching her composition on watercolor paper, Marilyn "cuts right to the chase," laying in her brightest colors in the center of interest.

Step 2
Playing off the bright colors, the shapes and shadows in background and foreground begin to balance the composition.

A Different Beginning

Usually, Marilyn suggests that her students paint large masses and values first, ignoring detail in the early stages. This time, however, she surprises me by beginning right at the center of interest.

M.S. — Once in a while, if I follow my own rule, I find that I lose the excitement I feel about my subject, and then the painting is not successful. That's why, when I am excited about one aspect of my subject (as compared to when I'm excited about the whole scene), I may just start with that part of the painting that excites me most. This keeps me enthused all the way through.

She lays bright color onto the dry paper, then with clear water, goes back in to soften and lose edges.

Background Interest

With the center of interest well stated, the artist turns her attention to the background.

M.S. — Background value is as important as foreground and center of interest. I'll usually place my darkest darks behind the lightest lights for maximum contrast.

Her background wash is a triad of manganese blue, raw sienna and permanent rose. While still wet, cobalt blue and alizarin crimson are dropped into it. Much of the appeal of Marilyn Simandle's watercolors arises from the loose, seemingly ac-

cidental way she blends and varies color on her surface.

Unlike many watercolorists, she paints vertically, with brush in one hand and paper towel in the other to catch runs; she occasionally trades toweling for the palette knife, which she uses to scrape lines and details into a still-moist area.

M.S. — I use my palette knife to add texture and interest, extending some lines outside the picture format to suggest the world that exists beyond it.

In rapid succession now, foreground is added, as are shadows on tablecloth and creamer. Brush alternates with palette knife as details are scraped into the washes.

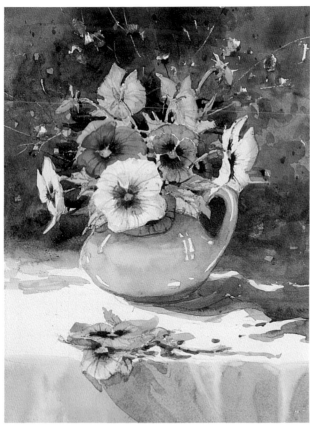

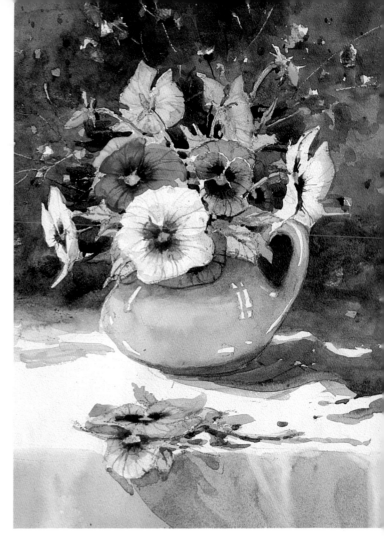

Step 3
Nearly complete now, the painting shows strengthened values, intensified color, and a wealth of scraped-out and painted-in detail.

Spring Fling
Marilyn Simandle
Watercolor
16" × 12"

The Best Part

With values firmly established, Marilyn goes back to what excited her in the first place—the blossoms—building up color intensity and value. Brightest colors and strongest value contrasts are kept close to the center of interest.

When the painting is completed, I ask Marilyn Simandle just what she strives to express in a floral painting like this.

M.S.—I'm not trying to reinvent the wheel. I'm simply focusing on the beauty of flowers. I'd like my viewer to focus in on that—and the color and contrasts.

Idea Starter
Forget "The Big Picture"

Focus on the little picture. If you're used to painting broad landscapes, try focusing on a single blade of grass. If you're getting tired of figure painting, concentrate on just a hand. (After all, many people feel that hands are the most expressive parts of the body.) If you're used to painting big, full florals, try concentrating on a single flower, or even a petal. (It didn't hurt Georgia O'Keefe's career any, did it?) If you usually work large, try a miniature.

And looking at things the other way around, take any one of the suggestions listed above, and reverse the direction. That can work just as effectively too.

Diane Maxey
Give New Life to an Old Photo

Watercolorist Diane Maxey keeps a bulging sketchbook filled with photos, ideas, value studies and sketches, which she refers to as her "thinking book." It's a volume the artist likes to leaf through to excite her eye, to jump-start her imagination, or at the very least, to get her moving when she's stalled on dead center.

This Monday morning, flipping pages, she pauses at a somewhat skimpy photo of pots and flowers in front of an iron gate. It's a photo she's worked from before.

D.M. — I'm wondering: How can I give this subject some life, find new challenge in it, and perhaps use that challenge to set a new direction for my work in the the coming week?

With ebony pencil and blank page, she begins.

D.M. — Maybe I can play the fence against a cascade of bougainvillea behind the foreground flowers.

A greatly simplified value sketch takes shape, as the artist redefines the design of the picture and establishes a value pattern.

When she is pleased with the effect, she turns to her half sheet of 140-lb. Arches cold-press paper.

D.M. — I like to do as little drawing as possible, yet still set proportion, size and perspective. This subject requires little more at this stage than placement of the gate bars, and establishing the openings for each pot.

Getting Right to the Fun Part

With a range of fresh reds on her palette (including permanent rose, rose madder genuine, Schmincke's red-violet and alizarin crimson), Diane starts with the excitement, laying in the bougainvillea with bold strokes of light, then more intense reds, on her dry, unstretched paper. Evaluating the red shape, she

Reference Photo

This photo, taken in a courtyard in Sedona, Arizona, is the inspiration for *In Full Bloom*. Like most reference photos, it has both strengths and weaknesses.

Value Sketch

Note how simplifying the values to dark, middle and white has made it easier to arrive at a dramatic composition.

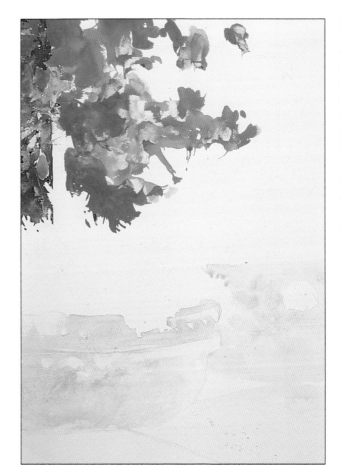

Step 1

Reds are laid in first. The artist places lighter values and warmer colors toward the right, saving cooler reds for shadow areas. Foliage greens are already being brought in at this early stage for complementary contrast.

notes light areas that could serve as points of interest, darker areas that will have to blend into the green shape to come, and negative areas in need of redesigning. She brushes in a light suggestion of foreground, and then picks up her pencil.

D.M. — I'll go back for a moment to plan the green shape.

Dominant Contrasts — Color and Value

D.M. — Boldly stating the green along with the red will clearly establish the dominant contrasts and excitement here.

Diane begins the foliage with a mixture of raw sienna and manganese blue for the light greens in the sunlit areas. Each time she returns to the palette for another pigment though, she alters the mixture: mid-temperature greens (mixed with Winsor green and burnt sienna) for middle values, and dark greens (Winsor green and alizarin crimson) for shadow areas.

D.M. — Looking ahead, cooler reds in the bougainvillea will help me shape its form in relation to the warm and cool areas of the green. Both shapes should complement each other.

Having established her contrasts, and moving on to the rest of the painting, the artist begins laying in the clay pots using new gamboge with a touch of permanent rose and cobalt violet. She tilts her watercolor board to move the wet pigment around, then scratches texture into the drying areas with a palette knife.

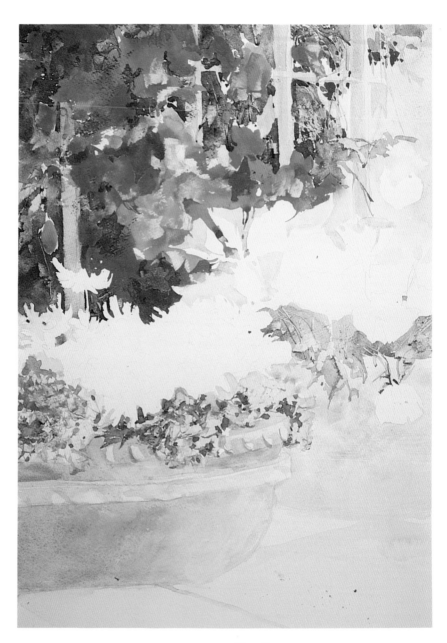

Step 2
Building values throughout the painting, reds and greens are intensified, as foreground and background begin to take shape.

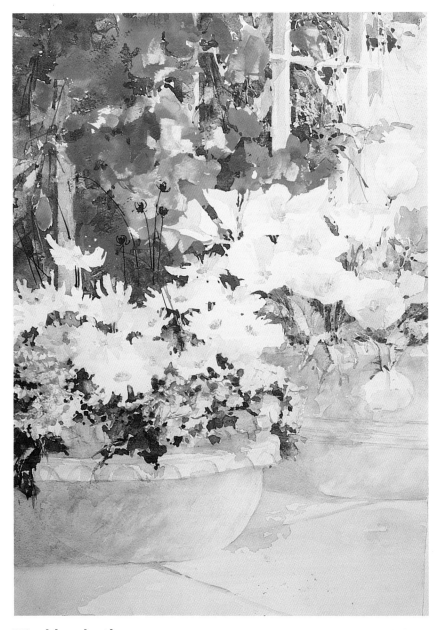

Step 3
Foreground floral masses are defined. At this stage, basic composition is clearly established. Attention is being directed to balancing hues and values, and the artist begins to define details.

Working in the Foreground

Violets and blues begin to suggest ageratum. Tiny blossoms are scratched out with the palette knife.

D.M. — I'll use green foliage to define these foreground flowers and the whiter daisies. The greens in the closest pot will be warmer. Behind it will be cooler, grayed-down greens.

Using the same warm greens, Diane reshapes the violet areas, and defines the white shapes of the daisies with washes to establish individual flower heads.

D.M. — I don't want to break up the white shape into small pieces, but I do need to give meaning to the area.

Cooler reds are added at upper right, behind the leaves and stems, to create depth and carry the red into that area. Foreground blues and violets are repeated in the iron fence. Quick washes of terra cotta colors define the tile floor. Splashes of color help texture the foreground and give a looser feeling.

Idea Starter
Got a Lemon? Make Lemonade!

Somewhere — in the back of your closet, in the bottom-most portfolio, in a dusty folder (I call mine "the grave-yard of forgotten paint-ings") — there's at least one painting that just didn't work, and you never knew quite why. You come across it every so often and puzzle over it, yet you just can't bring yourself to throw it away.

Next time you're looking for a new project, pull out one of those "lemons," and vow to either kill it . . . or cure it! Here's an instance where you have absolutely nothing to lose and everything to gain. At worst, you'll reclaim some space in your closet, and you might end up with a happy success!

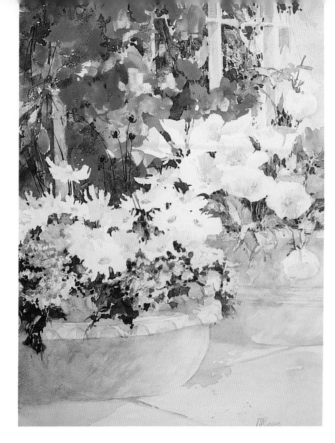

Step 4
As the painting nears completion, value range is drawn out to its fullest. Darkest values in shadowed foliage contrast dramatically with brilliant color, and with the white of foreground daisies.

The Painting I Wish I'd Never Sold

This floral painting, as surprising as it may seem, took several years to complete—the time it took me to mature enough to know what to do with what I had started.

It was 1980. I was painting with a group that day, and it was close to quitting time by the time I had started the underpainting for this one. A fellow artist looked over my shoulder and said, "That looks great! What are you going to do next?" I hadn't the foggiest idea!

I took that unfinished painting home, stuck it in a drawer, and didn't look at it again for two years. Then one day, I came across it. The moment I saw it, I knew how to finish it.

The painting received recognition in several competition shows, and traveled around the country for a year. After that, it hung in my studio. I loved to look at its flow of color and vibrancy. More important, though, I en-

joyed recalling that wonderful moment of rediscovery and knowledge.

Some years later, at a time when our daughter's college tuition loomed large, I sold it. Happily though, it was purchased by dear friends, who love it as much as I do.

—Diane Maxey

Floral #1
Diane Maxey
Watercolor
15″ × 22″
Collection of Mr. and Mrs. Charles Floyd

Shadows Make Sunlight

Picking up graphite pencil one last time, Diane lightly sketches in the shadow shapes.

D.M. – This is a fun part too. But I like to be sure I've got them right.

As the artist completes the shadows with a warm transparent hue, the sun is suddenly present in the painting, and shapes take on a more understandable form. Before leaving it, Diane glazes some of the shadow color over the bougainvillea for consistency.

Finishing Touches

Diane then determines the placement of small but important details. A few dark stems and dark wispy shapes in the bougainvillea foliage pushes back the plant, and helps focus attention on the white daisies. Bits of detail in the pots complete that area.

Finally, Diane places the painting in a trial mat and sits back to study the day's efforts.

D.M. – I'll save any little adjustments for tomorrow. Then the painting goes in a drawer, and I won't look at it for a while, because I know that if I keep looking at a painting too long, I will work on it again and probably worry it to death. I'll try to keep it out of sight until it's time to deliver it to the gallery.

If you compare the finished painting with the original photograph, you can understand how the artist's eye has transformed the not-too-exciting reference into a vibrant study in color and light.

Perhaps one of the amateur's greatest failings is a tendency to copy a reference photo, rather than use it as a springboard to a more creative interpretation that multiplies its beauty, while omitting its weaknesses. The cause is not so much laziness as being unaware of the possibilities.

It is a rare reference photo that can't be greatly improved upon by ignoring it — at least partially.

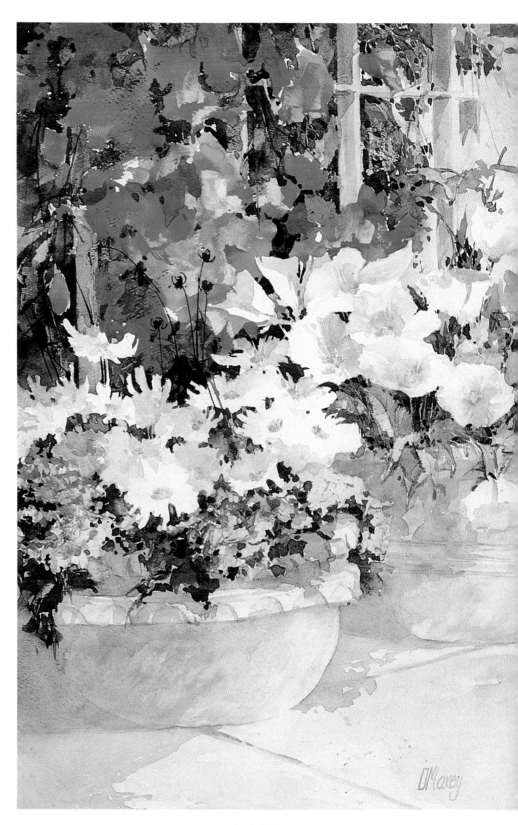

In Full Bloom
Diane Maxey
Watercolor
22″ × 15″

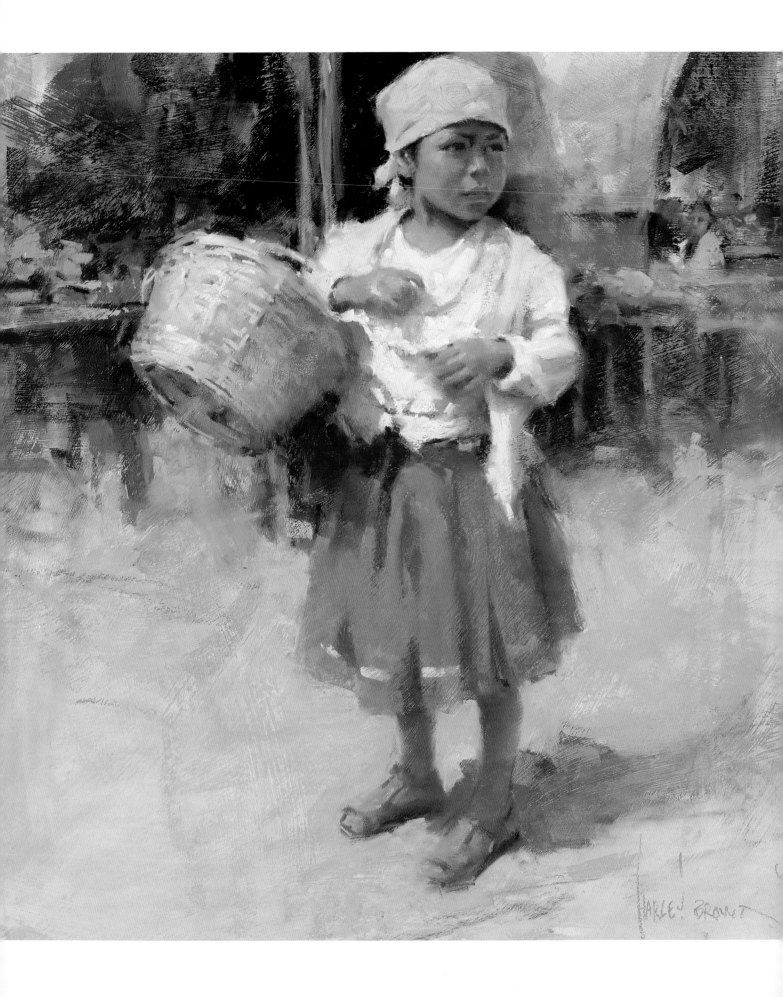

Chapter Five

Portraying the Human Spirit

Creating art out of one's personal sense of concern for humanity or outrage over disturbing events is a tradition that goes back for centuries. The works of Daumier and Goya come to mind, and the 1920s and 1930s paintings of the so-called "Ashcan School." Who can forget the searing images of Sacco and Vanzetti, or the Great Depression's victims in the powerful paintings of Ben Shahn? Or the bloated politicians and judges of Jack Levine's *The Feast of Pure Reason*?

I find it impossible to be unaware of, or unaffected by, the personalities and events of our world, but not every artist is comfortable dealing with the hurtful world in the context of his or her art. Some find it too upsetting to associate with a pleasurable pastime like painting. Some are uncomfortable going public with deeply held beliefs, or taking a stand and having to defend it in public. Others regard this type of expression as little more than glorified political cartooning, with narrow appeal and even more limited marketability.

There are various ways to come to this type of work, however. Harley Brown's sensitive portraits comment on the lives and livelihoods of everyday people. Ardyth Bernstein's sense of outrage and concern fires the boiler of her creativity.

Harley Brown
Capture Your Subject's Personality

When considering the world around us as subject matter, there is no stronger expression than the portrait. In infinite variety, the wonder, the mystery, the personality, the experiences of all humankind are written in its faces for us to read. For artists throughout the ages, portraying the human spirit in paint or pigment has always been the ultimate challenge. For them, humanity *is* the world around us.

Harley Brown, I submit, is one of the great heirs of that tradition. Artistically, he is totally involved in portraying the person — no, make that, the *personality* — of his subjects. His medium is pastel. Not only a painter of commissioned portraits, Harley is virtually obsessed with drawing and painting the human figure, in all its endless variety. In his forty-plus years in art, he has done so, by his own reckoning, over a hundred thousand times!

H.B. — By now, I'm very relaxed doing it. Therefore, problems of technique are minimized, and I can become fully aware of my sensitivities to my subject.

The importance of drawing from life cannot be overemphasized. Photos often stifle my imagination. I tend to go by the book, and my sense of composition becomes academic. I'm unable to get fully involved.

On the other hand, working from life, my creative juices come to the surface and take over. Inventive moments occur, over which I have no control. It is these "happy accidents" that make the work live and breathe.

The sitter for *Chiapas Mother* posed for Harley in Mexico during a recent painting trip. He made sketches and detailed studies from life, and took many photos, two of which are shown here.

Now, in his light-filled Tucson studio, Harley vividly recalls that

Reference Photos

These were taken during the original sitting while the model was at rest. They are indicative, says the artist, of the moment-to-moment possibilities for creative inspiration that we should always be aware of.

session as he reviews his photos. He will rely on the essence of that original sitting far more than on his photos as a reference.

One Subject, Many Possibilities

H.B. — I want to work out several ideas: hands in, hands out, the angle of the head, shapes and colors in the background.

I could work directly from the photos, which have their own interest. But, although her hand has great character, it covers an area that fascinates me: her expressive mouth. And there is that sliver of light on her chin. There are great possibilities here, and I want to be sensitive to them.

With a burnt umber pastel stick, Harley begins a series of small sketches, exploring various approaches. By the time he reaches his third sketch, he starts getting excited.

H.B. — This composition is flying in every direction, and I find myself unconsciously laying in vertical strokes throughout the background, trying to stabilize the design within the border.

Even though the outer border will not be visible as a painted design element in the finished painting, Harley considers it to be a vital part of the design. In a way, this commentary shows Harley's inner mind at work, sensitive to the relationships of all the various parts to the whole.

Trying It in Color

H.B. — Few artists, it seems, go to the trouble of doing a preliminary color sketch, despite the importance of this step, particularly if there are problems in the composition that are yet to be solved.

In this instance, the color "comp" goes easily, since most of the important decisions were made in the monotone studies.

H.B. — In no way do these preliminaries take away from the freshness of the finished painting. On the contrary, solving problems beforehand opens one's mind to the greater task: painting a truly inspired piece. Diving right into the finished work "ad lib" is a luxury best left to the professionals who are experi-

enced in solving visual problems on the fly.

An added advantage is that while working on the finish, I can go back to my color comp to test out a new idea or approach.

Midway through the finish, Harley, who had planned to have a light area in the background blend into his model's rebosa (shawl), decides that the shape of the rebosa is too interesting to break up.

Leafing through his photos, he decides the headdress has more character in the photos, and its angles relate more interestingly to the model's hands and face.

H.B.—After testing this decision in the comp, I worked it into the finished painting, at the same time increasing the fullness of the rebosa to "crown" her head.

A Thought on Color

The color in the finished painting is very close to what Harley remembers in the original sitting.

H.B.—I've always found nature to be very compatible with the artist. The hues in light, shadow and reflected light have a certain ambience that ties the various elements of a scene together. Trying to invent light often puts the artist at a disadvantage: Subtleties of natural light can be missed, leading to a disjointed, unconvincing color arrangement.

As Harley sees it, the artist should trust nature, but at the same time emphasize hues where they will aesthetically provide the most benefit.

Color Study

Harley creates a color study (about 12″ × 9″) of his subject. As seen here, it reflects the midpoint design change described in the text. Compare this with the corresponding monochrome. Notice, too, the relationship of the color comp to the finished painting—evidence of the creative process at work.

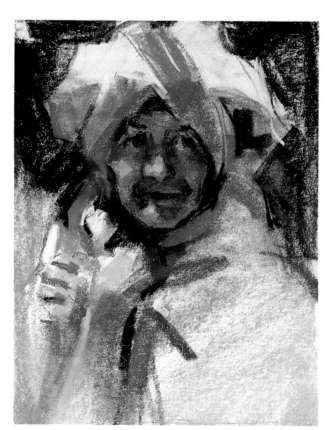

Monochrome Studies

These are based on the artist's recollection, photos and years of experience.

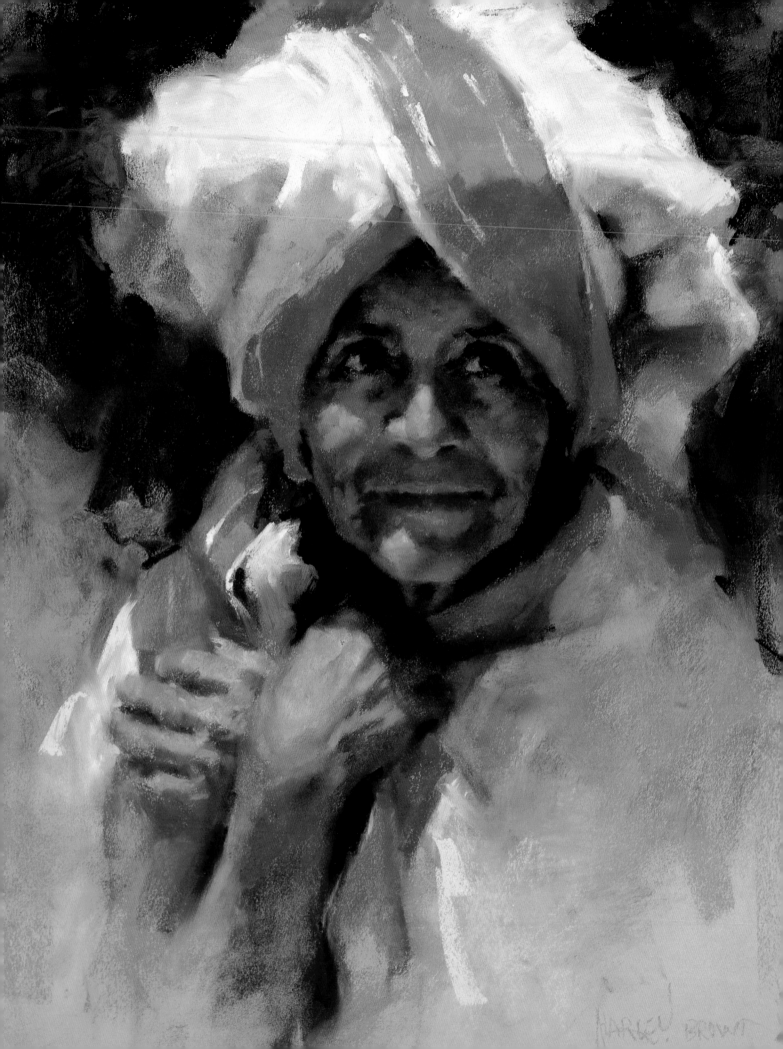

The Challenge of the Imperfect

This painting, says Harley Brown, started with total frustration. First he got lost on the way to the location. When he finally arrived, exhausted and frustrated, the only open spot in the crowded room was one tight, distant, badly lit corner. What should have been six hours of blissful painting from a single pose came down to an hour and a half.

H.B. — Upset? I couldn't have been happier! Just what I love: to try and pull a rabbit out of a hat. There's nothing I like better than the challenge of starting with impossible problems and turning them to my advantage.

Taking extra time to get his proportions right (no time for fixing later), Harley began to portray this elegant pose.

H.B. — My decisions were more intuitive than academic. The years have taught me to rely on my inner mind to carry me through rough terrain.

When the time was up, his painting was completed as you see it.

Not another stroke was added. The flaws and the accidents, he says, are there for all to see. Yet more than in a finished work, the finished piece shows Harley Brown's limitless fascination with the model, the moment, and the joy of the challenge.

H.B. — For an artist to believe in the creative process, there is one bit of advice I can give: Don't look for the perfect occasion. It will never happen. Throw yourself into a situation, no matter the conditions. Allow that moment of direct contact between you and your subject. At that moment you will understand why this mysterious mode of life has chosen you, and why others can never understand the euphoria of the artist.

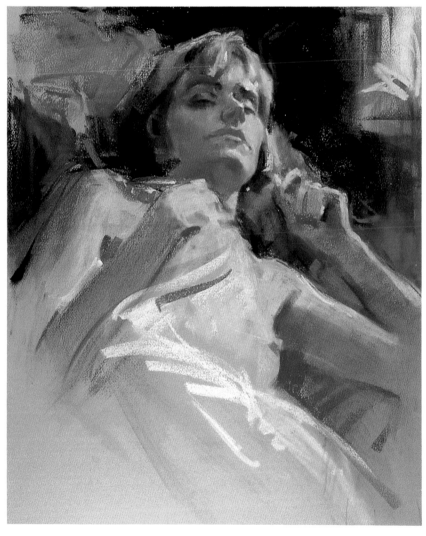

Chiapas Mother (Left)
Harley Brown
Pastel on Canson paper
18″ × 14″

The Model (Above)
Harley Brown
Pastel on Canson paper
26″ × 18″

Idea Starter
Make Changes

Many people who have changed their lives have done it in little bites. I am very much a creature of habit. But on my fiftieth birthday, I made a deal with myself. I'd start to change my life . . . *slightly*. I promised that every day I would do one thing — even a minor thing — differently. Slowly I've begun to break down the conservatism in myself. And before long, that started to show up in my art. New subjects. New techniques.

Secretly say to yourself that you're going to change the norm. Something else tomorrow. You'll find that small changes will start to graduate into big changes. And when you want to do those monumentally different things, it'll be easier.

— Harley Brown

Ardyth Bernstein
Inspiration From the Nightly News

Ardyth Bernstein's interest in women's issues is an outgrowth of her own experiences as a struggling, young, divorced mother, trying to build a home and career in the pre-feminist world of the 1950s and 1960s. She has not forgotten her struggles, and it is not surprising that her feelings are part of the foundation that underlies the art she creates today.

Ardyth's most successful and satisfying paintings in the last several years fill a series she refers to as "My Women." Each painting is a matrix of studies of her model in varying attitudes and costume. The studies, pastel-painted on rectangles of dark gray, fine sanded paper, are carefully arranged in a grid of three to thirty or more. This arrangement prompts a bouncy feeling of rhythm and motion as the eye travels through the piece.

The artist does not consciously seek events of the day to comment on, but neither does she try to escape their influence; she is perceptive enough to recognize their impact on her work.

A.B. — I started watching the Clarence Thomas/Anita Hill hearings on TV, and couldn't take my eyes off it. I knew what was happening. I knew it from my own experience! Not only the incidents, but the Senators' reactions. I was incensed. Outraged!

She'd go back to her studio, but all she could think about were the hearings.

A.B. — I thought, "What can I do?" I finally decided to start an Anita Hill series. I had no idea what that meant — as far as how it would come out in my art — but those feelings filled my mind and I had to deal with them.

The series began with *It's Not Easy Being Green*, and also includes *On My Way to Grandmother's House*.

**On My Way to Grandmother's House
(Anita Hill Series) (Detail left)**
Ardyth Bernstein
Pastel on sandpaper
32" × 56" framed

The jazz-like rhythms of Ardyth Bernstein's assembled pastel paintings are nowhere more emphatic than in this piece, with its twenty-one "frames," leading the viewer on, like stop-motion stills from an animated cartoon.

**It's Not Easy Being Green
(Anita Hill Series) (Right)**
Ardyth Bernstein
Pastel on sandpaper
46" × 15" framed

The title, says the artist, is a back-handed reference to the difficulties and basic unfairness of life.

At Work With a Model

Several mornings each week, Ardyth Bernstein has a standing appointment with her model. Rummaging through her closets and cabinets, the artist selects accessories, hats and so forth to harmonize with her mood and direction for the day. Artist and model work together in a series of short poses; studies quickly pile up on her tabo-

ret. A second or even a third session might be needed before the artist feels she has sufficient studies to choose from for the subject in mind.

Today, Ardyth has chosen a Latin American theme. The radio is tuned to a Spanish language station, and salsa music fills the studio. Her model moves with the beat, freezing into position for each brief pose.

Model

In her studio in Paradise Valley, Arizona, artist Ardyth Bernstein works with model Mona Rothenberg.

Hot Topics

Drawing inspiration from the issues and events of the day isn't for everyone. You may value the separation that art affords from the uncomfortable realities of the world outside your studio. That's a valid viewpoint. If, on the other hand, you can live with this kind of connection between art and reality, consider how your feelings might be expressed in your work. You might, like Ardyth Bernstein, prefer expressing them on a subliminal level. Keep open and receptive to their presence, but be content that the energy that drives your work will be known only to yourself. Or, you might be inspired to express your feelings head-on. There are many degrees of involvement.

If you do choose to express your strong feelings or beliefs in paint, be aware that you might find yourself involved in more controversy than you bargained for. (On the other hand, you might welcome that.)

An element of care is also to be recommended in choosing issues to attack or defend. Some concerns (election campaigns, for instance) are quickly dealt with and forgotten, relegating a painting on the subject to the dated limbo of historical trivia.

Regardless of the approach you choose, if your painting is to be any more than a full-color editorial cartoon, remember those issues always most critical to the artist: color, value and composition.

Assembling Composition

Between poses and after the modeling session, a large tack-up wall becomes an arena for arranging, rearranging, adding, subtracting and replacing elements as the composition begins to take form. This period, often the toughest time for Ardyth, may stretch over several weeks.

Several weeks pass while the artist arranges, evaluates and arranges once again. She may even have her model pose for additional studies if she can't find just what she wants. But finally I receive a call: *Mambo Queen* is at the framer and ready to photograph.

A.B. — I don't expect people to look at my paintings and connect with the themes that inspired them. They'll see a figure dancing, or moving, or whatever. These themes are only important to me. I have to know. It has to come across to me.

Plainly, the artist's awareness, concern or outrage is the primary source of the energies in these pieces, though, aside from those visible energies, she has chosen to keep her feelings private.

Assembly

As her stack of studies increases, the artist begins pinning them to the studio wall, searching for linkages and relationships.

Composition

A design begins to evolve out of the chaos. After each rearrangement, the artist stands back to evaluate colors and rhythms. It's a process that can go on for weeks.

Mambo Queen
Ardyth Bernstein
Pastel on sandpaper
34" × 58" framed

The finished work will be housed in a dramatic triangular frame, emphasizing the pyramid form of its elements. *Mambo Queen* is the final result of the creative process of painting and assembly that has taken, in this instance, some nine weeks to complete.

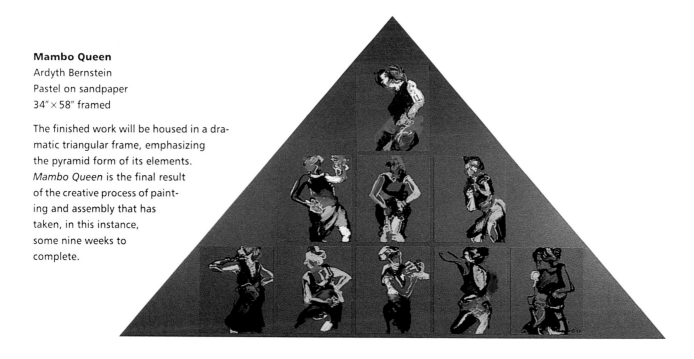

The Painting I'll Never Sell

I'm not sure exactly how the idea for my segmented style came about, but I remember that I wanted to take something simple, like a teacup, and interpret it from every angle, shape and form. Some of my renderings became realistic. Others became abstractions. Then when I put them together in that now-familiar pattern, something just clicked.

That was the beginning. I worked with simplified shapes for a while, but pretty soon I began doing my women, and the rest is, to coin a phrase, (art) history.

I still work in other media: gouache, acrylics, collage. But *Tee-Cups* marked an important turning point in my work, and for that reason I like having it around.

— *Ardyth Bernstein*

Tee-Cups
Ardyth Bernstein
Pastel on sandpaper
31" × 40" framed

Chapter Six
Exploring Your Inner Space

Zerega Avenue 1938 (From My Childhood Series)
Lewis Barrett Lehrman
Watercolor
24" × 36"
Collection of the artist

The second painting in this series was evoked by memories of the trolley car excursions my father and I took together when I was about five years old. The painting is done completely from those memories, except for the streetcar itself, which I researched for believability, if not authenticity.

A while back, an artist friend recounted how he'd come to paint his evocative scenes of farm life.

"I was haunted by imagery in my head that I could not paint," he said. "I went back to the home in Oregon where I had grown up, and spent several weeks roaming the countryside, searching my soul. Finally it began to manifest itself, and crystallize.

"It dawned on me that there was something very important about my background and my roots in the Oregon farm country."

With this new understanding, he then recognized that the images haunting him were of the people and places of his childhood, and he knew he was destined to express them on canvas.

We each carry in memory yellowing picture albums filled with images of our own past—pictures charged with every emotion the human spirit experiences. Some evoke love and tenderness. Others might be too painful to face. More scenes than could be painted in *several* lifetimes!

If it is true (and it is) that an artist's most powerful paintings are brought forth from deep within, then what surer way to tap into the power of those inner emotions than to explore one's own memories, and to express them in paint?

Lew Lehrman

Painting Thoughts and Feelings From the Past

I had never considered exploring my own inner space until I had that conversation with the artist. It was an intriguing direction, and it started me thinking.

Inevitably, my thoughts turned to my father, and a rush of memories overwhelmed me, as so often happens when I think of him. The beloved "Pop" of my childhood. He and Mom divorced when I was already grown, yet I was naïve and judgmental, and took sides with my mother against him, breaking off all contact. It was years later, long after his passing, that I realized my mistake. It has haunted me ever since.

Now, I decided, I would try to express my true feelings about our relationship. It was no easy task. The subject would be Pop, and me. I chose to place the locale in the years of my early childhood, the 1930s, in the Bronx, where we lived. I thought I had the painting clearly in my mind but, as so often happens, it didn't look as wonderful when I saw it on paper.

The Painting in My Head

In my preliminary thumbnails the two of us are standing side by side, but now that doesn't seem intimate enough. I try a number of variations before realizing that the child should be on the father's shoulders. I make the child a toddler.

Pop wears the gray flannel overcoat I recall, its pockets bulging with little gifts he'd bring home for me. I carry a fondly remembered toy figure. Pop wears his familiar fedora, his octagonal rimless glasses reflecting the light, eyes unseen, unknowable.

Pop stands firmly planted on the lower frame of the picture, the vanishing point at ground level. Vertical perspective is exaggerated to emphasize this monumental figure from my childhood. Behind him, the great, roaring mass of the ele-

vated train tracks rushes toward us out of the distance, swerving at the last moment in an unexpected direction—like life itself. The bleak, Depression-era streets of the Bronx contrast with the closeness of father and son. A peddler is the only other figure in the lonely scene.

Preparing to Paint

A final small sketch (about 9″ × 6″) incorporates my latest thoughts and changes. I grid and enlarge it to 24″ × 30″, redrawing, adjusting proportions and adding details as I do so.

The full-size sketch is placed on my light box, and partly traced, partly drawn (still developing and changing) onto my favorite paper, Japanese "Masa," a lightweight, smooth, machine-made sheet which I purchase in rolls.

In the Oriental watercolor technique I prefer (learned from watercolorist Frederick Wong), the paper is soaked, wrinkled and painted wet-into-wet during the initial stages; it's then dried and wet-mounted to acid-free board before

A Sketchbook Page

These sketches show the formative stages of *Pop and Me.* In a haphazard series of studies, I explore faces, hats, positioning of the figures, horizontal versus vertical format and other details as I try to lock in on the concept. The elevated train structure, a powerful symbol, is never in doubt. At bottom center is my first realization of the composition that would ultimately work.

being finished in a more or less traditional Western manner.

For my initial washes, I lay in a graduated wash of manganese blue, shading to raw sienna, then to cobalt violet/permanent rose, to set the tonal range of the piece — to me the colors of memory.

Much of the textural appeal of this Oriental process comes from the way pigment congregates in the cracks of the wrinkled paper, and I take full advantage of that effect in my watercolors.

Figures and elevated train tracks are essentially monochromatic, painted only in varying shades of warm and cool gray, while background details are keyed to the lighter background hues — subduing them and lending a dreamlike quality. The only clear color is in the blue of the baby's garment. Note how he stands clear against the sky. There are symbolic as well as compositional reasons for everything in this painting.

Therapy Painting

My wife calls this my "therapy painting." The longer I work on *Pop and Me*, the more my emotions crowd in on me. It evokes thoughts and feelings too complex to put into words, or even to translate directly to my paper, yet certainly destined to be present in the final piece. At times it is difficult to continue, so I stop and return to it a day or two later.

When I finish *Pop and Me*, and stand back to look at it, I know I have accomplished something extraordinary: one of those rare occasions when the artist knows he has painted beyond his capabilities. The painting is surely as much a part of me as my memories of my father and all that those memories evoke. It is certainly a painting I can never sell.

Pop and Me is the first of several paintings I have come to call my "From My Childhood" series.

A Sketch for Composition

I recall doing a number of variations of arm positions and other details on tracing paper, which was ultimately discarded. My gridding for enlargement was also done on a tracing paper overlay.

Value Sketch

My sketch has been enlarged to 30″ × 24″, and carefully redrawn to incorporate my latest thinking. Values are laid in before I transfer my drawing to the watercolor paper — an unusual step for me.

Pop and Me (From My Childhood Series)
Lewis Barrett Lehrman
Watercolor
30″ × 24″
Collection of the artist

Gary Kolter
Weave a Story With Memorabilia

Gary Kolter has always been intrigued with the past. The era from about 1880 to 1920, with its yellowing photos, characteristic style, advertising memorabilia and nostalgic artifacts furnishes him with attics full of source material for his intriguing *trompe l'oeil* paintings. The phrase itself means "fool the eye," and fool your eye they do, with peeling paint, shiny thumbtacks, old chewing gum wrappers, tobacco cans, postcards, daguerreotypes, mysteriously symbolic keys and more—all painted so precisely and shaded so realistically that you want to lift them off and look behind them.

The appeal of Gary Kolter's work, however, goes far deeper than the visual tricks he plays. His paintings seem to tap into each viewer's memories, recalling, perhaps, some bygone love: a soldier who never came home, a sorely missed parent, one's long-departed youth, the Western Frontier. Of the countless small compartments that make up our memories, a few seem to open gently when we view one of Gary's evocative pieces.

G.K.—I grew up hearing all the old stories from my aunts, uncles and grandparents. Maybe that's where it started. Today, I paint for other people, but I only paint what I like, what I relate to. When people who lived in that period see something in my painting that jogs their memory ("I haven't thought about that in seventy years!"), I love that.

One of the most surprising effects I notice is how Gary's paintings can get you feeling involved with eras you've never lived, places you've never been, lives you've never encountered.

G.K.—While these paintings start with my own thoughts and memories, somewhere in the process, the elements become characters in the story I'm weaving.

Paintings like these work because they evoke similar emotions in the minds of the folks who see them. They tell a story, and people love stories.

Gary haunts antique shops. People who know his interests send him things. Friends refer to his house as "the museum." Thinking about his next piece, he gathers elements almost at random, until something sparks his interest. Then he'll start seeking other artifacts from the same period.

G.K.—Take King of Hearts, *for instance. The postcard is from my collection. The stick of gum and the cigarette pack are actually from that era. I do a lot of research to get that kind of thing right.*

Lunch Break
Gary Kolter
Acrylic on rag board
18" × 22"

Gary's dry sense of humor tends to show up occasionally in his work, in small, subtle details. The rustic wood frame-liner for this piece, incidentally, is painted on the board, perfectly matching the painting's real rustic wood frame, its "shadow" precisely cast on the painting itself.

Pretty soon he'll begin building a story around them. It may take weeks for Gary to pull together the elements and research for a painting. Then it can take several more weeks to execute it. He works in acrylics, on the finest grade of Strathmore cold-press 100 percent rag board, which he mounts to Masonite for complete rigidity.

G.K. — I work my acrylics much as one might work with egg tempera — building thin layer upon thin layer, sometimes twenty or more before I get just the finish I'm looking for.

His brushstrokes are so fine as

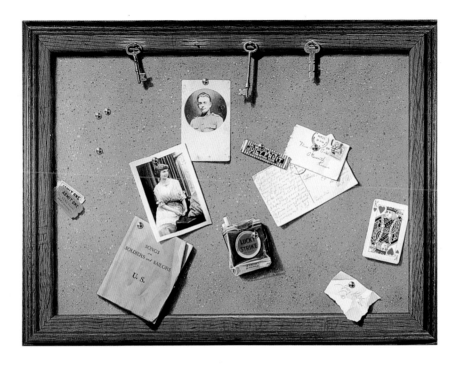

King of Hearts
Gary Kolter
Acrylic on rag board
18" × 24"

The inner frame, as in *Lunch Break*, is painted to match the real frame. The keys, of course, are painted as well.

News From Home
Gary Kolter
Acrylic on rag board
16" × 12"

Gary has always been intrigued with old enamelware, about which, he says, very little has been written. It was widely used in the days of the frontier, and shows up frequently in Gary's paintings.

to be undetectable. It's difficult to tell, even very close up, that the old photos in his paintings are not really old photos.

G.K. — Two things are important in terms of technique for a trompe: capturing the light, which means getting the shadows and reflections right, and careful, precise brushwork. You want people to forget it's a painting.

A graduate of Arizona State University (in art education) and the Famous Artists' School in Westport, Connecticut, Gary Kolter's repertoire consists of far more than just *trompe l'oeil.* He is well known in the West for his scenes and still lifes of ranch life, each painted with the same careful design, and the same exacting attention to authenticity, brushwork and detail.

G.K. — Realism, and trompe l'oeil in particular, are a genuine part of the American art genre. Though not American in origin, they have long since been adopted in this country as part of the American Realist School.

Memories Are Made of This

If you're a collector, you may have an attic — or at least a shoe box — filled with stuff from the past that you've never had the heart to discard — stuff that means something important to you, that could tell a story if only it could speak. Find that shoe box, why don't you. Take each memory out and let it speak to you. Wouldn't it be meaningful to give voice to those cherished memories in a painting?

Lazy Ike
Gary Kolter
Acrylic on rag board
16" × 12"

The artist started doing "peeling paint" motifs about twenty years ago, he says. He enjoys watching people try to pick at the paint chips on the painting, they look so realistic. The name of the painting, incidentally, is taken from one of the fishing lures.

Idea Starter
Focus on the Commonplace

Do you find yourself always looking for the grand scene? The Rocky Mountains? The Grand Canal? The perfect landscape?

Just once, try focusing on the commonplace. How about one of these for starters? A sink full of dirty dishes. A still life composed of the makings of breakfast. A coat on a coatrack. A pair of muddy sneakers.

Look around you and pick out the most mundane subject you can. Now make it a work of art!

Chapter Seven
Finding a New Direction

Is creative exploration a part of your agenda? Exploration suggests adventure, and in adventure there's no guarantee of success. Exploration can be risky. Yet the artist's job description has always included both adventure and risk: That new direction might lead to a dead end. The new technique you've developed just might not work the way you expected. Deviate from what your gallery — or your market — expects, and chance their loss!

Despite the risks, however, every painting you do can be an exploration of sorts: new look, new subject matter, new perspective, new way of working. Not surprisingly, the greatest breakthroughs will come only through the boldest — and therefore riskiest — exploration.

Therein lies the paradox: In risking, we may fail, but not risking is a kind of failure too. Choosing the security of the familiar, we cease to grow as artists.

It's hard to let go of what we know and what works for us. But creative exploration should be a part of every artist's agenda. Just remember that a salable painting is not the only goal. For the artist, success has many definitions.

Joni Falk

Take Advantage of "Happy Accidents"

Joni Falk is usually a very controlled painter. Her favorite subjects include carefully constructed florals, wonderfully evocative scenes of the Southwest, and light-filled paintings of Native American pottery and artifacts. Doing something "just for fun" is not what I would normally expect from Joni, but that's what she did when I met up with her.

I was discussing a demonstration painting with Joni, when she mentioned how she had once dropped her palette facedown on a canvas, then built a painting from the resulting mess.

"Could you make that happen again?" I asked her.

"Maybe," was her doubtful answer. "But if it works, it *would* be a lot of fun!"

A few days later I arrive at the spacious, light-filled studio that dominates the north side of the Falk's Phoenix home. A tree-shaded lawn is visible through the studio's huge plateglass windows.

Composition — the Quick Way

The first thing I see is a 5″×7″ snapshot, onto which Joni is daubing oil paints. It turns out to be the subject of today's experiment in painting just for fun.

J.F.—I want to get rid of those utility boxes in this photo. Instead, I'll place a rabbit in a little green glen.

With her instant study handy, Joni turns to her palette. A second palette of disposable waxed paper sheets stands ready. Reminding herself that she has to plan in reverse (the composition will be a mirror image when transferred to canvas), Joni attacks the blank palette sheet with fresh oil pigment, liberally applied and blended with the palette knife.

Original Photo

The rabbit lived next door, but had found its way into the Falk's backyard (perhaps in search of a modeling career?).

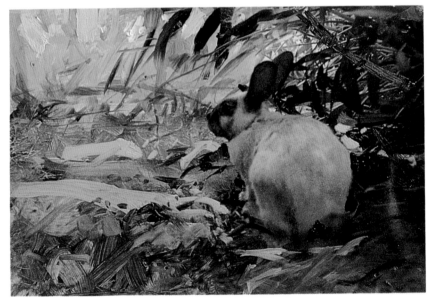

Study

Daubing oil paint directly onto a photo is an effective way to eliminate unwanted elements and experiment quickly with color and value changes. Oil paint wipes easily from the photo's plasticized surface with a solvent-moistened rag.

Color-Loaded Palette

The artist's working palette is at top, the disposable sheet palette below. Pigments have already been spread around the palette surface, and the whole affair is ready to be slapped against the canvas.

Splat!

Pleased, finally, with the distribution of pigment on palette, she takes it to a table and, laying an unmounted rectangle of primed canvas facedown on it, rolls that into contact with the paint.

A print maker's ink roller is pushed in various directions to press the canvas and palette together, squeegeeing paint to and fro. After a few moments, she peeks between to see what's happening, then puts the canvas back down.

J.F. — This is exciting! Let's take the end of a brush handle and move some paint around with that.

She scribes lines on the back of the canvas, occasionally lifting to check the progress.

J.F. — I like that! Let's try some other objects.

She grabs a kitchen fork, using it to scribe grasses and weeds. A moment later, the artist finally decides to lift the canvas fully away, to check the final results.

J.F. — Say, this is pretty good. I can work with it!

Step 1

What a mess! The canvas has just been pulled away from the palette and now is little more than a random riot of pigment. Can this *really* become a painting?

Working Differently

Removing the paint-loaded palette sheet from its padding, Joni tears away sections of the pigment-loaded palette, rubbing them along the margins of the canvas to transfer leftover pigment to its outer edges.

J.F. — It's a lot of fun to make things happen this way. Totally different from how I normally work!

I'm going to poke the image of the rabbit into place now.

With a solvent-moistened brush, Joni begins lifting out pigment where the rabbit will be placed. A touch of indigo is used to rough in the ear shape.

J.F. — I'll put the eye in first off. The minute that's in, everything will seem to pop into place.

She puts a tiny highlight in the eye and a touch of pink in the ear. Shadows begin to take shape on the rabbit, as she adds white along its upper body.

Now, Joni decides to work on background foliage.

J.F. — The accidental textures I get with this process either talk to me, or they don't. Look at the colors on the bunny's face! I'd never think of working with that green in his face, but I love it! It's as if there were back lighting through the grass. That's what will make him interesting.

As a matter of habit, Joni continually refers to the reflected image of her canvas in a large standing mirror placed directly opposite her easel. Evaluating now, she decides to pull some sky light in, and to lighten some of the more intense greens and yellows so they don't compete.

J.F. — I don't want to lose the darks. I like to have darks in the corners, with just a bit of light showing through.

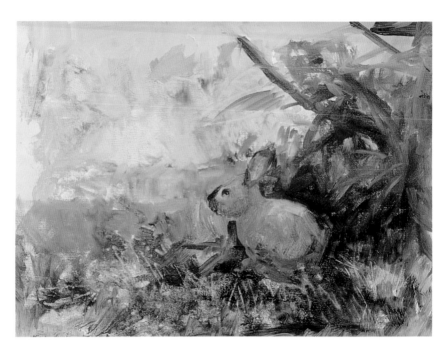

Steps 2, 3
The bunny is taking shape, and the artist is working on the surrounding background. The key to success with this approach lies in allowing the accidental textures to dominate, without trying to overrefine or overcontrol them. *Not* reworking these textures is quite difficult for a precise painter like Joni.

Shady Rest
Joni Falk
Oil on canvas
12" × 16"

Finish

The finished piece is delightful testimony to how little has actually been required in the way of brushwork to suggest foliage, earth, rocks and grass.

Listening to the Painting

J.F.—Initially, I was thinking of the light coming in from the left, but now it's telling me that the light is coming from distant right, filtering through the grasses.

She lays a bit more white along the bunny's upper back and haunches. Then, to plant him more solidly, she puts a trace of dark beneath him.

J.F.—What makes this kind of approach work is going with the wonderful things that seem to happen when you accidentally put down paint. It's really a fun way to paint—a luxury I just don't allow myself often enough. I really should.

Joni begins poking tiny light passages into the foliage at right.

J.F.—Now that I see the light coming from the right rear, I want it to sparkle through the foliage.

The Hard Part: Stopping

I remark that I don't think the painting needs much more to be finished. Joni agrees. She puts in a few more blades of grass and branches, dots some sparkles of light in the foliage at left, adds a bit of blue to the foliage at right, checks the composition in her mirror one more time, then stands back. It's finished.

She signs it. An unused frame, parked nearby, fits the painting perfectly, and that's how I photograph it.

Which goes to prove that happy accidents don't work *only* for watercolorists!

Idea Starter
Instant Lesson

It's probably safe to say that most of us have at least one demonstration-filled art book that we've never actually put to use, even though we know that just owning it won't have any effect on our work.

Pull the book out, open it up, select one of the demonstration paintings, and try to duplicate it, using the author's descriptions and step-by-step photos as your guide.

It may not be a museum piece. You may not even want to save it when you're done. But there's lots to be learned merely from painting alongside a professional. And it's another painting under your belt.

Southwest Images
Joni Falk
Oil on canvas
6″ × 7″

The artist's favorite bird is the Gamble's Quail, and she loves to paint pottery. How elegantly the two combine in this miniature. Note how the snow-covered branch helps link the two.

Visions of the Past
Joni Falk
Oil on canvas
30″ × 30″

The country around Jackson, Wyoming, has always inspired this artist to paint. A recent winter trip inspired her to capture the mood and aura of winter sunlight.

These are fine examples of Falk's more precise painting technique. Another example may be seen on page 46.

Patterns of Light
Joni Falk
Oil on canvas
14″ × 14″

Sometimes it only takes something as simple as color to move you off dead center. Joni Falk had been procrastinating on this commissioned piece, until she came across these flowers and visualized them in the composition. "I love painting pottery," she says, "but somehow these live flowers gave the painting another dimension."

Diane Maxey
Plan First, Then Let Yourself Paint

For Diane Maxey, the sheer pleasure of the experience—the coming together of pigment, brush and paper—is the reason she paints. What's important to her is the *process* of painting . . . the act of doing it. The painting itself, she emphatically affirms, is only the by-product.

I would probably find this viewpoint harder to accept had I not watched Diane at work. Her enthusiasm and exuberance, always a defining part of this artist's personality, seem to take control when she paints. Adding color brings visible delight, often an exclamation of outright pleasure.

Selecting a Subject

This morning I find the artist leafing through her sketchbooks, waiting for some subject to say "hello."

D.M.—This particular sketchbook consists of nothing but my photos surrounded by small value studies exploring how to use them. I never copy a photo. They're only for inspiration and information.

A snapshot catches her eye: flowers in buckets at a flower stand, beneath blue umbrellas.

She stops, goes back to it and grabs her pencil.

D.M.—I like the colors in the flowers and umbrellas. I'll have to fix the background. It's too busy, and all the umbrellas are parallel.

She begins sketching furiously, working toward the design in her mind. Immediately, the umbrellas are reduced to three. Light and mid-range values are massed, further simplifying the composition.

D.M.—It's critical that these studies remain simple, so I use only three values: the white of the paper, a midtone, and the darkest I can get from my pencil. "No detail" is the rule here.

Diane loosely sketches, as midtones, all the areas that will be either midtones *or dark tones.* Then, going over the middle tones with heavy strokes, she lays on the darkest values, using them to enhance the midtones and excite the lightest areas.

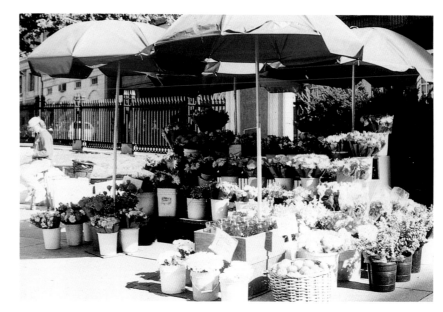

Original Photo

This colorful snapshot, from the artist's extensive photo file, is the basis of *Under the Blue Umbrellas*. The problems are immediately apparent: too much detail, confusing color arrangements, and the need to design, simplify and add interest.

Value Sketches

A progression of sketches, intended to simplify elements and values, comes down to these three. Diane chooses No. 2.

Putting It On

Moving now to her watercolor paper, an unstretched sheet of 140-lb. Arches cold-press, she does a minimum of drawing, indicating only key shapes and principal lines of the composition.

First washes for the umbrellas employ French ultramarine for local color and cobalt for sunlit surfaces. Manganese blue is added to each for its appealing granular texture.

Color Patterns

D.M.—Painting these color shapes is like putting together a patchwork quilt. I'll create color patterns that move and interlock the whole middle area of the painting.

Diane believes that doing too much preparatory work takes away the excitement of painting, so she doesn't preplan these color passages. Instead, she puts a color down, and tries to find, as she puts it, "where my eye wants to see the next bit of color." She's always evaluating what's happening with color, shape and texture. The value sketch tells her whether a particular color shape is to be in sunlight or shade. She then chooses warm colors for sunlit areas, cool colors for shaded areas. That way, she will be able to minimize the need to glaze shadow values over her intense colors later.

Step 1

Initial washes are in place. Notice how little drawing has been done. Part of the color intensity of a Maxey watercolor results from the near absence of pencil lines to smudge, complicate or gray down the sheet. Much of the freshness comes from having *not* overplanned it.

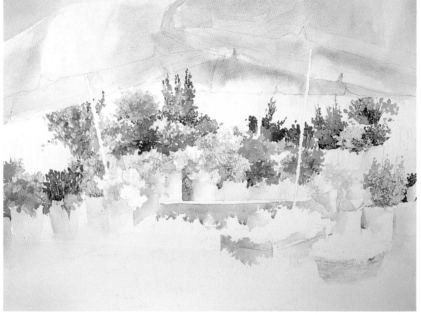

Step 2

As vibrant floral colors begin to move across the center, the painting starts to take on life. The principal planning for this part of the painting has been concerned with value. The artist lets her intuition decide which colors are to appear beside each other.

Building Value Contrasts

D.M. — Now, the color pattern for the middle area is set in place. At this moment, I'm real hungry for some darks!

Using a variety of greens — manganese blue with raw sienna; aureolin yellow and Winsor green with burnt sienna; Schmincke's vermilion green deep with Winsor blue — the artist sets up strong color and value contrasts against the blossoms. At the same time, she creates white picket fencing with negative-space painting to continue the horizontal movement of buckets and flowers to the edges of the paper.

Greens at the top left define the tops of the umbrellas. They also justify the dark greens of the middle ground, and help move dark values to the top of the paper.

D.M. — This is exciting! Notice how some of the flower shapes pop with excitement now, while others that are close in value to the green recede.

Everything Has an Effect

While dark and middle-range greens have enlivened the colorful blossoms with contrasts, Diane discovers that they have had precisely the opposite effect in another part of the painting.

D.M. — What has happened here? The umbrellas are no longer exciting!

Diane refers to her value study. The new, stronger values have changed all the relationships. The umbrellas, it is obvious, are now too light. She begins strengthening them, at the same time adding interest within their shapes.

Now that the artist sees her main color patterns, she can determine colors for the foreground blossoms.

D.M. — Color, texture and value are my main concerns for these flowers. Because they are closest to the viewer, they can sustain more detail interest.

She begins working on the foreground now, from light values to medium, and finally to the strongest, darkest values of the red, bringing in passages of green foliage for contrast. Experienced in brush-handling, Diane continually develops negative areas off one edge of a wash while creating positive areas along another.

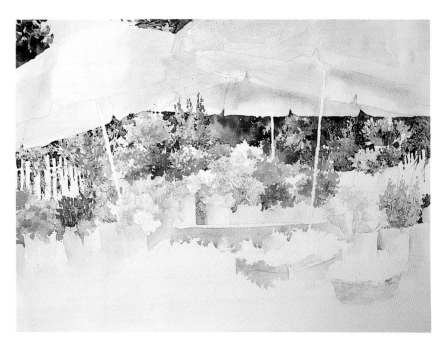

Step 3
Basic color movement established, the artist lays in her dark and middle range greens, furnishing instant color and value contrast.

Idea Starter
RX for Artist's Block

I keep a pretty extensive file of photos I've taken over the years: subjects I've thought might make good paintings. They're filed in 10″ × 13″ envelopes, by loose categories (Western Faces, New England Barns, etc.). When I feel stumped for a subject, I give myself an assignment: Pick one envelope and, without looking, reach in and select one photo. Now make a painting from that photo. No second choice. No whining. Do it! The total involvement that comes with problem solving to create a painting out of a not-always-wonderful photo lifts me out of my rut and gets me functioning again.

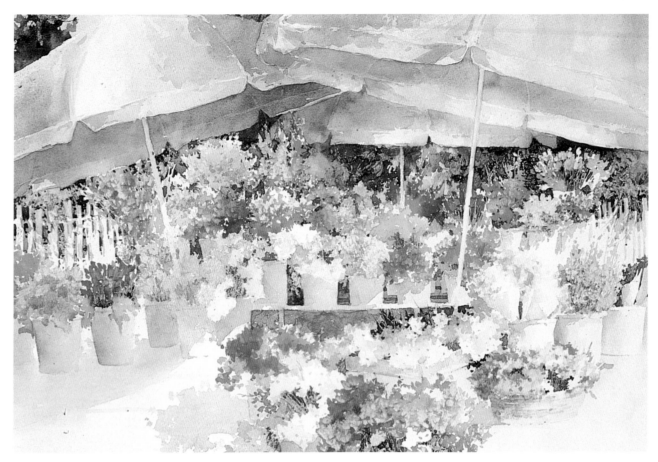

Pulling It Together

The painting is nearly complete now, and Diane is ready to add shadows around floral areas and within the pots to tie the diverse elements and colors together.

D.M. — I love the shadows. See how they redesign the foreground, how they decorate the surface of the buckets, and help to create eye movement through the patchwork of color.

Under the Blue Umbrellas is an excellent example of Diane Maxey's popular floral motifs in watercolor.

Refer to the original photo once again. Great subjects like this, so appealing when we encounter them, can be overwhelmingly complex to paint. What might have become a busy and disorganized painting is made visually appealing and accessible to the eye through careful planning and simplification. Note how the bright floral colors dance across the center of the painting, then move to the foreground to "take a bow." Dark values frame bright colors for maximum contrast. Unnecessary details have been omitted, while others, more essential (like the tilt of the umbrella poles), have been made more interesting.

Ultimately, all that careful planning enables Diane Maxey to allow exuberance to take control of her painting process.

Under the Blue Umbrellas
Diane Maxey
Watercolor
18" × 24"

Finish

Time to deal with foreground. Floral masses are laid in now, their values built up layer by layer.

Cheryl English
Wander a Different Creative Path

Cheryl English is best known in the Southwest for her colorful, precisely rendered, carefully detailed paintings of Native American pottery and sunlit adobe and shadows. But there is another side—another whole style—to her work, and therein lies one secret of this artist's freshness and creativity.

Maintaining family obligations, as well as keeping seven galleries supplied with her increasingly popular work, puts tremendous pressures on Cheryl, a dedicated artist who works virtually every day— and sometimes far into the night— in her Phoenix, Arizona, home-studio.

At those times when she gets tired of blocking in, detailing and rendering, Cheryl likes to pick up the palette knife and let her creativity wander a totally different path.

Departing From Her Norm

For this demonstration painting, Cheryl arrives at my studio with an 11″ × 14″ stretched, primed canvas, and a photo she took some years ago during a stay at a ranch near Cody, Wyoming.

C.E. — This photo brings back memories of a place I enjoyed. It has such a pleasant mood, and a wonderful feeling of depth. I also love the monochromatic nature of the scene. To me, colors seem to clutter up the spirit of a subject like this.

Cheryl lays out a limited palette of sap green, asphaltum, ivory black, yellow ochre, ultramarine blue, permanent green light, cadmium yellow light, white, and a dab of Winsor violet for flowers in the foreground. A pan of turpenoid sits beside it.

The penciled line-in on the canvas is almost nonexistent.

Perching on a stool, and with the canvas resting on her lap, Cheryl

Reference Photo

Pulled from Cheryl English's extensive reference files, this snapshot is the starting point for *Cody Vista*.

Shadow Play
Cheryl English
Oil on canvas
24″ × 18″

An example of her more familiar style, *Shadow Play* is an expression of the artist's fascination with light and shadows.

goes right to work.

C.E. — I prefer this technique for capturing a mood. It's faster, more spontaneous, and I can concentrate on getting the feeling, rather than on the technical aspects of painting.

Beginning, she scrubs in the darkest values, keeping the paint layer thin on the canvas, occasionally using a drop of turpenoid to move color around.

Light values are now added to the sky and to the distant mountains, continually dragging color back and forth between adjacent areas to blend them and lose edges.

C.E. — Switching styles like this keeps me excited about painting. It just changes my mood completely. People have told me that I'll never be known as an artist until I become known for one thing only, but I have to do this. I just need that break.

Letting It Paint Itself

Cheryl continues to work with lighter values, laying in the river, continually blending edges and altering shapes. At this point in the painting, she no longer refers to her photo, relying, instead, on the painting itself to dictate her actions.

C.E. — My photo is only to get me started. Sometimes the painting will go off in a whole different direction. I don't really have that much control over what's going to happen, but that's fine. I just let it go, and follow along. If it doesn't turn out, it just doesn't.

As the painting nears completion, I remark that there has been a great deal more blending than I'm normally accustomed to seeing in a palette knife painting, resulting in a thinner paint film.

C.E. — I know. I've watched other artists demonstrating palette knife technique, and that's not the way they do it. They lay it on and leave it. But this works for me. Some people don't even realize that these paintings are done with the knife.

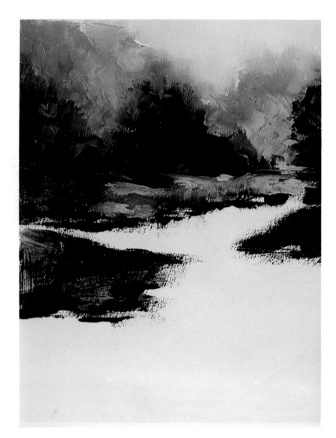

Step 1
Initial lay-in of color, and beginning the blending of sky and distant mountains.

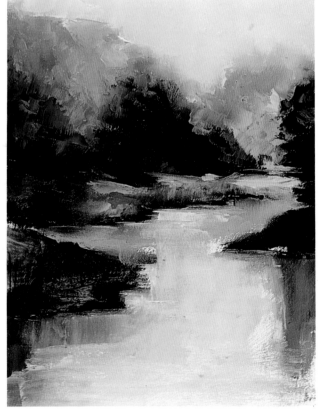

Step 2
Developing values and textures. Notice that even at this early stage a great deal of blending is going on between adjacent areas.

License for Spontaneity

In startling contrast to her more familiar controlled brushwork style, this painting and others the artist does this way are freer, more loosely constructed, and far more spontaneous. She started working this way so long ago that she doesn't remember exactly where or when, but it seems to give her license to bypass the exacting drawing and the careful attention to texture and brushwork she usually deals with.

C.E. — I tend to keep my palette knife paintings separate from my others. One gallery in Wyoming shows these exclusively. Many of my collectors have no idea that there's another side to my work.

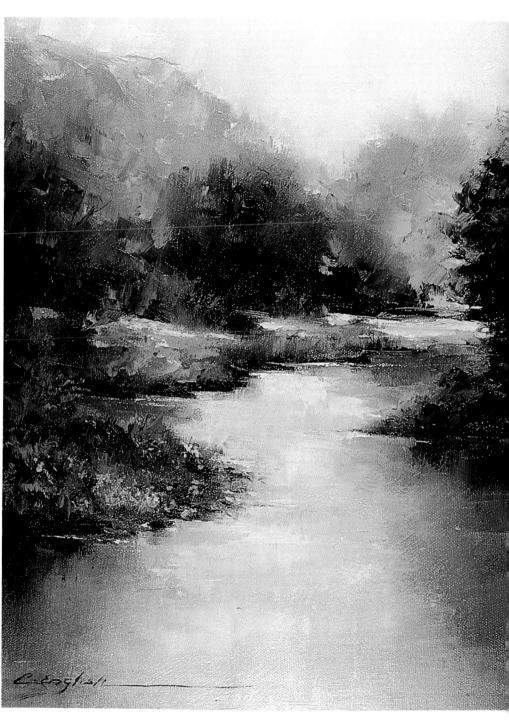

Cody Vista
Cheryl English
Oil on canvas
14" × 11"

Finish

Compare the finished painting with the previous picture to see how colors and shapes have evolved into the finished composition.

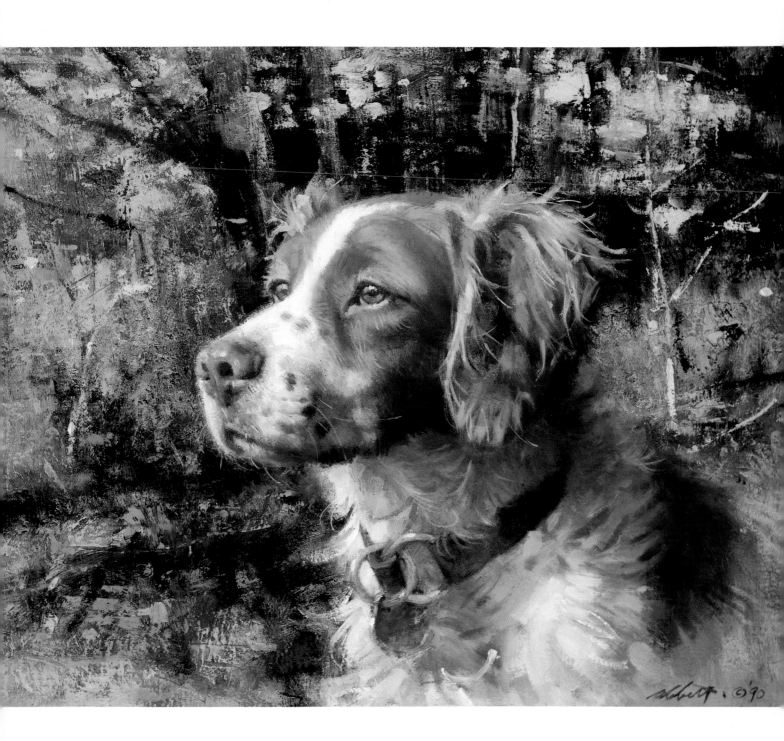

Chapter Eight

Expressing Creativity in Commissions

Buck — Brittany Head
Robert Abbett
Oil on Masonite
16" × 20"

Bob Abbett met "Buck," a Brittany spaniel, in Arizona at John Greer's former Top Knot Kennels. His alertness and intensity quickly gained the artist's attention. A natural subject for a painting, Buck appears in a series of limited edition prints featuring popular sporting dog breeds.

Does the thought of being told what to paint make you tense? Would a client telling you, "I think it needs a little more blue in the background" set you off? Do you believe that accepting a commission will somehow stifle your creativity?

As an artist, you challenge yourself every time you begin a new canvas. You give yourself an assignment (portray this landscape, this bowl of fruit, this emotion), and you set out to paint it. Your creative freedom is expressed in the way you paint it.

With a commission, the creative challenge is furnished: Your client chooses the subject. You still exercise your creative freedom in the way you paint it. That's what your client wants. The difference is merely the source of the challenge.

As Bob Abbett, Ann Manry Kenyon and I will affirm, far from stifling it, a commission will *challenge* your creativity. How? By focusing your choice of subject matter on something at which you are clearly quite adept, and which you already enjoy painting.

In this chapter, you'll see how three artists go about handling very different sorts of commissions: a dog, a child, a house. In each instance, a client has said, in effect, "I want this moment captured, and I want it done with that indefinable quality that only you can bring to it, so I may savor it always."

Isn't that a sufficient creative challenge?

Bob Abbett
Focus Creativity in an Animal Portrait

Where some artists might chafe at the restrictions placed on their artistic freedom by a demanding client, well-known animal and wildlife artist Bob Abbett is accustomed to this sort of challenge, and he welcomes it.

B.A. — What makes it go smoothly is that I'm able to work with people. The difficult part is that the people who can afford my work are wealthy, successful, and not used to turning over control of the creative process to someone else. There's a lot of back and forth, but they usually come to understand that I'm the artist, and they're the client. In the end, I just have to do the picture my way.

Rather than considering constraints as limitations, Bob regards them as a means for focusing his creativity.

B.A. — In my younger days, wanting desperately to please my clients, I'd do what they wanted. All of a sudden I'd find the painting wasn't as good. It wasn't my painting anymore.

His current project is a hunting dog, a Labrador retriever named Gus, owned by a North Carolina surgeon.

B.A. — The client is familiar with my work, and he likes what I do. After that, it's a matter of communication between the two of us. If the client doesn't have a good idea of the picture he's going to receive, it can be the kiss of death!

Avoiding the Dreaded "Surprise"

Clients usually hate unexpected surprises. To avoid them, the artist stays in close communication with his client. To begin this commission, Bob has several lengthy phone conversations with the owner to determine how he runs his dog and what he is looking for in his painting. Then he arranges a visit. In the field, working with Gus and his client, the artist takes numerous photos of dog, master, setting and action.

B.A. — I want to know whether my client is interested in my showing Gus in a field trial setting, or in a more generalized landscape. I need to know his feelings about the dog.

This owner particularly wants to show the dog's musculature, and requests that Bob use a pose which will emphasize that.

B.A. — A lot of creative thought comes into play at this time. Because Gus is a water dog, I'll show a hint of water in the foreground, some ducks flying off in the background, and perhaps another duck beside him.

Bob selects autumn as the time of year. The greens and golds of the season, the artist feels, will play well against the dark form of the dog, and his intense, yellow eyes.

A Concept, or Two

Developing his concept, Bob begins with dozens of simple pencil sketches on tracing paper. The best of these are photocopied and bound into a loose-leaf presentation book. Marginal comments, which explain the artist's thinking, are added to the pages and the book is sent off to his client.

B.A. — When he has reviewed them, we'll have a pretty extensive phone conference covering every aspect of every sketch before I go forward.

The next step is color sketches. These are miniature versions of the finished painting in oil. Usually I do only one, but this time my client was interested in alternative poses, so I did two.

The completed oil sketches are sent off, and after a second round of conversations, one of the two is approved. It's time to begin the painting.

Reference Photos

The artist took these during his visit to see Gus in person.

Lining in on the Board

Using an opaque projector, Bob projects the approved oil sketch on a 24″ × 30″ sheet of gessoed Masonite hardboard, and pencils in the major elements. Then, referring to his photos and sketches (as well as his extensive background and experience), he draws both subject and setting, developing them as he does so.

B.A. – Just pencil wouldn't show up strongly enough through my initial color layers, so I intensify my finished drawing with India ink.

Sketches

Dozens of quick sketches acquaint Bob with the dog's features and personality. The best of these are sent off to his client for comments and approval.

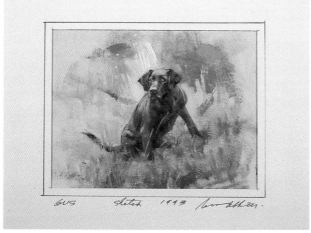

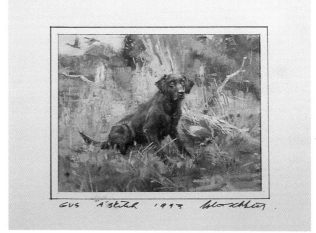

Color Studies

These two studies, rendered in oil on paper, are the last step in the approval process before the actual painting is begun.

Getting into Color

By the time Bob reaches this stage, he's halfway home. The composition has been thoroughly developed, the client knows exactly what he is going to receive, and all that is necessary is to bring the drawing to life in paint.

Keeping his initial oil sketch close at hand, the artist begins laying in a light khaki wash of diluted oil color to establish the tonality of the work.

B.A. —I used to use a flat, solid color for this initial wash-in, but now I tend to follow the general value scheme of the piece. The color might be different for some other painting, but it's right for the feeling here.

Hue and Value Ranges

Next, Bob begins laying in color with both solvent-thinned and opaque washes of oil pigment. At this point, he is interested in establishing value range, and verifying those aspects of composition that seem to change inexplicably when a subject is enlarged.

B.A. —I know some painters like to start at upper left, complete each part of their canvas section by section, and be done by the time they get to lower right. I find I have to bring my painting to finish all together.

Bob prefers to begin with the lightest values in his painting, then establish the darkest values before fully developing background and foreground.

B.A. —I like to have this part of the painting fairly well established before getting into seriously modeling the dog.

Three Nice Words

With values established, the artist now concerns himself with bringing the painting to a successful finish. Background details are further developed, but kept loose and impressionistic, while the most care and attention is lavished, naturally, on Gus.

Even so, detailing of the body is complete, but a heightened concentration of sharp definition is seen within the subject's face, especially his piercing eyes. This, of course, is the approach followed by nearly any professional portraitist.

When he has decided the painting is finished, Bob will take a few days to study it and make any last minute adjustments before signing and taking it to be framed. Finally, he crates and ships the finished painting, and waits to hear from his client.

When I last spoke with Bob, he had just received the call he'd been waiting for.

B.A. —He uttered those magic words: "I'm just ecstatic!" Three of the nicest words an artist can hear.

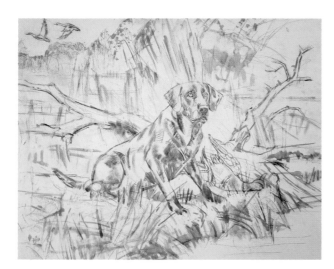

Step 1
Projected on the primed panel, drawn, redrawn and strengthened with India ink, the portrait of Gus is ready to be painted.

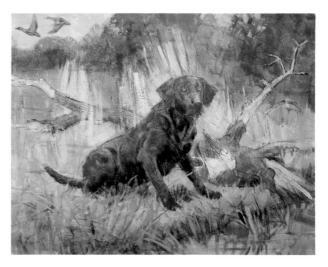

Step 2
At this stage, the values have been washed in with thinned oil paints. Though the painting is still far from finished, it will be developed mainly in terms of detail. Compare this with the finish to see how little the values and basic hues have changed.

Step 3

About 75 percent done, the painting nears completion. From here to the finish, most of Bob's efforts will be directed at refining the modeling of the dog, and adjusting value and color relationships in the background.

Gus
Robert Abbett
Oil on Masonite
24″ × 30″

Finish

Compare the finished painting with its immediate predecessor. Note how the artist decided that the foreground was too dominant, and reduced its value considerably. Note also the way Gus has been developed, with still stronger value contrasts and subtle modeling of the body.

Navajo Buddies
Robert Abbett
Oil on Masonite
18" × 24"

The theme is one that Bob Abbett has always found compelling: how animals interact with humans in the daily lives of both. "It was a cold, dreary day, and both horse and dog were taking defensive positions against the stiff wind."

Intrigued by the horse's well-worn tack, as well as the dog's unique shelter, Bob decided the pair ought to be painted.

The Neighbors II
Robert Abbett
Oil on Masonite
20" × 30"

"I rather wish I had kept this painting for myself," says the artist. He encountered this noisy convention on a farmhouse porch in western Texas, and decided he just *had* to paint it. He even left out an animal or two, thinking no one could possibly believe all of that. "The rather good-looking pointer came out to object to my presence," he adds.

After Lunch
Robert Abbett
Oil on Masonite
9″ × 12″

"The daily routine at Bob Wehle's Elhew Kennels in upstate New York includes lots of play, early training, and, of course, good food," says Bob Abbett. "The effect of all this, plus the warm afternoon sun, was just too much for this pair."

It would have taken a tough-hearted artist not to want to paint them.

Lew Lehrman
Paint a Personal House Portrait

I've always enjoyed painting houses, especially those wonderful old New England and midwestern Victorians. That's why I'm pleased to take on assignments of painting fondly remembered homes. You see, I make it known that I paint "house portraits." For many people, the house portrait I create will be an expression of pride in, and love for, their family home.

Usually, I can visit the house and photograph it from various angles. I used to paint on location, but found that the planning I like to do is best accomplished in the studio.

Frequently, though, I don't get to visit the house at all. It no longer exists, or it's too far away. The only reference I may receive is a handful of old photos, and spoken memories of the place. That's the case this time: Two photos, apparently taken in late autumn, are all I'll have to work with.

Setting a Direction

I take the time to learn about my client's feelings for the house—how he remembers it, the way he'd like it portrayed.

Skimpy reference limits my choice of viewpoints. I try to avoid head-on views; they're invariably flat and lack interest. Fortunately one photo shows detail obscured by the tree in the other, so I begin sketching the three-quarter view.

Preliminaries are an important step. I do want my client to sign off on the sketch, but there is a more important reason: A building's identity is defined through its subtle proportions and the relationships of its many parts. In no instance is this more true than in the Victorian. Just as if I were painting a person, I want to become thoroughly familiar with the personality of this house. That means a good number of sketches will be done before I show one to my client.

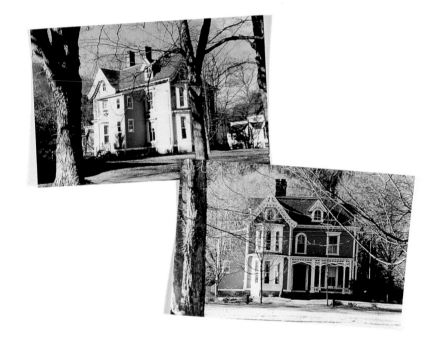

Reference Photos (Above)

My only reference for *Autumn, With Helpers*. Happily, the lighting is from an interesting angle, and what's obscured in one view can be reconstructed from the other.

Sketch (Below)

This is the last of the series of sketches that helps familiarize me with the house. As often happens, my client has asked that I omit neighboring structures visible in his photos.

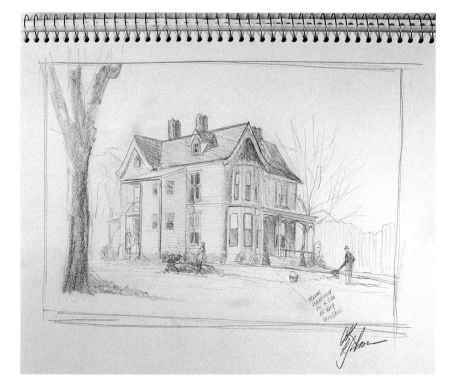

Building the Foundation

Preparing to transfer the approved sketch to a stretched half-sheet of 140-lb. Lanaquarelle hot-press paper, I photocopy and enlarge it to the finished size.

That assembled copy is taped along one edge to the margin of my sheet. Graphite transfer paper is placed beneath it, tracing paper hinged on top. Now, using a 2H pencil and straightedge, I begin transferring the image, correcting plumb lines and perspective as I go, peeking occasionally to make sure I'm pressing hard enough.

Overlays removed, I now use a soft ebony pencil, freehand, to redraw the house over the lightly transferred foundation image. At the same time, I sketch in background and foreground.

It would be nearly impossible to paint around all that gingerbread and millwork, so when the drawing is completed, I stop out all the white architectural details—both sunlit and shadowed—with masking fluid.

The client has asked for an autumn setting, which particularly pleases me. A nostalgic time of year, autumn will be ideal for this subject. The complementary color scheme—oranges against blues—will show the house well. Taking my cue from the photos (it's best not to fight the reference!), I'll paint warm afternoon light slanting in from left rear. Several figures will add life to what otherwise could be a somewhat dead composition.

The Enlarged Sketch

I transfer the photocopied and enlarged sketch to my watercolor paper. The wood border is a stretcher frame of my own making.

Drawing

With the redrawing completed, masking in place, I'm ready to begin background and foreground washes.

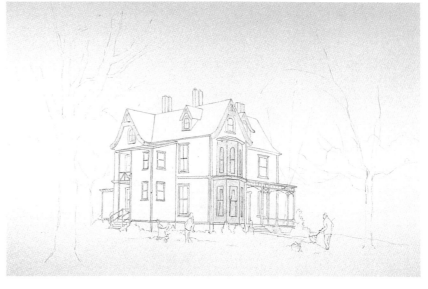

First Washes Set the Stage

I thoroughly wet the areas surrounding the house with water, and lay in a sky wash of manganese blue, cooled at top with a touch of permanent rose, warmed toward the bottom with a little raw sienna.

Keeping that wash quite moist with occasional spray-misting, I lay in background foliage, coaxing the colors to mix and blend. You'll find burnt sienna, brown madder alizarin, raw sienna, raw umber, permanent rose, cadmium orange, and Holbein's composé green no. 3.

I now move on to the foreground, still working quite wet, laying in warm yellow-green. The hue is cooled as it recedes, until I lose its upper edge in the background foliage, blending into shadowed shrubbery forms against the house.

Establishing Value and Color

As I begin the house itself, I particularly appreciate the masking. True, it does have its drawbacks: It's difficult to control, and tends to leave accidental "holidays" and hard edges, but it would take too much care and exactitude to work around all that detail, and I'd invariably overpaint some of it.

I lay in the roof, then both sunlit and shadowed faces of the house. The composition begins to take form.

Take Off the Mask

When the painting is thoroughly — and I mean *thoroughly* — dry, I lift away the masking. Even the slightest dampness now can cause a fatal smear!

For the shadowed sides, a wash of cobalt blue, cooled with brown madder alizarin, further darkens siding and tones the trim.

Before moving on, I wet the right panel of the bay window, lift out most of the shadow tone, and lay in that very important golden backlight.

I continue to build up details: windows, figures, background trees, fallen leaves and so forth, working all over the painting surface, trying hard to avoid stating too much.

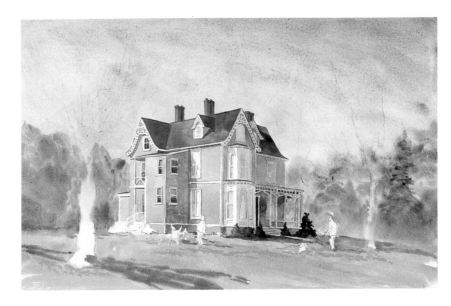

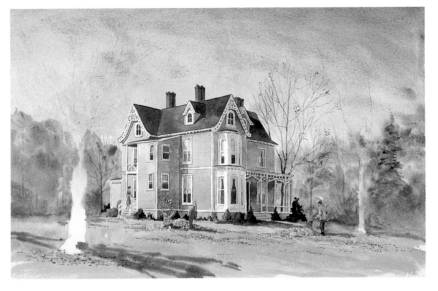

Step 1

After laying in the principal values on the house, I strip away masking, complete shadow tones and begin adding detail.

Step 2

House and surroundings nearly complete, I'm ready to add the two trees. Since they'll overlap the house in places, I want to complete all the details first to avoid working over dark tree washes, which smear easily.

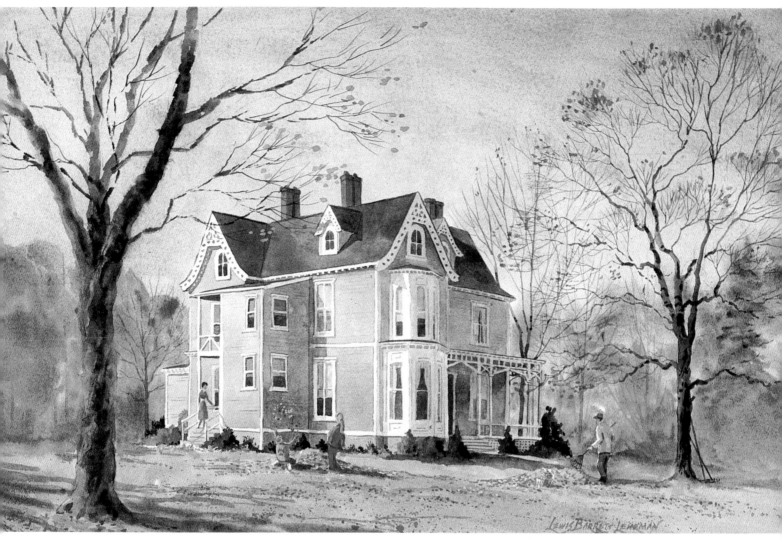

Final Touches

Foreground and middle ground trees are added last. I lay a lot of color into my foreground tree trunk, since it's an entry that I want to be interesting.

As the painting approaches completion, I take a good deal of time studying it and adjusting small details. Opaque white, mixed with color, is used sparingly to correct small errors, straighten lines, repair voids in the masking, and dot sunlit leaves into shadowed background.

When I decide that nothing I do is going to improve it, I sign the painting, place it in a trial mat, and leave it for a few days. When I look again, it will be with a fresh eye, and I can make final adjustments, if any.

A few days later, my client will receive (enthusiastically, I trust) his finished house portrait.

Autumn, With Helpers
Lewis Barrett Lehrman
Watercolor
13½″ × 21″

Finish

The finished painting confirms my decision that the calligraphy of bare branches will frame the house better than masses of leaves in full autumn color. A few last leaves, however, dot the branches.

"The Red House"

The Red House

Lewis Barrett Lehrman
India ink on illustration board
10″ × 21″

Occasionally, a client will prefer pen and ink to watercolor. This lakeside vacation cabin was drawn with a 00-point technical pen and India ink. Requiring much detail and texture, pen-line renderings are more time consuming to create than watercolors, though they do have their own appeal.

House in Jackson, Wyoming

Lewis Barrett Lehrman
Watercolor
13½″ × 21″

The Grand Tetons were brought in closer than they appear in my reference photos. They frame the house and place the subject in a more dramatic context. Clients rarely take exception to this sort of "artistic license."

Ann Manry Kenyon
Develop Expression in a Portrait Commission

I have known Ann Kenyon for several years, ever since taking part in her portraiture workshop at the Scottsdale Artists' School. An intensely busy and dedicated portraitist, she is normally backed up with twenty or more commissions awaiting completion. During the workshop I attended, she demonstrated her technique in oils, watercolor and pastel, each equally well. In exploring the world of portraiture, Ann Manry Kenyon is a natural choice.

Maggie and Anna Lane

This demonstration portrait of two young sisters begins, as do all of Ann Kenyon's commissions, with a visit to her clients—in this instance, a family in Ocala, Florida.

At their home, she meets with the girls' parents, gets to know the children, and then poses them for 150 to 200 photos, in full-figure poses and close-ups of every conceivable kind. In between, she may also do some sketches to capture a particular direction or idea.

Thank Heavens for One-Hour Photo Shops

A stack of freshly developed pictures in hand, artist and client review them.

A.K.—So often, my clients have no idea whatever of the sort of pose or the type of expression they're looking for. Years of family snapshots have conditioned people to want that head-on big smile pose. I explain to them that people are many faceted, and that there are countless other, more appealing expressions that can be developed.

I don't want someone to look at that portrait and think, "Look! She posed for the camera!" I want them to have something that's easy to live with, and that shows a depth and breadth of emotion.

Reviewing the photos, Ann points out the better aspects of different pictures: a hand here, an expression there, a costume detail in another shot. Her client's reactions are a vital part of her input.

When she returns to her studio, Ann and her client both have a very good idea of the approach. Now the real work begins. As the painting develops, the artist keeps the most relevant photos close by. The rest are kept for reference if needed.

When she began portraiture, Ann Kenyon did all her portraits on location, from life. It was a grueling way to approach the profession, though wonderful discipline, no doubt, for developing speed and accuracy under pressure. Today, almost all of her work is based on photo sessions like those described here.

Reference Photos

Four of the two hundred or so pictures Ann Kenyon has taken for this commission: from left to right, the pose their mother likes best; the pose the artist has selected for the younger child; the pose selected as reference for the feet; and the photo chosen for facial expressions. In the course of the painting, the artist will refer to these and dozens of other photos she keeps at hand, to verify and refine details.

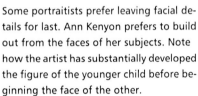

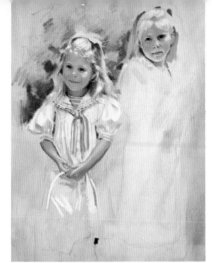
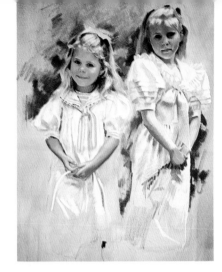

Some portraitists prefer leaving facial details for last. Ann Kenyon prefers to build out from the faces of her subjects. Note how the artist has substantially developed the figure of the younger child before beginning the face of the other.

Working Without a Net

That initial photo selection and discussion has traditionally been all that Ann's clients see until they receive the finished portrait.

A.K.—I am beginning to change that, though. I'm beginning to send my clients a fairly finished oil study, before I do the final painting. That way, they can see my direction, and the finished piece doesn't come as such a shock. Besides, there are so many ways to approach these beautiful subjects, I might want to show them more than one.

I ask Ann whether she often has to make changes to a finished portrait.

A.K.—Happily, not often, but I tell my clients, "Don't hesitate at all to call me with your feedback." Most often I have a really happy client—sometimes even to the point of tears.

The completed portrait of Maggie and Anna Lane was, incidentally, enthusiastically received by the family.

Maggie and Anna Lane
Ann Manry Kenyon
Pastel on pastel cloth
40″ × 30″

Lesson One

Apropos that old show business adage, "Never share the stage with a child or a dog," Ann Kenyon shows me her portrait of Paula Baker (below). Originally Baker had asked that her dog be featured in the painting, ears up, alert, looking straight out of the picture.

That was how the artist painted it, only to realize that it split the center of interest into two visually unrelated elements. The painting just didn't work!

A.K. – You couldn't decide where to look first! I phoned long distance and convinced her to let me show the dog curled up on the chair. She agreed, and that resolved the problem.

Molly
Ann Manry Kenyon
Oil on Belgian linen canvas
40" × 30"

In painting this sensitive portrait of a young girl, Ann Kenyon used not only her ample photographic reference, but also her own creative resources, to enhance the charm and appeal of her subject.

Paula
Ann Manry Kenyon
Oil on Belgian linen canvas
50" × 50"

Chapter Nine

Allowing Yourself to Do Something Different

Sometimes it seems that all our lives in art, we're being told what to do and what not to do: rules of perspective, rules of composition, rules about what's acceptable and what's not. "Don't be different just for the sake of being different," we're told. "It has to look like what you're painting" is so often the message.

Miles Batt could be thought of as the perfect antithesis of that kind of thinking. He's watercolor's strongest proponent of ignoring the nay-sayers, improvising, breaking whatever rules you want to and having fun!

"Most 'value-painters' tend to copy the world the way it is," says Miles. "Now, if you throw all that out the window, you discover that color and shape, by themselves, are entities. This discovery opens up a whole new theater of activity. Suddenly you see that color and shape are all that's *really* on the paper. Your painting is no longer trying to replicate something.

"If you're not going to paint values," he continues, "what then? Invent pattern, invent color, invent texture, so everything takes on a life of its own! Discover! Invent! Create your own world with a different kind of ordering process than when you merely replicate what you see."

Miles Batt
Paint One Scene Five Ways

The world of Florida watercolorist Miles Batt is unlike any you've ever experienced. As prolific in his work as he is articulate in describing his approach, Miles has drawn a broad circle of afficionados and collectors, not to mention students and readers of his self-published book, *The Complete Guide to Creative Watercolor*, which outlines his methods.

M.B. — Artists who wish merely to replicate what they see, and are happy with the results, are probably more in tune with the nineteenth century than today. They're not thinking beyond the obvious, which is just the first rung of the ladder. A lot of artists are at that point and will stay there forever, but to me that's just not creative.

Whether you agree with his viewpoint, there is no denying Miles's convincing reasoning as he encourages his students to redefine reality and explore new possibilities.

To illustrate his approach, Miles invited me to examine a series of Carmel Mission paintings. The series grew out of a teaching engagement at Carmel Mission, along the Pacific Coast, where he had to produce a demonstration painting of the same scene for a different group of students each of five workshop days.

Carmel Mission is a popular subject, which no doubt has been painted countless times by thousands of artists. Miles himself had painted the scene a few years previously.

Monday morning. Right off the bat (no pun intended), one can see that this will be no "usual" demonstration.

M.B. — There are only two reasons to sketch: to collect information and to compose on location. Many people have no idea what they're supposed to be doing, so they try to sketch reality as they see it. Then they wonder why they can't make that sketch into a painting. It's because they have not articulated an idea. Lots of ideas feel permissible when you're on the spot but don't feel rational later on. I start tearing apart and rearranging elements, imagining that I'm flying over the place — whatever suits my fancy. You have to give yourself permission to do this sort of thing. As an instructor, that's what I try to do.

The artist's Monday demonstration produces an exuberant, colorful interpretation not tied in any way to ordinary reality.

Tuesday morning. Miles tries a second approach. He sketches a grid that he plans to paint around, leaving the lines of the grid more or less unpainted.

M.B. — Many watercolorists avoid making a real painting by doing linear work instead. Here I'm utilizing the lines, painting around them, yet trying not to be too careful. Breaking the lines is important. It keeps your eye from being restricted within an area, allowing you to move through the painting in a fluid fashion.

This painting, with almost the character of a stained glass window, is the result of Tuesday's effort.

Reference Photo

Carmel Mission — the locale of Miles Batt's workshop, and arguably "motif number one" of the West Coast.

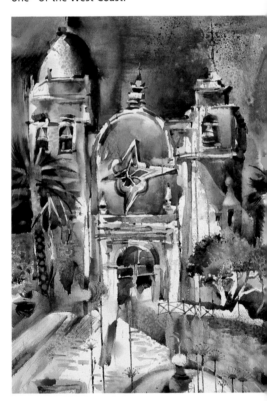

Value Painting

This was done by the artist several years previously, in muted colors based (as he puts it) on dirty primaries: Venetian red, raw sienna, and neutral tint substituting for blue.

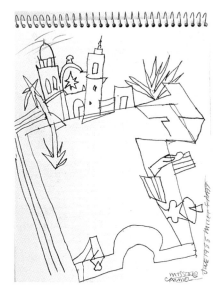

Monday

Sketching on location, Miles creates this drawing, a freely interpreted aerial view of the mission.

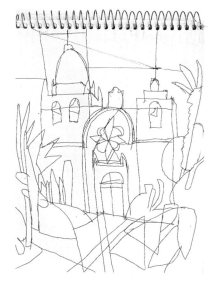

Tuesday

The demonstration begins with what the artist refers to as a "linear grid visualization."

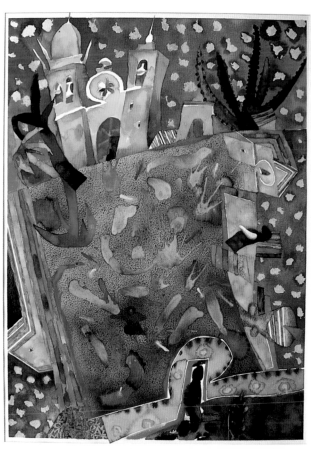

Sea la Alma (Be the Soul)
Miles Batt
Watercolor
29″ × 21″

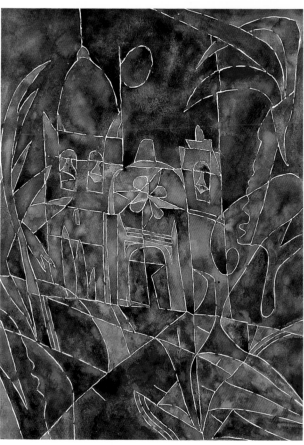

Dark Mission
Miles Batt
Watercolor
29″ × 21″

Wednesday morning finds the artist composing on-site once again. His sketch is looser, more fluid, completely different from its predecessors.

M.B. — In my sketches, in my visualizing, I am also reducing, exploring, looking for different ideas. The process of reduction might begin with something fairly realistic. Then I reduce and reduce, pulling out detail, elements — anything that just isn't needed.

The exuberant quality of the sketch carries through to Wednesday's finished painting.

Thursday, at it again with his fourth group, Miles sketches yet another completely different interpretation of the mission.

M.B. — A subject like Carmel Mission is pretty commonplace. Corny even. Each day, I tell my students that I will refuse to critique their paintings if they give me what I call a "generic" watercolor. That way, I've given them "permission" to do something very original.

Friday's starting point. Today's sketch is no less fresh and creative than the preceding four, and amazingly unlike any of them.

M.B. — Quite often, in one of these sessions, I'll ask five or six of my students to come up and, with brush and watercolor, make a random mark on my blank paper. Then I demonstrate how these elements can be incorporated into the finished painting.

That's one way I prove that it is not necessary to replicate what you see before you to create a successful painting.

As with many of my paintings, this one may be turned upside-down, to realize that the subject matter also works that way. You'll find the garden included there, inverted.

Miles Batt's way of working is plainly not for everyone. (If it were, you can be sure he'd have gone off in a totally different direction!) His message, however, of free, unbridled creativity is one that deserves close attention.

M.B. — Getting away from what you think of as the real world — that's a big hurdle. Conventional realism is a habit that results in

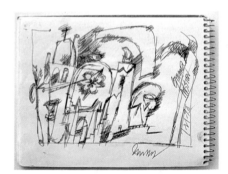

Wednesday (Left)

This sketch demonstrates the artist's complete freedom, as he takes off in a wholly different direction.

Thursday (Right)

The taking-off point is still another interpretation of the *Mission*, this time incorporating the walls of its famous gardens.

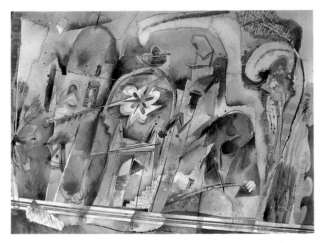

Mission '90
Miles Batt
Watercolor
21" × 29"

Mission, Mission
Miles Batt
Watercolor
21" × 29"

Brilliant colors vibrate out of a field of neutral tones in Thursday's version of the scene.

generic painting, which makes it very hard to differentiate yourself from everyone else.

When I'm teaching, while I give my students "permission" to be different for the sake of difference, I emphasize the underlying discipline of color, composition and value as well.

What's the reason for all this? It's my not-so-subtle way of getting fellow artists to understand what everyone else has been trying to tell you:

Whatever is different or unique about you is what is good about you. Express yourself in your painting!

Friday

One of several sketches the artist has done on-site for a fifth painting.

Carmelized Garden
Miles Batt
Watercolor
29" × 21"

Friday's painting was a recent award winner in the Florida Watercolor Society exhibition—as fresh and creative an interpretation of his subject as his preceding efforts.

Charles Sovek
Discover a New Approach to Color

I got to know Charles Sovek, an accomplished impressionistic oil painter, while working on *Being An Artist*. You may also know him from his several books.

Charlie and I got together one day while he was in town leading a workshop at the Scottsdale Artists' School. Over lunch, as I quizzed him about his approach to creative challenge, he told me about his own personal quest for new inspiration, new insights, new approaches to color and light. Here are his thoughts.

I didn't ask to be taken out of the rut I wasn't even aware I was in. After thirty-some years of being an artist, my painting seemed to be going well, and all I needed to do was continue working hard, keep an open mind, and start reaping some of the rewards of having finally learned how to paint.

But that was last year, before a student who just returned from California, brought in a book, *The Society of Six: California Colorists* (Nancy Boas, Bedford Arts Publishers, San Francisco, 1988). It discussed the art history of the area and some of the characters involved in it.

I found myself hypnotized by their remarkably colorful paintings, and spent two days poring over the text and illustrations. Then I phoned the Museum of Modern Art in San Francisco and ordered my own copy.

Thus began my odyssey.

I Prefer Tone Over Color . . . or Do I?

I read and reread the book, underlining passages and filling the margins with notes. I began questioning my basic beliefs as painter and teacher. I had always striven for vital, pulsating color, so why was I so obsessed with value? Was my early training as an illustrator (where

Brushes in Pot
Charles Sovek
Oil on wood
6″ × 8″

tonal strength is the name of the game) getting in the way? What about my super heroes: Corot, Sargent and Homer? What about the love for light which had kept me from completely losing my desire to build my painting style on color?

How had I missed these California colorists when I was back in art school in Southern California in the late fifties? Had I been too young? Was it the tunnel vision of being too involved with coming up with show-stopping illustration assignments? Or had I simply been too unsure of myself to follow the subtle tuggings of curiosity experi-

enced during occasional outdoor painting escapes? I had spent four years in "colorist heaven" without ever really knowing it!

Now, exposed to a quality of color that glistened with more life than I'd thought possible, I knew I'd have to learn more about the "Society of Six," its origins and its influences.

The Big Risk!

Collecting dozens of books on everything from California plein air painting to the Bay Area figurative school of the 1950s, I read, doodled and pondered. No longer was it a matter of thinking about new ways of approaching color, but how to go about doing it.

Up to now, my palette had consisted of about two dozen colors. Half were light blends of darker hues (primaries and secondaries, a warm and a cool variant of each). I would premix and put the colors into tubes, because I wanted complete control of both value and color. It had worked for me. I felt *very* apprehensive about changing that, let alone dropping the whole idea. Now, however, I had discovered the common denominator for nearly every one of these wonderful colorists: a simplified palette.

I cut down to seven colors: Thalo red rose, cadmium red light, cadmium yellow medium, cadmium yellow pale, French ultramarine, white, and a three-part viridian/one-part phthalo green concoction I prefer to store-bought viridian. Now it was time to start making pictures!

Feeling as if I were starting back at the beginning, I painted a small still life, *Brushes in Pot*—my first try at expressing myself in purely coloristic terms. The hues were overstated, I decided, and the execution a bit oversimplified, but when I compared this first effort with other finished works in my studio, it jumped right off the wall! I was off and running.

California Revisited

Determined to redirect my energies toward color rather than tone, I went to San Francisco to paint at some of the same locations the Society of Six and others of that period had preferred. Sadly, many of the motifs no longer existed, but I saw enough to inspire me to put down some of the best color of my life.

Revisiting California was a big event for me, as symbolic as the whirl of my own artistic renewal. Southern California was responsible for my becoming an artist, and yet I had never really known it. Could I, perhaps, salvage some of my early uncluttered innocence? Could I face the difficult questions I was asking today?

Feeling like a student, I walked, notebook in hand, through the Oakland Museum, the San Francisco Museum of Modern Art, and the Bedford Museum at Walnut Creek, seeing for the first time originals of the reproductions that had caused such a stir within me.

Finally, ready to paint, I decided to tackle *Oakland Estuary*, a popular Society of Six motif. Well, it got a little overworked, a trifle busy; still, the color carried the day, turning what could have been a mediocre paint sketch into a sparkly little portrait of sunshine on a harbor.

With increasing confidence and a new feeling of relaxation, I decided to try a San Francisco street scene. *View of Hyde Street* was my most ambitious piece yet. Rich color, gutsy treatment and a fun composition. I seemed to be hitting my stride!

All in all, I painted over a dozen pictures around the Bay area, and came home feeling like I'd just graduated from art school.

Keeping my emphasis on color, I found the lessons were sinking in. My old self-consciousness was gradually being replaced with a new naturalness. I found that putting color on canvas was again becoming the pleasurable experience it had been—before I learned so much.

Oakland Estuary
Charles Sovek
Oil on canvas
9″ × 12″

Putting It to the Test

A painting and teaching trip to New Mexico a few months later put my new approach to the test: Could I still be as uninhibited painting in the company of other artists as I was painting alone?

Taking a hint from the Society of Six, I supplemented my usual supply of 12″ × 16″ panels with a number of 6″ × 8″ panels. I ended up doing eight of those. One of them is *Erica's Laundry*. A simple, yet colorful vignette of ranch life, it took less than an hour. *Las Trampas Church*, a larger piece, took on a quality I never could have achieved with my previous tonal methods.

Erica's Laundry (Below)
Charles Sovek
Oil on wood
6″ × 8″

View of Hyde Street (Right)
Charles Sovek
Oil on canvas
12″ × 12″

Las Trampas Church
Charles Sovek
Oil on canvas
12″ × 12″

Coming Full Circle

East Norwalk Harbor, the final painting of this series, is pretty much the way I'm painting these days, now that I'm back home in Connecticut. (The paintings that appear on pages 114 and 115 were done after Sovek's return from New Mexico.) Six months ago, I'd never have dreamed of pushing pigment around like this.

But who knows? Perhaps in a month or a year from now, another student or friend will slip me a book, and I'll be off again on some odyssey I can't even imagine today!

East Norwalk Harbor
Charles Sovek
Oil on canvas
8″ × 10″

Galisteo Winter
Charles Sovek
Oil on canvas
12" × 15"

A momentary effect of the sunlight dramatically displayed this yellow church against the cooler colors of the sky and distant hills. With only moments to snare the mood before the light changed, the artist quickly and boldly established his key colors and tones. Minutes later, the light had shifted, yet he was able to complete this painting from the vivid memory of first seeing it.

Idea Starter
Switch Media

Few activities will motivate you to reevaluate your approach more than tackling a new medium. Everything you've been used to doing "on autopilot" must be thought out from scratch.

Switching media doesn't mean you have to buy a whole new outfit (though it might make a dandy excuse to do so). Grab a pencil, or a charcoal stick, and your old newsprint pad. Start sketching—anything. Experimenting and problem solving in a new medium will put thought processes back in motion and will eventually carry over to revitalize your old favorite.

Beached Lobster Boat
Charles Sovek
Oil on canvas
13″ × 16″

After a day of painting on the beach, Charles was preparing to leave when he noticed how the receding tide had altered the scene. This salty old boat was now nobly perched on the damp sand, evoking a quality that, earlier, had been absent.

Still Life With Fruit
Charles Sovek
Oil on board
12″ × 18″

The moment the artist saw the razzle-dazzle effect of the red slices of watermelon on the white tablecloth, he knew he had a winner. Note the way the crisp light and shadow patterns are accentuated by hard-edged shapes throughout the painting.

James Christensen

Turn Your Imagination to the World of Fantasy

While many artists strive to make a scene believable, no such criteria limits the fantasy painter. Here, the imagination can—indeed, must—run free, and believability takes on a whole new dimension.

The leap of imagination—that impossible "what-if" made visible—has existed in paint for centuries. You can trace fantasy through the allegorical paintings of the northern Renaissance, see it in the fanciful figures surrounding Catherine de Medici in Rubens' famous painting, and in the nightmarish visions of Hieronymus Bosch. You'll find fantasy in the dark paintings of Francisco de Goya, and works of the nineteenth century English "Faerie" painters.

Active in our own century (see *Hide and Seek*, by Pavel Tchelitchew, 1942), the genre experienced its own offshoot, the surrealists, before beginning to coalesce as a full-fledged movement in its own right. Today's practitioners of fantasy art may work comfortably with paint, print, animation, film and video.

What makes fantasy art so intriguing? Is it a desire to escape the commonplace reality? Is it the emotional response, both conscious and unconscious, of the viewer? Is it the thrill of discovery of an alternate world, or that intimate view into the artist's mind? Certainly, few genres involve the viewer as powerfully as the world within a successful fantasy painting.

What makes fantasy art work? Imagination, of course, careful draftsmanship that brings the fantasy to life, a touch of humor perhaps, plus careful attention to such traditional concerns as composition and color.

If the thought of fantasy painting intrigues you, try exploring this intriguing world. You might begin with a "what-if": *What if people looked like chickens, and vice versa? What if pigs had wings? What if the law of gravity were suddenly repealed?* Try starting with a pun: *"Lead us not into Penn Station,"* or a phrase: *"The walls have ears."* Your point of departure might be a remembered dream, or something you've overheard, or just some random, absurd thought.

Though imagination is clearly the key going in as well as coming out, remember not to shortchange your attention to technique: It's what will make believable the fantasy world you create.

On the following pages, James C. Christensen, internationally known for his fantasy art, embarks on *Voyage of the Basset*. Watch his creative processes in action, and see how one of his fantasies is conceived and executed.

Begin With a Premise

J.C.—This painting was a "what-if." I had seen a miniseries on television about Charles Darwin and the voyage of The H.M.S. Beagle *around South America and the Galapagos Islands. Darwin was the naturalist onboard. It just occurred to me, as I watched, that he'd missed a lot of the best creatures, like mermaids and griffins.*

I began wondering, "What if somebody else had sailed in the other direction and seen all the critters that Darwin missed?" That was the beginning of it.

Sketches

The artist developed many sketches to consolidate the details of a single element. He has no idea, yet, just where it will fit into the painting.

Voyage of the Basset
James C. Christensen
Acrylic
48" × 36"
©1992 The Greenwich Workshop, Inc.
Reproduced with the permission of The
Greenwich Workshop, Inc.

Research, Development and Imagination

From there, it was a matter of research into all those wonderful creatures of mythology, finding resources to make the animals real for the painting.

J.C.—I have a huge library of things I can refer to: photos of places I've been, architecture, textural stuff, old walls, trees . . . and I read a lot. I start with ideas of elements I can put into a piece, let them percolate in my brain, and find that they come out a little differently than they went in.

Eventually, the dozens of individual elements that Jim has researched and drawn come together in a master sketch. It's not a finished concept, but a map of where things will go, and a chance for Jim to see what the finished painting might look like.

As the concept progresses, the artist has also prepared a Masonite panel for the painting, using four coats of acrylic gesso. With a general feeling for the tonality of the piece, he tints his prepared surface with colored acrylic washes.

J.C.—Now the master sketch is photo-enlarged to the scale I will paint, then transfered to my prepared panel with white Saral transfer paper.

Roughing in Forms and Elements

The image in place, Jim begins laying in the basic forms and color, not trying to develop the images too far, primarily establishing a pattern for color and value. This helps him see the compositional flow of the painting before he gets caught up in its detail.

Model

Jim likes to get things just right, and will often photograph a model and work from prints. You'll have no problem finding this young woman in the finished painting.

Master Sketch

This is done on tracing paper, consolidating many of the individual elements he has developed, to make a cohesive composition that fits his overall vision of the piece.

A Patchwork of Enlarged Photocopies

The master sketch is prepared for transfer to the primed, tinted Masonite board.

Early Noodling

J.C. – Because these paintings take so long to do, I have to keep myself interested. After I rough in elements for a day or two, I go back and "noodle," or detail, a section, before doing any more rough-in. Seeing the figures start to take shape is the most exciting part of the process for me.

It also helps him make placement decisions for elements not yet planned for. Those unplanned elements suggest themselves throughout the course of the painting process, Jim tells me, and he has learned to allow for them.

J.C. – I don't have the end in view when I start. Just the concept. There will be a blank area next to a finished one, with a kind of sign on it that says, "Some little something goes here, but I don't know what it is yet." I never have trouble filling them.

Getting It Right

After he has laid in all the elements, Jim goes back and begins bringing each character and element to finish. This is where the bulk of his time is spent. Interestingly, depending on subject matter, he may switch from acrylic to oils for this finishing stage.

J.C. – About three-fourths of the way through, I may go over my acrylic with a layer of Liquin or painting medium, and finish the painting with oils, doing all my final noodling in oil.

He particularly values acrylics for their ease in glazing colors, as well as the speed with which the medium dries, so he can work over things quickly. On the other hand, oils have their own virtues, helping him lose edges, and control color and detail precisely. (As it happens, though, *Voyage of the Basset* will be completed entirely with acrylics.)

Is It Done Yet?

J.C. – For me, the most difficult moment in the creation of a painting is deciding when it's done.

At the same time, he's aware that, having lived with the piece for so long, he really can no longer view it objectively. Years of experience have taught him to do the next best thing: Get some fresh input from trusted artist friends, his wife, and whomever he can drag to his studio.

J.C. – Finally, I have to let it go.

I've learned that when I come back to a major work after not seeing it for six months, I usually can't find those little things that bothered me so much when I was trying to finish it.

A final note: *Voyage of the Basset* was chosen as the subject of a print by Greenwich Workshop, and now the mythical voyage itself will be fully recounted in a book containing some eighty James Christensen paintings to be completed over the next two years. Publication is scheduled for 1995.

Early Stage

Here the basic forms are being roughed in. Note how the toned background helps the artist maintain color and value relationships even at this early stage.

Detail

Voyage of the Basset. The acrylic underpainting has now been overlaid with finishing details.

Sometimes the Spirit Touches Us Through Our Weaknesses
©1992 James C. Christensen
Mixed media
16" × 12"

The hunchback serves as a symbol for everyman. Each of us has a hump of some kind to carry. Says the artist, "Sometimes it's because of these afflictions that we find our strength and our magic. The idea is not to look at adversity as 'Why me?' but instead, as 'By overcoming this I will become a stronger person.'"

Once Upon a Time
James C. Christensen
Mixed media
36" × 48"
©1991 The Greenwich Workshop, Inc. Reproduced with the permission of The Greenwich Workshop, Inc.

The painting was commissioned as a poster for a Utah storytelling festival. The artist had to decide how to convey that enchanting art as an interesting, magical image. Why not, he thought, conjure up a Celtic bard, and have him sit in the forest, telling stories to the characters from the stories themselves?

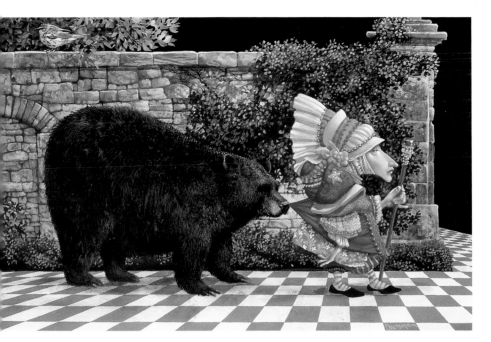

Lawrence Pretended Not to Notice That a Bear Had Become Attached to His Coattails
James C. Christensen
Acrylic
12″ × 16″
©1991 The Greenwich Workshop, Inc. Reproduced with the permission of The Greenwich Workshop, Inc.

The artist explains: "A few years ago, when pondering life's questions, I realized that I was avoiding some problems in my own life by pretending they weren't there. The thought came out as this painting, in which I was looking at myself."

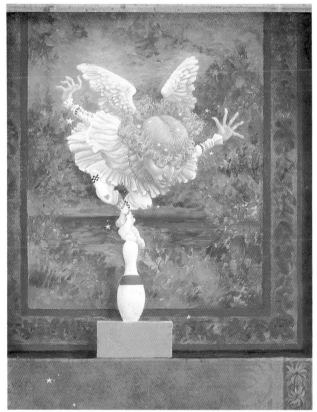

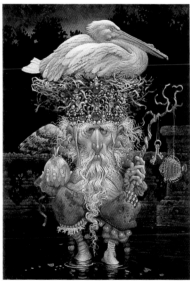

The Pelican King I
James C. Christensen
Acrylic
14″ × 10″
©1991 The Greenwich Workshop, Inc. Reproduced with the permission of The Greenwich Workshop, Inc.

The image of this mysterious little man occurred to the artist fairly quickly. He painted the figure, a pelican atop his head, his mitre an onion, his scepter unraveling, and left him there, unexplained. Some people regard the figure as an old, redundant, neglected person. All the artist will say, though, is that he had more respect for his little personage than that. When asked, Jim just shrugs and answers, "If I could explain my images, I'd be a writer, not a painter."

How Many Angels Can Dance on the Head of a Pin?
©1992 James C. Christensen
Oil
16″ × 12″

A crazy visual pun is the genesis of this wonderful painting—a play on images and words. The old ecclesiastical question that has confounded theologians for centuries is answered by the artist, who posits a somewhat clunky angel precariously on a rather different pin than the philosophers had ever proposed.

What Do I Paint Next?

Four Artists Talk About Staying Fresh and Creative

Competition included the last night of the basketball play-offs and the final episode of "Cheers," but judging from the turnout, the topic of the panel discussion, "What Do I Paint Next?" was uppermost in the minds of many artists on that warm May evening.

Sponsored by the Scottsdale Artists' School, the discussion took place at The Scottsdale Center for the Arts. Four talented artists, all of whom approach their profession from very different angles, shared their views on how an artist can stay (or become) fresh and creative:

Ed Mell, well known and highly successful Arizona oil painter, whose distinctive, bold, semi-abstract style is instantly recognizable to southwestern art lovers.

Diane Maxey, popular water-colorist and teacher. Her radiant and creative florals are much in demand wherever she shows. (Her demonstration paintings appear on pages 51-55 and pages 81-84 in this book.)

Louise McCall, artist in a wide variety of media and styles, and muralist (together with her husband, noted space artist Robert McCall) whose works appear in the Air and Space Museum in Washington, D.C., and in Houston, Florida and elsewhere.

Dick Phillips, watercolorist and teacher of watercolor, whose work in recent years has taken a sharp turn to the abstract. (His demonstration painting begins on page 42 in this book.)

Following is an edited transcript of the evening's discussion. I began with a specific question for each of the panelists.

L.L. — Diane Maxey, you are so prolific in your work, and you always seem to be exploring new areas and new means of expression. How do you sustain your creative intensity?

D.M. — I've chosen to be a floral painter, and because there is so much out there, I'm always inundated with the color and the shape of all the subject matter that's available to me.

I used to have a bad habit of allowing life to creep in every so often. I used to be able to blame my children for my not painting, but not anymore. Now I try to paint every day. That's the real secret: to paint every day.

L.L. — Dick Phillips, can you tell us about your monumental change to abstract design and how it relates to our topic tonight?

D.P. — I'm not sure how it started, but in the late seventies I was losing excitement with what I was doing in watercolor. I began searching for other possibilities, other media. I combined media,

The panelists and myself: Dick Phillips stands at left, behind Diane Maxey. To the right, Louise McCall and Ed Mell.

Photo by Bob McCall

tried collage, did a little bit of everything. I followed many dead-end routes trying to find direction.

An artist will understand this: I didn't know what I wanted out of my work during that time, but I felt that I would know it when I saw it. It was a very difficult process for me, which is not unusual when making a drastic change like that, but that wasn't the hardest part.

Early on, I found I couldn't continue doing both my watercolors, which were figurative, and my exploratory work, which was purely abstract. I discovered that I wasn't being taken seriously by those people interested in more abstract things, and I had lost credibility with those folks who liked the more realistic works. Very quickly, my market—the people who might spend money on my work—simply evaporated. I was not accepted in either camp! It was very traumatic, and it took a long time—I'm talking about six or seven years—before my new style achieved any consistency and acceptance.

I was extremely fortunate to have a gallery owner who saw me through this very difficult time when my one-man shows looked as if six or seven people had worked on them.

I'd like to think that if it came time now to move on to something else, I'd have the guts to do it, but I'm not sure.

L.L.—Louise McCall, your work encompasses so many media, so many different directions, how do you sustain creativity across this broad field without losing focus?

L.M.—First of all, I don't paint to please anyone but myself. I'm very temperamental about that. My paintings are really kind of a personal diary of my life—a response to places, beauty, feelings and events, and I react to my experiences this way. It's always been my therapy, my passion. Fortunately I

live with an artist, so there's always this creative high going on. Lots of creative people coming and going.

How do I stay fresh and creative? I'm not a very disciplined painter. I don't paint every day. I'm sort of like the moon. I go through a period where I'm on a roll. Then I go through a period where I do all the non-art things we all have to do. But I'm not wasting a single minute. I'm gathering all the time, experiencing all the time, putting all my impressions and observations into the basket of my psyche, my soul, my heart. That artist part of me is always on the lookout for beauty. And when I see it, I store it away, and think about it at odd times.

When I'm finally ready to paint, something beautiful will trigger it. Then off I go! I start painting, and one leads to another, and another and another.

L.L.—Ed Mell, your style is probably as well-defined and distinctive as any in the galleries today, and I know you're loaded with commissions and commitments. How do you sustain creativity within the limits of your tightly defined style?

E.M.—To answer, I'll go back to its origins. I was a commercial illustrator in New York. Realistic stuff. Always doing something for someone else. Then I got a summer teaching job on a Hopi reservation in Arizona. All of a sudden, I found myself in this great landscape, with these wonderful people, and it triggered something in me. I wanted to express my feelings about the landscape, and the strength of it, and that's where my angularity came from—the power in the geometry of the landscape.

My early painting style was very minimal, very angular, but the more I painted landscape, the less concerned I became with style and the more I found myself concerned with substance. My work has

evolved since then, and I've branched out into florals and bronze sculpture, but I find myself returning now to my earlier angularity and abstract feeling. It's mixing things up that keeps me fresh. I have more ideas in each of my areas than I can get around to doing.

L.L.—A question for all of my panelists: Do you ever get creatively blocked? What would you suggest an artist do when that happens?

L.M.—Just drop it. Walk away. Change the scenery. Go find something lovely to look at. Invite a friend over. Take a trip. But stop. Don't push hard. Because it shows in your work—at least it does in mine. It has to be spontaneous, has to come from spirit, has to be a re-

Idea Starter
Do Some "Art" Every Day

OK. So you can't paint every day. Few of us can. And the longer we're forced to stay away from the easel, the less we feel like real artists. But if you resolve to do something that's art-related every day, you'll feel much better about the time you *can't* spend painting.

What can you do? Read an art magazine. Clean your brushes. Organize your workspace. Call a fellow artist. Spend five minutes in a gallery. Do a quick sketch: a face on the train, your shoe, the anchor person on the nightly news, anything! Don't go looking for your sketchbook. Draw on any handy scrap of paper—even the margin of your newspaper.

sponse to life. If I push hard when I'm feeling blocked, then the work is dull. It's no good.

Another thing: I'll go to the museum and look at art. I'll read about an artist. I'll listen to music, do things that stimulate my senses. That's what I do.

D.M. — My block doesn't stop me when I'm in the studio, it's when I'm *going* to the studio. Just getting away from the kitchen or the vacuum cleaner can be a block. Sometimes, even if I make it to the studio, I let the world come in there, and I have to find ways to shove it back out.

The world is constantly pulling me away. It might be another child, another project, another flower bed I want to dig. I just have to leave all that behind, and walk into the studio with no goal in mind. Just those elements I have there: the brush, the paper and the pigments. Leave everything else behind.

E.M. — Sometimes I just lack enthusiasm. I think, "Nah, I don't want to work." Just recently, I came off a two-year schedule of solid work. Very productive. I found that I just didn't want to paint. I was burned out.

My solution? I took a month off. Did some traveling. Painted very little. I let everything wait. I had the gallery people tell my clients I was ill. That's all right. I know they'll get a better painting when they do get it.

D.P. — I'm a painter. I paint. It's what I do. And I paint whether I feel like it or not. I don't get away, though I probably should at times, but I do have my breaks. I do some teaching, some other things when I'm in the studio every day, that give me relief. I just keep going, whether I like what I'm doing or not. It's as simple as that.

L.L. — *Speaking of the intrusions and imperatives of life, can you outline ways an artist can*

maintain freshness and creativity in spite of them?

D.P. — It has been my experience that you only stay fresh when you're trying to push the outer edge of what you're capable of doing — not simply relying on past successes and things you know will work. I think that when you do that, you begin to lose the zest and the creativity. I'd say, push yourself, and risk a little more, and don't expect a successful painting every time.

Happiness
Louise McCall
Acrylic on canvas
52″ × 38″

A spontaneous expression of the artist's emotions, this painting was purchased by a Saudi prince, who fell in love with its exuberant feeling.

D.M. – Go look for something new, something you haven't seen before. Take a paper viewfinder, or a camera, or just your own eyes. Go out and look around you. Sit down in the dirt and draw a square. Write down every color you see in it. Go look at the shape of a leaf or a blossom with the sun coming through it, or with the sun shining on it. Then try to express what you see, what you feel.

Oftentimes, the excitement of what I see, that I carry back to the studio, is not what I end up painting. What is important is that excitement of something new.

L.M. – Because I paint my feelings, I try to stay aware of them. I'm always looking for exciting juxtapositions of form and light and shadow. That goes on all the time. It's exciting, and I'm never bored, because my mind is always focused on the beauty in life.

I don't do anything in my art world that's systematic. I respond to something, and I paint it. Then if I connect with my subject matter,

when someone looks at it, they'll connect too.

My recommendation would be to change your scenery, stay alert to your surroundings, be aware of your feelings and respond to them, and keep your mind's eye open to all the color and excitement in the world.

E.M. – You've got to make yourself excited about what you're doing. If you were born to be an artist, you'll stay turned on, you'll find ways to keep yourself pumped up about it. I went through a period when all I was painting were landscapes. Then I started painting flowers. When I went back to landscapes, I brought with me the new color sense, the new intensity of the florals I had been doing. So for me, the two fed on each other, both consciously and unconsciously. Mixing the two was my way of staying excited about what I was doing.

D.P. – Let me add a footnote here. I think there's a misconception among many people that the artist's inspiration comes from

some outer source, that somehow he's charged with this celestial vision to do something.

The fact is, for everyone I know, inspiration tends to come from within—from the act of drawing, sculpting or painting.

Just executing the craft of painting is not all that exciting. When you can get that sense of excitement going is when it begins to become more creative. That's what you're after: the special high that comes when everything seems to work, and the painting seems to fall off your brush. It happens enough to keep you going through the rough spots.

D.M. – Going along with what Dick said, I think it's the memory of that special high that draws you back to the studio whenever you hit one of those dead periods. It's important to know you've done it before, and you can do it again.

L.M. – Creating art should be joy. It is hard work, but I'm speaking of the joy you reach when you get there. Keeping alive the child in-

Japanese Garden
Dick Phillips
Watercolor
21" × 29"
Collection of Multi-Com Systems, Rancho Mirage, California

Though done over a decade ago, this painting still ranks as one of the artist's favorites. As with most of his watercolors, no preliminary drawing was done. The painting was simply started with washes forming random, abstract shapes and patterns on the paper. Colors were selected without concern for subject matter, and the shapes and colors were allowed to suggest the subject and ultimate design long after the initial washes had been laid.

The piece was painted very directly and rapidly, with very little "fussing" over details.

Residents of Encanto Park
Diane Maxey
Watercolor
22″ × 30″
Collection of Jane Wentling

"A painting for a show highlighting Phoenix" was the assignment. What to do? Palm trees? Cactus? *Bor-ing*! With the due date fast approaching, Diane Maxey was, as she describes it, "brain-dead."

Then she read about a newly renovated park in town that featured a duck pond. She approached the problem just as she would tackle one of her popular florals: with a close-up view.

side you and your awe and wonder at the world—this is just part of what makes artists want to record their feelings.

I know it's hard work, and that it takes discipline, and stick-to-itiveness, and disappointment, and all of that, but it should still be a joy!

L.L.—I'd like to open the discussion now for questions from our audience.

Question: I'm a beginner, and I hear you all talk so much about staying creative. I don't even know how to get creative. How do I even get there?

D.P.—I've taught for a long time, and I do run into people who say to me, "I don't think I'm creative." I suppose that if you tell yourself that long enough, it will eventually be self-fulfilling. But I don't think you have to be taught to be creative. I think you already are. You were born that way. We all were. It's just that life, and to a certain degree education, tend to stifle the creativity that's inherent in each child.

I guess what I'm suggesting is to go back and discover that same freedom you had when you were a child. That same creativity is still inside you.

L.M.—I agree. You need to regain that feeling of play. Don't think that everything you do is precious. Just

do it and feel free to tear it up. The point is to do it. Take a color and just play with it for a whole day. Add other colors to it and see what happens. Expand from there. Don't try to make a painting, do it only as an exercise. You're not going to frame it or sell it. It's just something to have fun with and learn from. And if it stops being fun, just put it down.

D.P.—Give yourself permission to fail. Learn to say that this one is not working, and go on to the next. And don't be afraid of what other people will say—not your spouse, not your public—because everyone is a critic.

Creativity is openness—openness to understanding things which are not necessarily what you've always thought of as being art.

If you want to be creative, you'll need a certain amount of craft to control the materials. But the craft of painting (and I don't want to diminish the importance of craft) is, I think, the least important aspect of it.

Beyond that, just paint or sculpt one hell of a lot. You'd be surprised how much you can learn by just doing that.

E.M.—I've found that some of my best paintings have come out of feeling crummy, and not wanting to paint, and just starting out. You

push it a little, and something kicks in, and you're on the way. The more you do it, the more you feel in command, the freer it becomes.

Question—I work in a lot of media and I'm having difficulty focusing. Do you work in one medium for a while, then transition into something else? Or do you do oils one day, watercolor the next day, sculpture another day?

D.P.—I tend to work in two media: watercolor and acrylic. I usually group them in batches. From my experience, I tend to lose the feel for watercolor quicker than for other media. So if I just dash in and out of it, I won't really get a full feel for what I'm doing. A friend of mine, Adrian Hansen, used to say that when he came back to watercolor after six or eight months of working in oils, it would take him several weeks before he got back his feeling for the medium. I think a lot of people will batch their output simply because it allows them to get back into the feel of the medium, and run with it for a while.

L.M.—For me, very often the subject matter suggests the medium. A very delicate floral seems to call for watercolor, or I might choose rice paper and a quill. Other times I might use acrylic, which I love because it's so speedy. But for me, oil is the grand, grand medium.

Question—My ideas come, but

I doubt my ability. I don't think I quite have the talent. Does that ever happen to you, and how do you deal with the problem?

D.P. – Self-doubt is a natural thing. I suspect that, as skilled as Ed Mell is in doing what he does, even he, in his heart of hearts, doubts whether he can really paint those clouds the way he really and truly wants to. Is that true?

E.M. – Oh yes. Many times, I'll do paintings that, when I'm finished with them, I feel I've failed. I remember sending one of those "failures" to Santa Fe for a show it had to be in. Then my friend called to tell me he thought it was one of the best paintings I'd ever done. And it sold.

I think the reason for my doubts was that I felt it didn't accomplish what was in my mind at the time. Sure, we all have doubts, but the more accomplished you become,

the less those doubts play a part in your painting.

L.M. – I think that taking classes is important. If you're a beginner, learn from other artists. Drawing classes are very important. I took drawing all the twenty years my children were growing up. Take life drawing. Mix and mingle with creative people. Sharing ideas is very important, just as we're doing tonight. It's very stimulating.

D.P. – I think self-doubt is something everybody lives with. I don't care who they are. And so it's like any other thing, you learn to live with it. Just recognize that you're not the only one who has it.

Question – My doubt is not whether somebody will like it, it's whether I can remotely capture this idea, this nuance that I saw. Are you familiar with that anxiety?

D.P. – I can't speak for all of us,

but I think everybody feels that way.

D.M. – Ed Whitney told me, many years ago, that what you know is always more advanced than your ability to do it, so most of the time you're not going to succeed entirely. As Ed said, "You're far above where your painting is. But if you don't try, you won't ever get there."

D.P. – Far better to have your ideas bigger than your canvas, than to have your canvas bigger than your ideas.

Question – I gather that craft is very important. But is there a time when you realize that you know enough craft, that you're ready to go on and do?

D.M. – I think you'll find that, somewhere in your going to school and workshops, you'll gradually change the reason you're going. When you start, it's to learn the craft. But eventually, you'll begin looking for someone who will stimulate your mind more creatively, who will push you in new directions, who will pull you out of a slump you're in. Suddenly you'll realize that you're no longer going for the purpose of learning the craft, but for the purpose of expanding your own mental capacities.

You'll never learn all there is to know about the craft, because there's just too much. But eventually you won't have to be led. You will become your own teacher.

D.P. – It's going to sneak up on you. You're worried to death about craft now, but it's going to sneak up on you like a thief in the night. One day you'll look up and see that somehow you have become a craftsman without even knowing it.

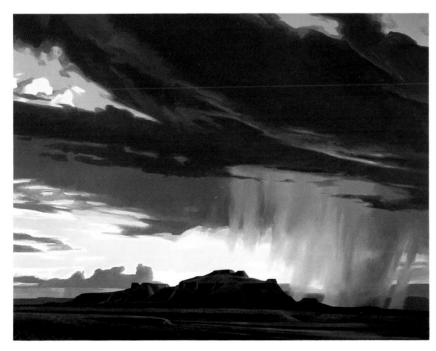

Rainy Season, Four Corners
Ed Mell
Oil on canvas
30" × 40"
Collection of Dr. Charles Taggart and Mrs. Virginia Taggart

A fine example of the artist's simplified and abstracted style, as he exhibits his skill with atmospheric effects, big skies and radiant lighting.

Creativity's Deadliest Enemies

As I interviewed artists for this book, I asked them what they considered the greatest enemies of creativity. I was surprised by the responses.

I had thought, for instance, that "rejection" would have been one of the most commonly mentioned enemies of creativity, but not one artist focused on it. Ted Goerschner, perhaps, put it best: "When you're an amateur, you shouldn't take rejection too badly. We all have a human need to be liked, but you have to be careful who likes you! If your mother likes your work, OK. If a critic who knows art likes you, that's a feather in your cap. But the general public mostly likes art better when it looks more like a photo. You have to be careful what kind of 'like' you go after."

Every artist, I found, interpreted my question somewhat differently, and their viewpoints and personal experience were reflected in their responses.

My Own Choice: Acceptance

When you're new at art, and casting about for direction, that's when your creativity is at its most active level. However, once your work is in the galleries, and it's accepted, recognized, even sought after, that's the dangerous time. The greater the acceptance of your work, the harder it becomes to experiment. Galleries expect you to continue to send them the kind of material they've been successful in selling. Collectors look for consistency of style and subject matter. They don't realize that an artist has to grow, too. If you stay in one place, painting only for collectors and galleries, you must realize that in seeking commercial success as a way to achieve creative freedom, the result can turn out to be just the opposite!

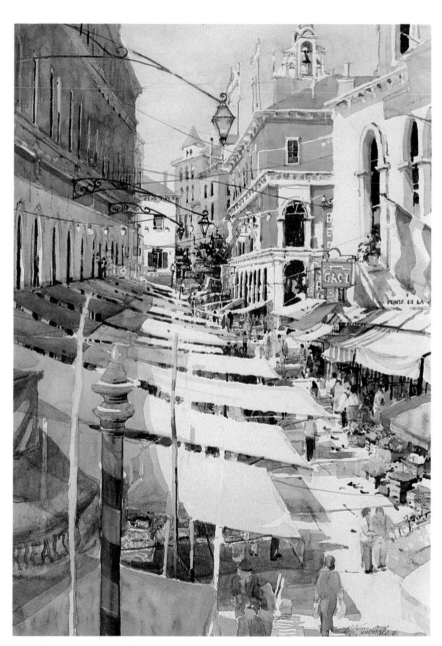

Market Mecca
Marilyn Simandle
Watercolor
36" × 24"

Notice how powerfully the rhythmic repetitive shapes of the awnings draw you into this painting of a busy marketplace. The artist avoids what could have become overwhelming busyness by hiding all that activity behind those same awnings. This painting was in the 1993 American Watercolor Society exhibit.

Harley Brown: The Conscious Mind

Your inner mind is overflowing with wonderful thoughts and ideas, all on its own, uncensored by the trickery—the "gremlins" of the conscious mind. There's the "timid gremlin" that tells you not to try anything new or different, the "technical gremlin" that focuses all on technique rather than content, and the "commercial gremlin"

which tells you, "You'd better sharpen this up, put in a few blues, and a little pink in the corner if you want to sell it!"

The conscious mind is continually obstructing, putting up walls, refusing to allow that perfect flow of ideas that lies within each of us. Your natural creativity comes to full flourish when you are somehow able to set your conscious mind aside. Let it listen to music, or deal with something totally unrelated. Occupy it so your subconscious mind can surface, releasing all its wonderful ideas and energies.

Ted Goerschner: Public Bad Taste

My list of creativity's worst enemies is led by people who don't know anything about art, who buy art and thereby influence artists to do things decor-wise and not aesthetically.

An artist can be sucked into the commercial trap—painting for no other reason than to sell. A lot of artists find one thing that sells, and because it's easy and doesn't require a whole lot of difficult creative thought, they just keep cranking that out, time after time. And *that's* one of creativity's worst enemies.

Marilyn Simandle: Money

Economic necessity is a tightrope every would-be professional artist walks. It's a constant battle between painting for money and painting for yourself. Always ask, "Why am I doing this painting?" If I can be honest with myself, I'll say, "OK, this is for the gallery, or this is for a print," and I can deal with that. But when I can honestly say, "This painting is for me!" that's the one I'll have the most fun with. That's when I do my best work, and feel like I'm on vacation!

Sally Strand: Other Commitments

For many artists, juggling commitments that are more important at the time than art (like raising a family, keeping a house, earning a living) results in relegating creativity, and the time to express it, to low priority. Not only do these commitments curtail—even eliminate—time to paint or draw, but they also result in a sense of isolation from the art world at large: the exciting world of museums, galleries, and the give-and-take of being with fellow artists.

Life's commitments can rarely be ignored. They're part of what define us, our relationships, and our place in the world. The key to being able to live with the present day's priorities is to maintain whatever minimal contact one can with the art world. Grab moments here and there to paint, to sketch, to read an art book. Keep the spark alive, and plan for that time when art can regain its place of importance in your world.

Bob Abbett: The Desire to Please

As an artist, you are constantly being pressured by well-meaning people who want to pull you one way or another with your work. Gallery people, customers, collectors, and folks who offer you commissions all want you to be a success in *their* eyes. They all want to put their two cents in.

When I was younger, desperately wanting to please these people, I'd try to do what they wanted. All of a sudden, I found that my paintings weren't my own.

An artist has to define his or her own personal filament of creativity, and guard it jealously. You just have to be very strong, and ride your own trail.

Miles Batt: Aesthetics

I tend to define aesthetics as somebody else's idea of what perfection is all about. Creatively, perfected ideas tend to leave us at a dead end, because there's nothing we can do with them. Picasso said that once he knew exactly how a thing was going to look, the fun was over.

Aesthetics, then, is the enemy of creativity. Aesthetics tends to tell you what you *can't* do, and whenever "they" tell you not to do something, that's probably where you should put your efforts. At the same time, be aware that you need to understand the rule you want to break (otherwise how will you know if you've broken it?). Then you'll know where to focus your efforts.

Tom Darro: The "Mystic Quest" Syndrome

To me, the most dangerous enemy is the tendency to see creativity in some different light, to cloak it in a kind of strange mysticism, or as some far-off gleaming ring that you have to suffer for, to be a genius for. That's nonsense.

Creativity is not rare! Creativity is the central core impulse of the universe. Creativity is the source of all beings, and what powers humankind in its continuing expanding and unfolding. It's the most natural impulse in the universe—more natural than breathing.

You have to know that creativity resides within *you* from birth. At the very core of your being, within every cell, is the desire, the knowledge and the wherewithal—indeed the *imperative*—to create.

If that all sounds very metaphysical, it's not. It's very real. We may all have been damaged to some extent by life, but creativity is still strong within us, waiting only to be called on.

The Artists

Robert Abbett

Bob Abbett came to fine art after a long career in illustration, working at leading studios in Chicago and New York, and freelancing. In his day, he did countless covers for major paperbacks.

His wildlife art is featured in many important books, including *Great American Shooting Prints*, published by Knopf, and *Contemporary Western Artists* by Peggy and Harold Samuels. He is also the subject of *The Outdoor Paintings of Robert K. Abbett*, published by Bantam/Peacock, and *Abbett*, by Michael McIntosh, part of the "Masters of the Wild Series" from Briar Patch Books. Over one hundred editions of prints have been made from his paintings. A series of limited edition prints of his sporting dogs series is available from Wild Wings, Inc., P.O. Box 451, Lake City, MN 55041.

Abbett's work has been exhibited in major shows at galleries and museums all over the United States—too numerous to list.

Joe Abbrescia

Joe Abbrescia is a native of Chicago, where he founded the Village Art School in Skokie, Illinois, and directed it from 1965 to 1976. Today, Abbrescia lives and works in Kalispell, Montana, where he enjoys painting the impressive scenery around Glacier National Park. Abbrescia's work is exhibited in galleries in Colorado, California, Montana, Illinois, Wyoming, Arizona and Massachusetts. He is well known as guest lecturer at the American Academy of Art, was Artist of the Year for the American Royal Art Association, and has had a one-man show at the Museum of the Southwest in Midland, Texas.

Abbrescia still gives painting classes and workshops. His painting, *Spring's Mountain Kingdom* was chosen as the 1990 fine art limited edition print for Glacier National Park's art collection. He is also featured in *Energize Your Paintings With Color* (North Light, 1993).

Miles G. Batt

Miles Batt—artist, author, teacher, juror—is widely known for his singularly personal painting style—a style that has won him more than 140 national and regional awards since 1968.

He has participated in more than three hundred group and solo exhibitions, has conducted art seminars worldwide for some twenty-five years, and is author of *The Complete Guide to Creative Watercolor* (Creative Art Publications, 1988, 2120 Hammock Lane, Fort Lauderdale, FL 33312, $35.00).

Batt is a signature member of the American Watercolor Society, the National Watercolor Society, and a host of regional societies.

Throughout public school, he says, he was always the "kid who could draw." Today he devotes his time to painting, and vigorously promoting his own unique watercolor vision, from his home in Fort Lauderdale, Florida.

Photo by Lisa Simond

Ardyth Bernstein

As a young girl, Ardyth Bernstein wanted to be an actress, torch singer or dancer. She also loved Nancy Drew, team sports, books, gardens and (not least of all) art. She received her bachelor's degree in painting from Arizona State University, then attended U.C.L.A in Los Angeles. She lobbied extensively for the "Artists' Consignment Bill" and saw it signed into law in 1983. Her figurative pastels and monoprints, always created from life, present an insightful look into the feminine mystique and the struggles and consequences of today's personal choices.

The artist, who currently lives with her husband in Paradise Valley, Arizona, has had numerous solo shows, including galleries in New York, Scottsdale and Boston. She has participated in group shows in many other locations. Her work is represented in numerous collections, both private and corporate, across the country.

Photo by H.M. Brown

Harley Brown

A totally dedicated devotee of pastel portraiture, Harley Brown, a native of Canada, attended the Alberta College of Art and the Camberwell School of Art in London, before embarking on a long and arduous struggle to establish himself as a professional. Today, recognized as one of the most accomplished artists in his field, Brown together with his wife, Carol, spend most of their year in Tucson, Arizona. He has been a member of the National Academy of Western Art since 1977, and has received from the organization five gold medals, one silver medal, and the prestigious Robert Lougheed Award (given by vote of academy members). Eager to share his knowledge, Brown conducts invariably sold-out workshops at the Scottsdale Artists' School and elsewhere each year. He also guides an occasional workshop group to exotic destinations, often with fellow artists and close friends Barbara and Tom Hill.

Photo by Stephen Collector

Len Chmiel

Len Chmiel says he began his art career at an early age, copying Vargas and Petty pinup matchbook covers. By high school he was pin-striping cars and airbrushing gory monster T-shirts; he later went on to successive jobs in sign painting and technical illustration.

Chmiel attended Chouinard, and the Art Center College of Art and Design in Los Angeles, where he studied design, drawing and illustration.

After graduation, Chmiel worked in aerospace industry art departments, then continued as a freelance advertising illustrator and designer.

In the 1970s, he deserted the commercial art rat race to enjoy becoming a painter and a student of life.

"Participating intensely," he says, "I've loved it all."

James C. Christensen

In addition to his career as a fine artist, Jim Christensen is a professor of art at Brigham Young University. His art has been the focus of fifteen one-man shows and more than one hundred group shows, among them the International Conference on the Fantastic and NASA's "Visions of Other Worlds" exhibit. He was featured artist at the World Fantasy Convention, and won Best in Show at ChiCon, the World Science Fiction and Fantasy Convention, in 1991.

His works have appeared in *U.S. Art, Southwest Art* and *Collectors' Mart*, and are published as high-quality limited edition prints by the Greenwich Workshop. He is working on two books, *Journey of Imagination, the Art of James C. Christensen*, to be released in 1994, and *The Voyage of the Basset*, a fantasy adventure illustrated with eighty-five new paintings, scheduled for publication in 1995.

The artist lives in Utah with his wife, Carole, and their five children.

Joni Falk

Born and raised in Chicago, Falk moved to Phoenix, Arizona, in 1960 with her husband, Bob and established a small crafts shop. Her involvement with teaching crafts and tole painting converged with a growing passion for Southwest culture and history, and she began a series of miniature paintings of Native American pottery. These paintings provided entry to the gallery scene, and her career has grown ever since.

Falk has been the recipient of numerous gold and silver medals including the Old West Museum's Purchase Award at the Governor's Invitational in Cheyenne, Wyoming. Her work has appeared in *Art of the West, Southwest Art* and *Art West* magazines, and in *Energize Your Paintings With Color* (North Light, 1993). Her work may be seen on exhibit in galleries in Arizona and Wyoming. It has been published in calendars and cards, and in nineteen limited edition prints.

Tom Darro

Tom Darro's career as a fine artist has its roots in a long and carefully guided apprenticeship with his father, Peter Darro, a religious illustrator of national reputation. Then Darro met one of America's foremost authorities on American and French Impressionism, Dr. Christian Title. A painter himself, Title exposed the young artist to some of the most sophisticated forms of color orchestration, and the physical properties that give Impressionism its power. After six years with Title, Darro studied with European-trained painter and teacher, Theodore Lukitz.

The culmination of Darro's years of study is visible in his contemporary Western paintings, which are eagerly sought by collectors, and hang in public and private collections the world over. *Desert Rain* and *Winter Corn* (in chapter two) have been published as limited edition prints by Leslie Levy Publishing, Scottsdale, Arizona.

Ted Goerschner

Following graduation from the Newark School of Fine and Industrial Arts and two years serving in the Korean war, Goerschner attended Tampa University, immersing himself in the abstract expressionist movement. He returned to New York to pursue a career as a commercial art director, attending classes at the Art Students League. During this time his work evolved into the loose, impressionistic style for which he is best known today. He wound up in California, where he lives with his wife, watercolorist Marilyn Simandle. His work has been profiled in many arts publications, including *Southwest Art, U.S. Art, American Artist*, and *Art of the West*. *Energize Your Paintings With Color* (North Light, 1993) includes a Goerschner painting demonstration.

Always busy, Goerschner conducts numerous workshops, produces and markets the couple's instructional videos, and still finds time for his passion: plein air painting.

Cheryl English

Cheryl English moved to Arizona, from Illinois, after graduating from Southern Illinois University with a master's degree in business education. She spent several years teaching in the Scottsdale school system, then left to devote her time to husband and family. It was during those years that English discovered her interest in painting, and its expressive possibilities.

Since that time she has studied with many painters, evolving not one, but two styles that are distinctly her own. Her work is greatly in demand, with four galleries in Arizona and others in Wyoming and New Mexico showing her paintings.

English's work was featured in *Art of the West* magazine in 1988.

Ann Manry Kenyon

Ann Kenyon has always known what she's wanted to do. Her passionate love for drawing developed when she was very young, and her life, aside from her family, has been devoted primarily to art.

Following five early years of private classical training with British artist Harold Hilton, she enrolled as an art major at Huntingdon College, ultimately graduating summa cum laude from Jacksonville University, where she earned departmental honors in studio art.

In 1975, she embarked on a career venture in portraiture, renting a small studio, and selling her art to friends and neighbors. Today, she is solidly established in the profession and is represented by several highly regarded portraiture galleries, including Portraits South, Portraits, Inc., and Portrait Brokers of America. At this writing, several hundred Kenyon portraits are included in private and corporate collections from Greenwich, Connecticut, to Houston, Texas.

Though she will often turn her attention to other subjects for diversion, she invariably returns to portraiture, her first love.

Raleigh Kinney

After obtaining his master's degree from St. Cloud State University in Minnesota, and teaching in the Minnesota public schools for fifteen years, Kinney decided to change direction. He currently resides in Tempe, Arizona, where he devotes his time to practicing watercolor and conducting workshops and classes regionally and in more than fifteen western states. He is founding member, signature member, and served as first vice president of the Midwest Watercolor Society. In the past twenty years, he has been juried into over forty-eight American and Canadian exhibitions, earning many best of show, merit and purchase awards. His work appears in *Energize Your Paintings With Color* (North Light, 1993).

Diane Maxey

Growing up in rural Texas, Maxey had little access to art, though she was strongly drawn to it from her earliest days. Enrolling at North Texas State University in art, and finding herself well behind graduates of big city schools, she chose to major in art education.

Due to an allergy to turpentine, Maxey turned to watercolor and has never gone back to oils. In nearby Arlington, Al Brouillete was teaching a night class in watercolor. Maxey enrolled in his class, which she continued taking for six years. Diane has studied with Dick Phillips, Robert E. Wood and Milford Zornes.

Today, Maxey lives with her husband, Bill, in Paradise Valley, Arizona, where she paints daily and continues to explore the byways of watercolor. She is a signature member of the Southwestern Watercolor Association, the Arizona Watercolor Association and the Texas Watercolor Society. Her work is shown in galleries in Arizona, Texas and Michigan.

Gary Kolter

Born in Indiana, Kolter grew up in Phoenix, Arizona. His four years at Arizona State University earned him a teaching certification. Instead of looking for placement in the school systems, however, he began painting and exhibiting at local art shows. Thus began his career in art.

Kolter lived a rural life with his wife in the desert north of Phoenix for a dozen years. Here he acquired his love for wildlife and Western traditions. Western genre painting and still lifes are a natural for him, he says.

From the mall shows in the seventies, Kolter graduated to Western invitational shows which he attended in nearly every state west of the Mississippi except North Dakota, plus many states east, and in Canada.

Louise McCall

A native of Oklahoma City, McCall created her first mural in grade school and has been doing them ever since. She went on to major in fine art at Oklahoma State, the University of New Mexico, and The Art Institute of Chicago.

In the early 1970s, McCall and her husband, Robert, an artist best known for his work documenting the nation's space program, moved to Arizona. McCall's murals, painted with her husband, may be seen in the Air and Space Museum in Washington, D.C., the Johnson Space Center in Houston, the Epcot Center in Florida and elsewhere. Her paintings and drawings are in the NASA collection, as well as in corporate and private collections both in the United States and abroad.

Venturing into a new medium, McCall and her husband recently designed the brilliant glass-stained windows at the Valley Presbyterian Church in Paradise Valley, Arizona.

Lewis Barrett Lehrman

Watercolorist and author Lew Lehrman came to fine art following nearly three decades in commercial art and illustration. Until 1984 he and his wife, Lola, ran Design Unlimited, a graphic design and food service consulting firm. Until 1993, the couple alternated between Scottsdale, Arizona, and the Berkshires of western Massachusetts, where Lehrman wrote, painted, taught watercolor, and helped run their shop, The Gallery at Mill River. Today the Lehrmans are full-time Arizona residents.

Lehrman's first book, *Being An Artist* (North Light, 1992) was inspired by his own interest in learning what it takes to become a professional fine artist in today's world. His second, *Energize Your Paintings With Color* (North Light, 1993), includes an additional painting from his "From My Childhood" series.

Lehrman received his graphics and fine art education at Carnegie Institute of Technology and at Pratt Institute in New York. A member of the faculty at the Scottsdale Artists' School, his work is currently on exhibit at galleries in Arizona, Connecticut and New York.

Ed Mell

Ed Mell's distinctive style is probably as well known as that of any Arizona artist. A native of Phoenix, Mell graduated from the Art Center College of Design in Los Angeles and worked for many years as an illustrator and art director in New York. In 1973, he returned to Arizona, and left commercial art for fine art.

The artist has had many shows in the Southwest, including a one-man show at the Scottsdale Center for the Arts and annual shows at The Suzanne Brown Gallery in Scottsdale.

He has been the subject of articles in *Arizona Highways, Southwest Art, Southwest Profile* and *Art Direction Magazine*.

Gerry Metz

A native of Chicago, Gerry Metz was an art school dropout who unexpectedly landed a job at one of the city's better art studios. This prompted him to return to school, where he enrolled in night classes for the next four years. Metz took that experience to Scottsdale, Arizona, where he briefly ran a small art school in the early seventies, and then began working his way, one painting at a time, to his present degree of recognition and success. Metz was profiled in *Being An Artist* (North Light, 1992). His work also appeared in *Energize Your Paintings With Color* (North Light, 1993).

In addition to his popular paintings, Metz has successfully issued a number of bronze sculptures in limited editions. His work is exhibited through galleries in Arizona, New Mexico, California, Indiana, Wyoming and New York. Even with all this activity, the artist still finds time to volunteer for charitable and community services.

Photo by Kevin Macpherson

Charles Sovek

Sovek has been painting, teaching and writing about art for more than thirty years. He studied art at the Art Institute in Pittsburgh and continued at the Art Center College of Design in Los Angeles and the Art Students League of New York. He has written three books: *Oil Painting, Develop Your Natural Ability* (North Light, 1990); *Catching Light in Your Paintings* (North Light, 1985); and *Painting Indoors* (North Light, 1980). He is a contributing editor for *The Artists Magazine*.

Sovek has received awards from the Salmagundi Club and Connecticut Classic Arts. He has twice won the coveted Martha Rathbone McDowell award, and has been a finalist in the 1992 Art for the Parks competition. His paintings are in more than four hundred private and corporate collections. He is an associate professor at Paier College of Art in Connecticut, the Silvermine School of Art in Connecticut, and conducts workshops and demonstrations all over the United States.

Dick Phillips

A native of Breckinridge, Texas, and a graduate of Texas A & M University, Dick Phillips spent a long career in the corporate world, pursuing art as a hobby before devoting his full-time attention to it. Since becoming a professional artist in 1973, he has continually taught drawing and painting. During his formative years as an artist, he studied with such noted painters as Milford Zornes and Robert E. Wood.

Today, married, with two grown daughters and five grandchildren, Phillips lives in Scottsdale, Arizona, with his wife, Margaret. Since 1975, he has had twenty-two one-man shows and has exhibited in more than one hundred juried shows across the United States. A signature member of the National Watercolor Society, and the Southwest Watercolor Society, Phillips is represented by galleries in Arizona, New Mexico, Tennessee and Alabama. His work is represented in corporate, public and private collections throughout the country and abroad.

Peter Van Dusen

With a master's degree in physical geography and a doctorate in geography, much of Van Dusen's career before art was spent teaching ecology courses, conducting environmental research, planning land use and illustrating scientific manuals. Today Van Dusen is a full-time artist, living and painting in Scottsdale, Arizona, with his wife, Mary.

Van Dusen's major artistic interests are the Southwest and Hawaii, though his subjects encompass many parts of the country. His work is featured in private collections throughout the United States, Germany and Australia, and is exhibited at galleries in Arizona, Wyoming, New York and New Mexico. His work was featured in the book *Energize Your Paintings With Color* (North Light, 1993).

Marilyn Simandle

Born in Toledo, Ohio, Marilyn Simandle earned her bachelor's degree in commercial art and illustration from San Jose State University. Her fine arts career began in 1969, after a stint as a flight attendant with a major airline. In the ensuing years, her watercolors and acrylics earned her more than forty-five one-woman shows, and numerous prestigious professional awards. In 1991, she became the recipient of the "High Winds" medal, awarded at the American Watercolor Society's National Exhibition. She was profiled in *Southwest Art* (1982), *Art of the West* (1989), and in the book, *Being An Artist* (North Light, 1992). A painting demonstration by her is included in *Energize Your Paintings With Color* (North Light, 1993).

Simandle currently works from her studio on a ranch in Southern California, where she lives with artist/husband Ted Goerschner and their son, Nathan. She occasionally travels to paint on location in Europe, or to conduct workshops in California or Scottsdale, Arizona. Her work is exhibited in California, Arizona and elsewhere; her prints and cards of more than fifty subjects are distributed worldwide through a leading publisher of fine art reproductions.

Index

Abbett, Bob, 88-95, 129
Abbrescia, Joe, 16-21
Abstract design, 36
 recreating, 41
After Lunch (Abbett), 95
Artist's block, overcoming, 16
 by working abstractly, 44
 through problem-solving, 83
At the Zocalo (Brown), 56-57
Autumn, With Helpers (Lehrman), 99

Background interest, 49
Batt, Miles, 104-109, 129
Beached Lobster Boat (Sovek), 115
Bernstein, Ardyth, 62-65
Blending, with palette knife, 86
Breaking Surf (Goerschner), 41
Brown, Harley, 56-61, 128-129
Brushes in Pot (Sovek), 110
Brushwork, precise, 73
Buck—Brittany Head (Abbett), 88-89

Canyons I-IV (Abbrescia), 16
Carmelized Garden (Batt), 109
Catalina Colors and Patterns (Kinney), 10
Center of interest, beginning with, 49
Chiapas Mother (Brown), 60-61
Children of the North Country (Darro), 25
Chmiel, Len, 11-15, 73-74
Christensen, James, 116-121
Cibola (Phillips), 45
Client, communicating closely with, 90
Cody Vista (English), 87
Color
 adding, 37-38
 establishing, 98
 rethinking, 110-111
Color, and value
 contrasts, 9
 establishing, 17-18, 52
 pattern for, 118
Color comp, 58-59
Color patterns, 82
Color sketch, 90
Color studies, 91
Commentary, adding, to sketches, 30
Composition
 assembling, 64
 sketch for, 69
 unifying, 28
Composition, simplified, 8-10, 48
Concepts
 developing, for client, 90
 two, from photo shoot, 24
Contrasts, 52
 value, 9, 83

Dark Mission (Batt), 107
Darro, Tom, 22-29, 129
Desert Mother (Darro), 28
Desert Rain (Darro), 22-23
Detail
 adding, 38
 facial, 102
Drawing
 from life, 58

from projected sketch, 91
 minimal, 51
 preliminary, working without, 36-42
 See also Sketches, Studies

East Norwalk Harbor (Sovek), 113
English, Cheryl, 85-87
Enlarging, from sketch, problems with, 18
Erica's Laundry (Sovek), 112

Falk, Joni, 46-47, 76-80
Fantasy painting, 116-121
First Light, Sierras (Goerschner), 40
Floral #1 (Maxey), 54
Fragile Elegance (Falk), 46-47
From the Cliffs (Abbrescia), 21

Galisteo Winter (Sovek), 114
Gin Clear (Chmiel), 15
Goerschner, Ted, 36-41, 129
Grand Canal, The (Abbrescia), 20
Grand View, A (Abbrescia), 19
Greek Harbor (Goerschner), 40
Greek Sunset (Goerschner), 39
Gus (Abbett), 93

Happiness (McCall), 124
House in Jackson, Wyoming (Lehrman), 100
How Many Angels Can Dance on the Head of a Pin? (Christensen), 121
Hues, in nature, 59

In Full Bloom (Maxey), 55
It's Not Easy Being Green (Anita Hill Series) (Bernstein), 62

Japanese Garden (Phillips), 125

Kenyon, Ann Manry, 101-103
King of Hearts (Kolter), 72
Kinney, Raleigh, 8-10
Kolter, Gary, 71-73

Land Ho (Van Dusen), 7
Las Trampas Church (Sovek), 113
Lawrence Pretended Not to Notice That a Bear Had Become Attached to His Coattails (Christensen), 121
Lazy Ike (Kolter), 73
Lehrman, Lew, 30-31, 66-70, 96-100, 128
Light
 deciding on direction of, 79
 hues in, 59
Lunch Break (Kolter), 71

Maggie and Anna Lane (Kenyon), 102
Mambo Queen (Bernstein), 65
Market Mecca (Simandle), 128
Materials, for sketching, 31
Maxey, Diane, 51-55, 81-84, 122-127
McCall, Louise, 122-127
Meals on Wheels (Goerschner), 41
Media, switching, 114
Mell, Ed, 122-127
Memory, painting from, 66-67
Metz, Gerry, 32-33
Mission '90 (Batt), 108
Mission, Mission (Batt), 108

Model, The (Brown), 61
Models
 for photo shoot, 24, 32
 working with, 63
Molly (Kenyon), 103
Monochrome, developing in, 5
Motrico, Spain (Batt), 104-105
Mountain Man (Metz), 33
Mountain Winter, New Mexico (Phillips), 34-35

Navajo Buddies (Abbett), 94
Neighbors II, The (Abbett), 94
News From Home (Kolter), 72

Oakland Estuary (Sovek), 111
Of Snowy Billows and Dawn (Chmiel), 14
Oil study, 12
On My Way to Grandmother's House (Anita Hill Series) (Bernstein), 62
Once Upon a Time (Christensen), 120
Oriental watercolor technique, 68-69

Painting
 fantasy, 116-121
 value, 106
Painting trips, importance of, 16-17
Paintings
 on-location, 16
 plein air, 11
 trompe l'oeil, 71
Palette, limited, 85, 111
Palette knife paintings, 85-87
Paper, Masa, 68
 See also Sandpaper, as painting surface
Patterns
 abstract, 42-44
 color, 82
Patterns of Light (Falk), 80
Paula (Kenyon), 103
Pelican King I, The (Christensen), 121
Phillips, Dick, 34-35, 42-45, 122-127
Photo sessions
 for commissioned portrait, 101
 with models, 24
Photos, 4, 6, 8, 24, 26, 32, 36, 51, 58, 85, 90, 96, 101, 106
 assembling many, for reference, 29
 daubing paint onto, 76
 limited use of, 86
 old, getting ideas from, 38
 original, 81
 working from, problem with, 58
 working immediately from, 6
 8" × 10", 32
Pilot to Copilot (Kinney), 10
Plein air paintings, 11
Pop and Me (From My Childhood Series) (Lehrman), 70
Portrait, 58
 animal, 88-93
 commissioned, 101-103
 of house, 96-99

Rag board, 72
Rainy Season, Four Corners (Mell), 127
Red House, The (Lehrman), 100

Reference file, building, 32
References
 assembling many photos for, 29
 building solid story with, 24
 fitting to concept, 26
 method of using, 33
 photo. *See* Photos
 plein air paintings as, 11
Research
 for era's details, 71
 for fantasy painting, 118
Residents of Encanto Park (Maxey), 126
River Encampment (Van Dusen), 7
Rules, breaking, 105

Safe Haven (Van Dusen), 6
Sandpaper, as painting surface, 62, 65
Sea la Alma (Be the Soul) (Batt), 107
Shadow Play (English), 85
Shadows, 55, 84
 hues in, 59
Shady Rest (Falk), 79
Shapes, simple, starting with, 36-37
Simandle, Marilyn, 47-50, 129
Sketchbook, 51, 68
 transforming, into journal, 30
Sketches
 for client approval, 91, 96
 color, 17, 58-59, 90
 for composition, 69

enlarging and transferring, 97, 118
enlarging from, problems with, 18
location, 8
master, 118
pencil, 12, 26
preliminary, 116
value, 48, 51, 69, 81
vs. photos, 30
See also Studies
*Society of Six: California Colorists,
 The*, 110
*Sometimes the Spirit Touches Us
 Through Our Weaknesses*
 (Christensen), 120
Southwest Images (Falk), 80
Sovek, Charles, 110-115
Spring Fling (Simandle), 50
Still Life With Fruit (Sovek), 115
Strand, Sally, 129
Studies
 color, 5, 59, 91
 monochrome, 59
 oil, 12, 76
 value, 4
Styles, switching, 86
Subject
 controversial, 63
 selecting, 81

Tee-Cups (Bernstein), 65

Texture, 26-27
 scratching in, 52
Toning, 26
Tracking, The (Metz), 33
Trompe l'oeil paintings, 71
Twilight on the Lawn, Tanglewood
 (Lehrman), 31

Under the Blue Umbrellas (Maxey), 84
Unkempt and Happy (Chmiel), 73-74
Urban Renewal, Jerome, Arizona (Phil-
 lips), 45

Value, and color, 52
 contrasts, 9, 83
Value painting, 106
Values, establishing, 37, 43, 92, 98
Van Dusen, Peter, 4-7
View of Hyde Street (Sovek), 112
Visions of the Past (Falk), 80
Voyage of the Basset (Christensen), 117

Watchtower, The (Abbrescia), 2-3
Watercolor technique, Oriental, 68-69
Winter Corn (Darro), 29
Winter Frieze (Chmiel), 11

*Zerega Avenue 1938 (From My Child-
 hood Series)* (Lehrman), 66-67

More Great Books for Painters!

Splash 3 — You'll explore new techniques and perfect your skills as you walk through a diverse showcase of outstanding watercolors. Plus, get an inside glimpse at each artist's source of inspiration! #30611/ $29.99/144 pages/136 color illus.

Capturing Radiant Color in Oils — Vitalize your paintings with light and color! Exercises will help you see color relationships and hands-on demonstrations will let you practice what you've learned. #30607/ $27.99/144 pages/222 color illus.

Painting with Passion — Discover how to match your vision with paint to convey your deepest emotions. With step-by-step instructions, fifteen accomplished artists show you how to choose a subject, and use composition, light and color to suffuse your work with passion. #30610/$27.95/144 pages/225 color illus.

Enrich Your Paintings with Texture — Step-by-step demonstrations from noted artists will help you master effects like weathered wood, crumbling plaster, turbulent clouds, moving water and much more! #30608/$27.95/144 pages/262 color illus.

Enliven Your Paintings with Light — Sharpen your light-evoking abilities with loads of examples and demonstrations. #30560/$27.95/144 pages/194 color illus.

Strengthen Your Paintings with Dynamic Composition — Create more beautiful paintings with an understanding of balance, contrast, and harmony. #30561/ $27.95/144 pages/200 color illus.

Dramatize Your Paintings with Tonal Values — Make lights and darks work for you in all your paintings, in every medium. #30523/$27.95/144 pages/270 color illus.

Energize Your Paintings with Color — Create paintings alive with vivid color and brilliant light. #30522/$27.95/144 pages/230 color illus.

Paint Watercolors Filled with Life and Energy — Discover how to paint watercolors that vibrate with emotion! Using the "Westerman No-Fault Painting System," you'll learn how to overcome your fear of making mistakes by using your materials and brushstrokes to create powerfully expressive work. #30619/$27.95/144 pages/ 275 color illus.

Jan Kunz Watercolor Techniques — Take a Jan Kunz workshop without leaving home! With 12 progressive projects, traceable drawings, and Kunz's expert instruction, you'll paint enchanting still lifes and evocative children's portraits in no time! #30613/ $16.95/96 pages/80 color illus./paperback

Welcome To My Studio: Adventures in Oil Painting with Helen Van Wyk — Share in Helen Van Wyk's masterful advice on the principles and techniques of oil painting. Following her paintings and sketches, you'll learn the background's effect on color, how to paint glass, the three basic paint applications, and much more! #30594/$24.95/128 pages/146 color illus.

Timeless Techniques for Better Oil Paintings — You'll paint more beautifully with a better understanding of composition, value, color temperature, edge quality and drawing. Colorful illustrations let you explore the painting process from conception to completion. #30553/$27.95/144 pages/ 175 color illus.

Splash 1 — If you missed out the first time, this is your chance to draw inspiration from the beautiful showcase of contemporary watercolors that kicked off the Splash craze. Plus, you'll refine your skills by observing a wide range of styles and techniques in large, full-color detail. #30278/ $29.95/152 pages/160 color illus.

Learn Watercolor the Edgar Whitney Way — Learn watercolor principles from a master! Excerpts from Whitney's work-shops, plus a compilation of his artwork will show you the secrets of working in this beautiful medium. #30555/$27.95/144 pages/130 color illus.

Webb on Watercolor — Discover how to put more expression in your painting style! Frank Webb shows you the entire watercolor process — from choosing materials to-painting philosophy. #30567/$22.95/160 pages/200 color illus./paperback

Zoltan Szabo: Watercolor Techniques — Learn to paint the beauty of an azalea bloom, the delicacy of a spider's web and more! You'll master the techniques of watercolor as Szabo takes you through the creative process. #30566/$16.95/96 pages/ 100 color illus./paperback

Painting Watercolor Florals that Glow — Capture the beauty of flowers in transparent watercolor. Kunz provides six complete step-by-step demonstrations and dozens of examples to help make your florals absolutely radiant. #30512/$27.95/144 pages/ 210 color illus.

Splash 2 — Feast your eyes on over 150 full-color reproductions of the best contemporary watercolors as you draw inspiration from the personal success stories of 90 watercolorists. #30460/$29.95/144 pages/ 150 + color illus.

Ron Ranson's Painting School: Watercolors — No matter what your skill level, you'll be able to dive right into the world of watercolors with the practical teaching approach of noted painter, Ron Ranson. #30550/$19.95/128 pages/200 + color illus./ paperback

How To Make Watercolor Work for You — You'll discover the expressive potential of watercolor using the secrets and inspiration of a master watercolorist, Frank Nofer! #30322/$27.95/144 pages/114 color illus.

Fill Your Watercolors with Light and Color — "Pour" life and light into your paintings! Here, Roland Roycraft gives you dozens of step-by-step demonstrations of the techniques of masking and pouring. #30221/$28.99/144pages/350 illus.

Creating Textures in Watercolor — It's almost magic! Discover how textures create depth, interest, dimension . . . and learn how to paint them. Johnson explains techniques for 83 examples — from grass and glass to tree bark and fur. #30358/$27.95/ 144 pages/115 color illus.